Writings and Interviews 1962–1993

Gerhard Richter
The Daily Practice of Painting

Writings and Interviews 1962–1993

Edited by Hans-Ulrich Obrist
Translated from the German by David Britt

The MIT Press
Anthony d'Offay Gallery London

Photo Credits

Peter Dibke: 17, 25, 32, 36, 40, 59, 72, 79, 81, 83, 85, 86; Volker Döhne: 215; Victoria von Fleming: 223, 257, 271; Foto K 58: 56; Isa Genzken: 91, 95, 102, 104, 106, 110, 116, 126, 168, 169, 176, 204, 208, 210, 232, 234, 238; Ulrich Horn: 89; Benjamin Katz: 131, 135, 144, 147, 157, 164; Manfred Leve: cover, 97, 98, 228; Sabine Moritz: 241; Timm Rautert: 170, 171, 179, 181, 184, 188, 191, 197, 201; Katrin Schilling: 193

Translated from the German, Gehard Richter Texte, by David Britt
© 1993 Insel Verlag Frankfurt am Main and Leibzig
English translation © 1995 Anthony d'Offay Gallery, London

First published in the United States in 1995 by
The MIT Press, Cambridge, Massachusetts,
in association with the Anthony d'Offay Gallery, London

Coordinated by Robert Violette
Designed by Peter B. Willberg
Typeset by ACC Computing
Printed and bound in Italy by Grafiche Milani

Library of Congress Cataloging-in-Publication Data

Richter, Gerhard, 1932–
 [Text, English]
 The daily practice of painting: writings 1962–1993 / Gerhard
Richter, edited by Hans-Ulrich Obrist; translated from the German by
David Britt.
 p. cm.
 Includes chronology, bibliographical references and index.
 ISBN 0-262-68084-X (pb)
 1. Richter, Gerhard, 1932– —Philosophy. 2. Richter, Gerhard,
1932– —Interviews. 3. Artists—Germany—Interviews. I. Obrist,
Hans-Ulrich. II. Title.
 N6888.R49A35 1995 95-9818
 759.3 dc20 CIP

10 9 8 7 6 5 4

Contents

Preface



La traversée peut, je crois,
se dire dans les deux sens,
selon les deux directions,
l'image traverse les textes et
les change; traversés par
elle, les textes la
transforment, Change,
transformation, métamorphose
et peut-être mieux encore
détournement; pouvoirs de
l'image saisis par transit, et
dans le transitus, par
quelques textes; à travers
eux, interroger l'être de
l'image et son efficacité.

Traversing can, I think, be
interpreted in two ways,
according to direction: the
image traverses the text and
changes them; traversed by the
image, the text transforms it
Change, transformation,
metamorphosis – perhaps
hijacking is a better word:
the powers of the image
captured on the wing, in
transit, by some text.
Through those powers, examine
the nature of the image and
its effectiveness.



(Louis Marin, *Des pouvoirs de l'image*, 9–10.)

Until now, Gerhard Richter has been reluctant to publish his own writings. This book brings together for the first time the artist's most important texts and interviews. Spontaneous notes and journal entries appear alongside essays, letters, statements, manifestos, conversations and dialogues produced for specific public occasions.

The themes of Richter's writings range widely over the intrinsic problems of art. His journal entries characteristically contain reflections on the current practice of painting as well as commentary on the social and political issues of the day. Richter is our contemporary, and his writings are disarmingly clear and direct: now cool and detached, now emotional, now tentative, now bluntly critical. They always go straight to the point.

In contrast to Barnett Newman, whose major works were preceded by a lengthy period of writing, and in contrast to Hans Hofmann's didactic impulse, Gerhard Richter's writing runs parallel to the act of painting, accompanies it, questions it and is corrected by it. They are concurrent, retrospective and reflective thought processes, in which

a high degree of self-reflection keeps doubt alive. In this publication, the overtly biographical photographs that Richter himself has selected offer a further parallel directly related to his work.

Richter's energizing contradictions as a painter do not constitute what critics have often unthinkingly sought to hypostatize as the 'Richter Style'. His work occupies the point where the originally categorical distinction between photo-realism and abstraction dissolves, or at least blurs, into fluid strategies, permeated by the doubts that arise in the practice of painting. Likewise, almost all of his texts work by contraries, as a check on – and exploration of – painting and its premises. Crossovers and contradictions bring certain related basic structures into play, without allowing them to harden into ideology.

Many of Richter's denunciations of certain forms of contemporary ideology may well seem over-vehement, now that hostility to ideology is often no more than a fashionable pose; but his critique of ideology is deeply rooted in his own experience. Born in Dresden in 1932, he grew up under two dictatorships, and, in the West from 1961 onwards, he took a sceptical view of the influence of any kind of ideology in artistic and intellectual circles. If Richter continually reverts to the subject, this is largely the result of his conviction that there is no escape from ideology through personal experience: one must instead try, undogmatically, to translate one's own passion into reality. In this sense, his statement, 'I believe in nothing', paradoxically confirms a belief: a free-flowing *coincidentia oppositorum*, or union of opposites, that transcends the opposition between intuition and reason. Richter's stylistic and thematic diversity as a painter embodies a consistent and powerful collection of ideas that he has come to express with increasing precision.

Like no other contemporary artist, Gerhard Richter addresses the possibilities and impossibilities, the function and the autonomy of art today. Without promising direct experience of the object, but also without blindly submitting to the illustrative function of painting, Richter paradoxically succeeds in recovering something like a daily yet critical practice in dealing with the medium. Painting is only one truth surrounded by many other truths; Richter's works are heterogeneous

models which allow, even demand, perpetual change and mutation.
In its present form, this book is the result of a dialogue for which I am deeply grateful to Gerhard Richter. I owe a particular debt of gratitude to Angelika Thill, for her dedicated and scholarly backing of this project. My thanks also to Henning Weidemann and Lydia Wirtz, for a rewarding collaboration. Special thanks to Anne and Anthony d'Offay for their generous support, to David Britt for his careful and superb translation, and to Robert Violette for his enthusiasm and commitment to the publication of Gerhard Richter's writings in English.

On my own behalf and on that of Gerhard Richter, I would like to thank his interviewers for granting permission to reprint their texts.

Hans-Ulrich Obrist
London, February 1995

Notes, 1962

The first impulse towards painting, or towards art in general, stems from the need to communicate, the effort to fix one's own vision, to deal with appearances (which are alien and must be given names and meanings). Without this, all work would be pointless and unjustified, like Art for Art's Sake.

The idea that art copies nature is a fatal misconception. Art has always operated against nature and for reason.

Every word, every line, every thought is prompted by the age we live in, with all its circumstances, its ties, its efforts, its past and present. It is impossible to act or think independently and arbitrarily. This is comforting, in a way. To the individual, the collective experience of the age represents a bond – and also, in a sense, security; there will always be possibilities even in disaster.

It makes no sense to expect or claim to 'make the invisible visible', or the unknown known, or the unthinkable thinkable. We can draw conclusions about the invisible; we can postulate its existence with relative certainty. But all we can represent is an analogy, which stands for the invisible but is not it.

There is no excuse whatever for uncritically accepting what one takes over from others. For no thing is good or bad in itself, only as it relates to specific circumstances and to our own intentions. This fact means that there is nothing guaranteed or absolute about conventions; it gives us the daily responsibility of distinguishing good from bad.

Picturing things, taking a view, is what makes us human; art is making sense and giving shape to that sense. It is like the religious search for God. We are well aware that making sense and picturing are artificial, like illusion; but we can never give them up. For belief (thinking out

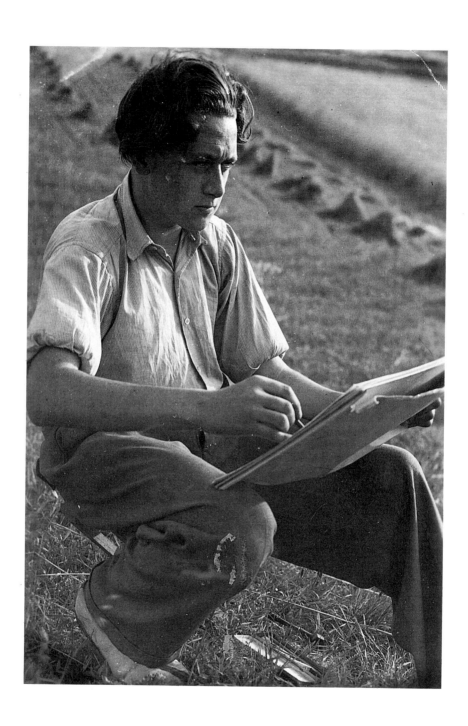

12 Waltersdorf/Oberlausitz, Germany, 1950

and interpreting the present and the future) is our most important characteristic.

Art's means of representing a thing – style, technique and the object represented – are circumstances of art, just as the artist's individual qualities (way of life, abilities, environment and so on) are circumstances of art. Art can just as well be made in harmony with the circumstances of its making as in defiance of them. In itself art is neither visible nor definable: all that is visible and imitable is its circumstances, which are easily mistaken for the art itself.

As soon as artistic activity turns into an 'ism', it ceases to be artistic activity. To be alive is to engage in a daily struggle for form and for survival. (By way of analogy: social concern is a form and a method that is currently seen as appropriate and right. But where it elevates itself into Social*ism*, an order and a dogma, then it loses its best and truest qualities and may turn criminal.)

I did not come here to get away from 'materialism': here its dominance is far more total and more mindless. I came to get away from the criminal 'idealism' of the Socialists.*

Painting has nothing to do with thinking, because in painting thinking is painting. Thinking is language – record-keeping – and has to take place before and after. Einstein did not think when he was calculating: he calculated – producing the next equation in reaction to the one that went before – just as in painting one form is a response to another, and so on.

Art serves to establish community. It links us with others, and with the things around us, in a shared vision and effort.

My concern is never art, but always what art can be used for.

* In 1961 Richter left East Germany and moved to Düsseldorf.

Since there is no such thing as absolute rightness and truth, we always pursue the artificial, leading, *human* truth. We judge and make a truth that excludes other truths. Art plays a formative part in this manufacture of truth.

The sciences certainly have influenced the arts. To an Aztec, the sunset was an inexplicable event, which he could not cope with or even survive without the imagined aid of his gods. Obvious phenomena of this sort have since been explained. But the sheer unimagined vastness of the explicable has now made the inexplicable into such a monstrous thing our heads spin, and the old images burst like bubbles. The thought of the totally inexplicable (as when we look at the starry sky), and the impossibility of reading any sense into this monstrous vastness, so affect us that we need ignorance to survive.

Strange though this may sound, not knowing where one is going – being lost, being a loser – reveals the greatest possible faith and optimism, as against collective security and collective significance. To believe, one must have lost God; to paint, one must have lost art.

Letter to a newsreel company, 29 April 1963

Neue Deutsche Wochenschau
Düsseldorf

Dear Mr Schmidt,

We take the liberty of drawing your attention to an unusual group of young painters with an unusual exhibition. We are exhibiting in Düsseldorf, on former shop premises in the section of Kaiserstrasse that is due for demolition. This exhibition is not a commercial undertaking but purely a demonstration, and no gallery, museum or public exhibiting body would have been a suitable venue.

The major attraction of the exhibition is the subject matter of the

works in it. For the first time in Germany, we are showing paintings for which such terms as Pop Art, Junk Culture, Imperialist or Capitalist Realism, New Objectivity, Naturalism, German Pop and the like are appropriate. Pop Art recognizes the modern mass media as a genuine cultural phenomenon and turns their attributes, formulations and content, through artifice, into art. It thus fundamentally changes the face of modern painting and inaugurates an aesthetic revolution. Pop Art has rendered conventional painting – with all its sterility, its isolation, its artificiality, its taboos and its rules – entirely obsolete, and has rapidly achieved international currency and recognition by creating a new view of the world.

Pop Art is not an American invention, and we do not regard it as an import – though the concepts and terms were mostly coined in America and caught on more rapidly there than here in Germany. This art is pursuing its own organic and autonomous growth in this country; the analogy with American Pop Art stems from those well-defined psychological, cultural and economic factors that are the same here as they are in America.

We take the view that the *Wochenschau* ought to document this first exhibition of 'German Pop Art', and we ask you to consider the possibility of a report. If you would like further detailed information on us, our work, and our ideas, we shall be glad to supply them.

We* look forward to hearing from you.

Yours truly,

Gerd Richter
Hüttenstrasse 71
Düsseldorf
Tel. 18970

* The painters Manfred Küttner, Konrad Lueg, Sigmar Polke and Gerhard Richter.

Programme and Report:

The Exhibition *Leben mit Pop – eine Demonstration für den Kapitalistischen Realismus*, Düsseldorf, 11 October 1963

Please note that the number assigned to you is:

PROGRAMME (roman numerals) CATALOGUE (letters)
for a Demonstration for Capitalist Realism

Living with Pop
Friday, 11 October 1963, Flingerstrasse 11, Düsseldorf

I) Start 8 p.m. Report to 3rd floor.

A Waiting room, 3rd floor (decor by Lueg and Richter)

II) When your number is called, visit Room No.1, 3rd floor.
 Disciplined behaviour is requested.

B Room No.1: sculptures by Lueg and Richter
 (plus one work on loan from Professor Beuys)
 (*Couch with Cushions and Artist*
 Floor Lamp with Foot Switch
 Trolley Table
 Chair with an Artist
 Gas stove
 Chair
 Table, Adjustable, with Table Setting and Flowers
 Tea Trolley, Laid
 Large Cupboard with Contents and Television
 Wardrobe with loan from Professor Beuys)

III) When your number is called (approx. 8:45 p.m.), visit other
 exhibition rooms on 2nd and 1st floors and ground floor.
 During this tour (Polonaise), please refrain from smoking.

C Exhibition rooms on several floors (selected by Lueg and Richter)
 (52 bedrooms, 78 living rooms, kitchens and nurseries, paintings
 by both painters; guests of honour, Messrs. Schmela and
 Kennedy)

IV) On completion of tour, see A etc.

Subject to alteration.

> Thank you for your attention.
> Konrad Lueg and Gerd Richter

REPORT

[12 September 1963.] Planning of exhibition in furniture store, Düsseldorf. Available space consists of one room on 3rd floor of office block, floor area 32 m².

A number of exhibition concepts were rejected, and it was resolved to hold a demonstration as follows:

a) The whole furniture store, exhibited without modification.

b) In the room set aside for the exhibition, a distilled essence of the demonstration. An average living room as a working exhibit, i.e., occupied, decorated with suitable utensils, foods, drinks, books, odds and ends, and both painters. The individual pieces of furniture stand on plinths, like sculptures, and the natural distances between them are increased, to emphasize their status as exhibits.

c) Programmed sequence of the demonstration for 11 October 1963.

List of rooms to be viewed on 11 October 1963:

I) Passage lined with window displays (26 large windows). Office entrance. Lift to 3rd floor.

II) Waiting room (large landing on 3rd floor). On the walls: 2 boards inscribed WAITING ROOM. 14 pairs of roebuck antlers (shot in Pomerania, 1938–42). On display: 39 simple chairs, on each a copy of the *Frankfurter Allgemeine* for 11 October 1963. On the stairs lie assorted picture magazines; by the lift stand two life-size figures (paper on wire mesh, varnished and painted), representing the art dealer Alfred Schmela and President John F. Kennedy. The space is lit by cold, rather dim fluorescent light.

III) Exhibition room. On 9 white plinths stand the following items. A tea trolley bearing a vase of flowers, and on its lower shelf the works of Churchill and the home-making magazine *Schöner Wohnen*. A cupboard with assorted contents. A wine-red chair. A gas stove. A green chair, occupied by K. Lueg (dark suit, white shirt, tie). A small occasional table; on it, a television set (showing News followed by 'The Adenauer Era'). A small standard lamp. A couch; reclining thereon, with a detective story, G. Richter (blue suit, pink shirt, tie). A table set for coffee for two, with cut marble cake and napfkuchen and coffee in cups, plus 3 glasses and a plastic bag containing 3 bottles of beer and 1 bottle of grain spirit. The walls are painted white, with no pictures or other adornment. Next to the door is a wardrobe, containing the official costume of Prof. J. Beuys (hat, yellow shirt, blue trousers, socks, shoes; to which 9 small slips of paper are attached, each marked with a brown cross; beneath is a cardboard box containing Palmin and margarine). The room is lit by very bright, warm fluorescent light, and by the standard lamp; there is a persistent smell of pine air-freshener.

IV) Extensive furniture exhibition of all current styles on 4 floors (81 living rooms, 72 bedrooms, kitchens, individual pieces. Store rooms. Tightly packed alcoves, cubicles, rooms, stairs and passages filled with furniture, carpets, wall decorations, appliances, utensils).

In a number of installations in the bedroom and living-room sections, paintings by Lueg and Richter are on show.

By K. Lueg: *Four Fingers*; *Praying Hands*; *Bockwursts on Paper Plate*; *Coathanger*.

By G. Richter: *Mouth*; *Pope*; *Stag*; *Neuschwanstein Castle*.

 These rooms are lit normally.

8:00 p.m. Two store employees stand at the entrance, giving out individually numbered programmes. A total of 122 visitors were counted in, a small proportion of whom left before the end of the event.

The visitors take the lift to the 3rd Floor and enter the WAITING ROOM. Loudspeakers all over the building broadcast dance music and the voice of an announcer, who welcomes the visitors and summons them in numerical order to view the exhibition room, which they do in groups of 6–10 individuals every 3–5 minutes. The first visitors to be called enter the room hesitantly. The room soon fills up. By approximately 8:30 the announcements are being ignored, and everyone simply squeezes in. The food and drink in the exhibition is consumed by the visitors, and some of the contents of the cupboard are looted.

8:35 p.m. The exhibited artists descend from their plinths. They and the voice on the loudspeakers request the visitors to begin the grand tour.

Richter leads a first group to the bedroom department on the 2nd floor; Lueg follows with more visitors.

The loudspeakers continue to broadcast dance music, interspersed with selected texts from furniture catalogues. From the 2nd floor the tour proceeds to the living-room department below, and then on through the store room to the kitchen department in the basement.

Most of the visitors fail to observe the prescribed itinerary and scatter or stray into the various departments.

By approximately 9 p.m., all the visitors have reached the kitchen department. They seat themselves in the 41 display kitchens and drink the beer provided. One visitor (an art student) protests against the Demonstration by removing all his clothing except a pair of swimming trunks. He is escorted from the building with his clothes under his arm.

By 9:30 p.m. the last visitor has left the building.

Notes, 1964

As a boy I did a lot of photography and was friendly with a photo-
grapher, who showed me the tricks of the trade. For a time I worked
as a photographic laboratory assistant: the masses of photographs that
passed through the bath of developer every day may well have caused
a lasting trauma. Then I went to Dresden, to the Academy, and did
nothing but paint – in a realistic style influenced by Beckmann.

When I went to study with Götz in Düsseldorf in 1961 (which was
when I moved across to the West), I was pretty nonplussed and
desperate to start with. What eventually set me free was the encounter
with Fluxus and Pop Art.

My first Photo Picture? I was doing large pictures in gloss enamel,
influenced by Gaul. One day a photograph of Brigitte Bardot fell into
my hands, and I painted it into one of these pictures in shades of grey.
I had had enough of bloody painting, and painting from a photograph
seemed to me the most moronic and inartistic thing that anyone
could do.

I collect photographs (nowadays, I also get a lot given to me) and I am
always looking at them. Not 'art' photographs, but ones taken by lay
people, or by ordinary newspaper photographers. The subtleties and
tricks of the art photographers are easily seen through, and then they
are boring.

Happenings, pictures, objects: the lay person has and makes all these
in a way that puts every artist to shame. Have artists ever made objects
remotely as large and as good as a lay person's garden?

Composition is a side issue. Its role in my selection of photographs is
a negative one at best. By which I mean that the fascination of a
photograph is not in its eccentric composition but in what it has to say:

its information content. And, on the other hand, composition always also has its own fortuitous rightness.

It is hard, say, to cross out six different numbers on a Lotto ticket in such a way that the arrangement looks convincing. And yet the sequence that emerges after the numbers are drawn seems entirely right and credible in every way.

I prefer the 'naive' photograph, with a simple, uncomplicated composition. That's why I like the *Mona Lisa* so much; there's nothing to her.

In every respect, my work has more to do with traditional art than with anything else.

For me there really exists a hierarchy of pictorial themes. A mangel-wurzel and a Madonna are not of equal value, even as art objects. The virtuosity of the *peinture* is only an attempt to conceal this. I hate the dazzlement of skill: e.g., being able to draw something freehand from life, or – even worse – inventing or putting together something entirely original: a particular form, a particular composition or an eccentric colour scheme. It's all too easy to get carried away by one's own skill and forget about the picture itself. There are legions of painters who are just too talented to paint good pictures. Being able to do something is never an adequate reason for doing it. That is why I like the 'non-composed' photograph. It does not try to do anything but report on a fact.

I have no favourite pictorial themes. Naturally, particular things have a special fascination for me. But I don't want to tie myself down: there are many aspects to the world that photography represents.

I also paint from photographs that I have taken myself; and of course I can set these up the way I want them.

I simply copied the photographs in paint and aimed for the greatest possible likeness to photography. So I avoided brushmarks and painted as smoothly as I could. Factors like overexposure and lack of focus

found their way in unintentionally, but then they had a decisive effect on the atmosphere of the pictures. Nowadays I sometimes work the other way round, so that pictures derive from technique. The *Doors* and *Curtains*, for example, are pictures constructed and designed on the basis of my experience with blurring. Technique is really a side issue.

Perhaps one day I shall find something that works better than painting! For the moment, however, I am used to working with brush and paint, and I find this both simpler and more full of potential than photography, which is too bound up with easily repeatable tricks and manipulations. And even when I paint a straightforward copy, – something new creeps in, whether I want it to or not: something that even I don't really grasp.

'Capitalist Realism':
Contact with like-minded painters – a group means a great deal to me: nothing comes in isolation. We have worked out our ideas largely by talking them through. Shutting myself away in the country, for instance, would do nothing for me. One depends on one's surroundings. And so the exchange with other artists – and especially the collaboration with Lueg and Polke – matters a lot to me: it is part of the input that I need.

Poster text for the exhibition *Klasen und Richter,* Galerie Friedrich & Dahlem, Munich 1964

Prescribed

Prescribed course: flight to Göppingen-Berneck and return to take-off point at Roth-Kiliansdorf, total distance 147 km. Bad weather caused numerous emergency landings. Rudolf Lindner (Nabern/Teck), who had taken over the lead in the standard class from Heinz Huth after the second trial, force-landed his Phoebus near Bopfingen after flying approximately 100 km. Rolf Kuntz (Braunschweig) landed on the Hausknecht, near Böhmenkirch, 694 m above sea level. As this went to press, the World Champion, Heinz Huth, and the leader of the open class, Rolf Spanig (Speyer), were still in the air.

Interview between John Anthony Thwaites and Gerhard Richter written by Sigmar Polke, October 1964

Mr Richter, you are the most talented of the German Pop painters; you went through all the hardships and the hostility that the movement encountered in its early days; and you now occupy a leading position in the movement. Perhaps you can tell us something about your work and your artistic development.
I have a lot of work, and I am well developed artistically, and also mentally and physically. I pull the expander front and back. And if you saw my new pictures, Mr Thwaites, you would collapse!
Why?
Because they're so good! You've never seen such good pictures in your life. No one has ever seen such good pictures, and I can't show them to anyone, because everyone would collapse. So in the first place I hung cloths over all the pictures, and then in due course I overpainted them all white.

And now?

Now I don't paint at all any more, because I don't want to have the whole human race on my conscience.

How many victims have your works accounted for?

I don't know, exactly. The exact statistics do exist, of course – they run into the tens of thousands – but I can't concern myself with trivia. It was more interesting earlier on, when the big death camps in Eastern Europe were using my pictures. The inmates used to drop dead at first sight. Those were still the simple pictures, too. Anyone who survived the first show was killed off by a slightly better picture.

And your drawings?

I haven't done a lot. Buchenwald and Dachau had two each, and Bergen-Belsen had one. Those were mostly used for torture purposes.

The Russians are said to have five of your paintings and drawings. Is that so?

I don't know how many.

Stalin mounted his reign of terror with two pictures. After killing millions of Russians, it's said that he caught an accidental glimpse of one of your pictures, just for a fraction of a second, and immediately dropped down dead. Is that so?

I don't know. One of my best paintings is in the Soviet Union.

So what happens next?

I don't paint any more. I can't, because I don't want to spread terror, alarm and anxiety everywhere, and depopulate the earth. But now it's come to the point where I only have to think my paintings out and tell someone about them, and the person rushes off in a state of panic, has a nervous breakdown, and becomes infertile. That is the worst effect. Though I can't say so for sure, as yet, because – depending on who tells the story – I have already caused dumbness, hair loss (mainly in women) and paralysis of limbs.

Is it true that you supply paintings to the US Army?

I can't tell you anything about that.

Have you no scruples, or anything?

I am an artist.

Do you believe in God?
Yes, I believe in myself, I am the greatest, I am the greatest of all!
Thank you, Mr Richter.
Not at all, Mr Thwaites.

Letter to Heiner Friedrich, 23 November 1964

Dear Mr Friedrich,

Thank you again for your letter (already acknowledged by postcard).
I wanted to wait to get both the openings* over before writing to you.
Everything got delayed, and I still have no catalogues and posters
(or only one copy of each). Please write and let me know how many
to send. The poster has come out very well, especially if you put up
three at a time, one above the other. But to take matters in order:

Jährling: you know the poster, I'll send more. You know the
building, of course. It's a good hanging space, and the show makes a
very colourful, cheerful impression. A group show like this is entirely
suitable for making a strong, fresh statement (the fact that everything
looks a bit too decorative is an advantage, if anything).

The opening was fine and festive. We didn't put on a show at all,
just dance music from the radio. Mr and Mrs Baum (they have my
Secretary) bought one painting apiece from Polke and me, and a figure
by Lueg, a *Footballer* sawn out of plywood and brightly painted. Mine
was the little female reclining figure, *Deckchair*. I don't know the price
off-hand. Jährling's and Block's net prices are rather higher, some of
them, than the prices agreed with you. If you like, I'll send the exact
figures. Their net prices are higher anyway, because both only take
one-third.

I put a lot into the Jährling show, 22 pieces including *Piano*.
Almost everything I have, in fact. I can't recommend much of this to

* *Pop etc.*, Galerie René Block, Berlin, and *Lueg, Polke, Richter*, Galerie Parnass
Wuppertal.

you. I mean, I still like the *Stag*; maybe the *Negro*; the *Cathedral*; *Interceptor*, that's new (so is *Tame Kangaroo*, but probably not so well painted); and then maybe two or three others.

It's been very hard from my point of view, having two exhibitions at the same time. I don't want to do that again, and I must also paint a bit slower and take it more quietly (so that when I have a terrific basic idea, like *Tame Kangaroo*, I can make it work better). I'm sure you'll understand. And while we're on the subject: I'm not going to paint on cotton duck any more, it's too difficult technically.

Block wrote to me today. The opening was put off until 3 p.m. on Saturday 21 November, in order to ensure 'adequate art-historical documentation'. For the opening I sent in a tape of business news, political reports and a chapter from Brehm's *Animal Life*, which was played back over the PA system. For the Hague Realists opening on 21 November, Block stationed a sandwich man at the door of the Academy with my poster in front and a placard on his back saying '... New German Realists at Galerie Block, etc.' Then there was a young lady who handed out copies of the Galerie Block prize competition: 'Please count up how many German artists are missing from this exhibition, and why ...'

Today my exhibition is being filmed for TV Channel 3. Heinz Ohff wrote about the Hague Realists in the *Tagesspiegel* (22 November), mentioning my name as an omission from that show, and promised to write on the subject later. The catalogue text by de la Motte I don't like particularly, it's too glib, I don't see the point of churning out commonplaces and definitions of Pop in this way. There is plenty more that needs saying (I've noted some of it down, and I'll send it to you if you like). As far as the catalogue is concerned, I regret seeing the illustrations folded, that's really a shame. But, all in all, I'm glad to be showing there, and I think Block is the right person.

One problem I think I haven't mentioned yet: Block would like a picture of mine, *Christa and Wolfi*. He asked me to let him have this one cheap, so he could use the saving to print the catalogue. Now he writes to add that the picture would be at my disposal at any time, and that he would never sell it. I told him I would discuss it with you. For

my part, I think we can easily spare the picture, and it would be a good thing to have a picture by me (and perhaps another, smaller one as well) permanently in Berlin. Then, whenever anyone walks in, they see a sample, and they can see the real thing at Friedrich's.

Please write and let me know what you think.

I have written to tell Block that you have also bought *Renate and Marianne* and *Sphinx*.

I'm glad you've been able to fix the Rome exhibition for the spring, but please change the selection. *Party, Pallbearer*s, *Hitler, Mustang Squadron*: we have better ones to send in place of these. One of them might be included, explicitly marked as an 'Early Work'. That's all the news. For the last few days I've been doing jobs around the house and decorating. I shan't get round to any painting this week; I have to collect material first, by which I mean make some sketches. I hope this letter reaches you in time, before you go off to Rome and London. I'd be happy to come to Munich, but I don't think it's possible at the moment, much though I'd like to.

That's all for today. Best wishes to you and your wife; my wife sends hers.

Gerd Richter

Notes, 1964–1965

When I draw – a person, an object – I have to make myself aware of proportion, accuracy, abstraction or distortion and so forth. When I paint from a photograph, conscious thinking is eliminated. I don't know what I am doing. My work is far closer to the Informel than to any kind of 'realism'. The photograph has an abstraction of its own, which is not easy to see through.

It's what everyone believes in nowadays: it's 'normal'. And if that then becomes 'other', the effect is far stronger than any distortion, of the sort you find in Dali's figures or Bacon's. Such a picture can really scare you.

The photograph took the place of all those paintings, drawings and illustrations that served to provide information about the reality that they represented. A photograph does this more reliably and more credibly than any painting. It is the only picture that tells the absolute truth, because it sees 'objectively'. It usually gets believed, even where it is technically faulty and the content is barely identifiable. At the same time, photography took on a religious function. Everyone has produced his own 'devotional pictures': these are the likenesses of family and friends, preserved in remembrance of them.

Photography altered ways of seeing and thinking. Photographs were regarded as true, paintings as artificial. The painted picture was no longer credible; its representation froze into immobility, because it was not authentic but invented.

Life communicates itself to us through convention and through the parlour games and laws of social life. Photographs are ephemeral images of this communication – as are the pictures that I paint from photographs. Being painted, they no longer tell of a specific situation, and the representation becomes absurd. As a painting, it changes both its meaning and its information content.

The photograph is the most perfect picture. It does not change; it is absolute, and therefore autonomous, unconditional, devoid of style. Both in its way of informing, and in what it informs of, it is my source.

A photograph is taken in order to inform. What matters to the photographer and to the viewer is the result, the legible information, the fact captured in an image. Alternatively, the photograph can be regarded as a picture, in which case the information conveyed changes radically. However, because it is very hard to turn a photograph into a picture simply by declaring it to be one, I have to make a painted copy.

The first time I painted from a photograph, I did so in a mixture of exhilaration and fear, partly because I was strongly affected by

32 Studio, Fürstenwall, Düsseldorf, 1966

contemporary Fluxus events, and partly also because I once did a lot of photography myself and worked for a photographer for eighteen months: the masses of photographs that passed through the bath of developer every day may have created a lasting trauma. There must be other reasons. I can't tell exactly.

There is nothing strange about the fact that I paint from photographs (as distinct from, say, making photographic enlargements of them). Everyone who uses photographs 'paints' from them in one way or another: whether with brush, collage, silkscreen or photographic canvas is immaterial. The only strange thing is that I want to produce just this kind of picture and no other: the kind of picture that I can't at the moment produce in any other way. (Maybe it could be done without a brush, through darkroom manipulations of some kind. But that doesn't appeal to me, because I have no desire to manipulate. Tricks of some kind would occur to me, and I'd be able to repeat them endlessly. To me that is a horrific idea; the pictures would be no good, either.) Perhaps it is old-fashioned of me to think like this. But it appeals to me, when a photograph falls into my hands, to deal with it in this way.

Perhaps because I'm sorry for the photograph, because it has such a miserable existence even though it is such a perfect picture, I would like to make it valid, make it visible — just *make* it (even if what I make is then worse than the photograph). And this making is something that I can't grasp, or figure out and plan. That is why I keep on and on painting from photographs, because I can't make it out, because the only thing to do with photographs is paint from them. Because it attracts me to be so much at the mercy of a thing, to be so far from mastering it.

Do you know what was great? Finding out that a stupid, ridiculous thing like copying a postcard could lead to a picture. And then the freedom to paint whatever you felt like. Stags, aircraft, kings, secretaries. Not having to invent anything any more, forgetting everything you meant by painting — colour, composition, space — and all the things

you previously knew and thought. Suddenly none of this was a prior necessity for art.

If my paintings differ from the originals, this is not intentional on my part: it is not a matter of design but of technique. And technique lies outside my voluntary control and influence, because it is itself a reality, like the model, the photograph and the painting. Whether an object is on the right or on the left in the painting is utterly immaterial. If it is on the right, this must be correct in its own way, and it would be presumptuous to put it on the left.

As far as the surface is concerned – oil on canvas, conventionally applied – my pictures have little to do with the original photograph. They are totally painting (whatever that may mean). On the other hand, they are so like the photograph that the thing that distinguished the photograph from all other pictures remains intact.

I want to leave everything as it is. I therefore neither plan nor invent; I add nothing and omit nothing. At the same time, I know that I inevitably shall plan, invent, alter, make and manipulate. But I don't know that.

I want to have everything very clear, simple and unconditional, and I would rather make no art at all than just any old unspecific painting.

There is no way to paint except the way I do it.

When I paint from a photograph, this is part of the work process. It is never a defining characteristic of the vision: that is, I am not replacing reality with a reproduction of it, a 'Second-Hand World'. I use photography to make a painting, just as Rembrandt uses drawing or Vermeer the *camera obscura*. I could dispense with the photograph, and the result would still look like a painting from a photograph. *Reproductive* and *direct* are therefore meaningless terms.

The photograph reproduces objects in a different way from the painted picture, because the camera does not apprehend objects: it sees them. In 'freehand drawing', the object is apprehended in all its parts, dimensions, proportions, geometric forms. These components are noted down as signs and can be read off as a coherent whole. This is an abstraction that distorts reality and leads to stylization of a specific kind. By tracing the outlines with the aid of a projector, you can bypass this elaborate process of apprehension. You no longer apprehend but see and make (without design) what you have not apprehended. And when you don't know what you are making, you don't know, either, what to alter or distort. Your apprehension that an arm is so wide, so long and so heavy is not only unimportant: it becomes a fraud, if it leads you to believe that you have truly apprehended that arm.

I don't copy photographs laboriously, with painstaking craftsmanship: I work out a rational technique – which is rational because I paint like a camera, and which looks the way it does because I exploit the altered way of seeing created by photography.

I like everything that has no style: dictionaries, photographs, nature, myself and my paintings. (Because style is violence, and I am not violent.)

Theory has nothing to do with a work of art. Pictures which are interpretable, and which contain a meaning, are bad pictures. A picture presents itself as the Unmanageable, the Illogical, the Meaningless. It demonstrates the endless multiplicity of aspects; it takes away our certainty, because it deprives a thing of its meaning and its name. It shows us the thing in all the manifold significance and infinite variety that preclude the emergence of any single meaning and view.

I don't create blurs. Blurring is not the most important thing; nor is it an identity tag for my pictures. When I dissolve demarcations and create transitions, this is not in order to destroy the representation, or to make it more artistic or less precise. The flowing transitions, the

36 Studio, Fürstenwall, Düsseldorf, 1968

smooth, equalizing surface, clarify the content and make the represent-
ation credible (an *alla prima* impasto would be too reminiscent of
painting, and would destroy the illusion).

I blur things to make everything equally important and equally
unimportant. I blur things so that they do not look artistic or crafts-
manlike but technological, smooth and perfect. I blur things to
make all the parts a closer fit. Perhaps I also blur out the excess of
unimportant information.

I am a Surrealist.

As a record of reality, the thing I have to represent is unimportant and
devoid of meaning, though I make it just as visible as if it were
important (because I paint everything as 'correctly', as logically and as
credibly as it would appear in a photograph). I am not saying that the
thing represented is abolished as such (the painting cannot be turned
upside-down). The representation simply acquires a different meaning:
it becomes the pretext for a picture. (Photography suits my purposes
here: the photograph confronts me as a statement about a reality which
I neither know nor judge, which does not interest me, and with which
I do not identify.)

All that interests me is the grey areas, the passages and tonal sequences,
the pictorial spaces, overlaps and interlockings. If I had any way of
abandoning the object as the bearer of this structure, I would immedi-
ately start painting abstracts.

My sole concern is the object. Otherwise I would not take so much
trouble over my choice of subjects; otherwise I would not paint at all.
What fascinates me is the alogical, unreal, atemporal, meaningless
occurring of an occurrence which is simultaneously so logical, so real,
so temporal and so human, and for that reason so compelling. And I
would like to represent it in such a way that this clash is maintained.
That is why I have to avoid intervening or altering anything, for the

sake of a simplicity that can thus be more general, definitive, lasting and comprehensive.

It is aggressiveness and brutality of construction that makes Surrealism, and the borderline situations of Bacon, into 'specialities': that is to say, something specific and unbalanced. By this I mean that I have to do without brutality and intervention in any form, because I find that, for instance, an object is more compelling if it does not float but stands in its normal place (it just has to be painted).

The photograph makes a statement about real space, but as a picture it has no space of its own. Like the photograph, I make a statement about real space, but when I do so I am painting; and this gives rise to a special kind of space that arises from the interpenetration and tension between the thing represented and the pictorial space.

Art is not a substitute religion: it is a religion (in the true sense of the word: 'binding back', 'binding' to the unknowable, transcending reason, transcendent being). This does not mean that art has turned into something like the Church and taken over its functions (education, instruction, interpretation, provision of meaning). But the Church is no longer adequate as a means of affording experience of the transcendental, and of making religion real – and so art has been transformed from a means into the sole provider of religion: which means religion itself.

All things artificial and natural, whether in planned or fortuitous arrangements, have the capacity to turn into fetishes. Belief, for one: that is, making statements and predictions beyond the actual circumstances of time and place. And for another: depriving an object of its utilitarian value and believing in it.

If I were to exhibit a urinal today, this would be legitimate, because I would not be demonstrating anti-art but setting the urinal up as an altar and object of art and faith. I want to be like everyone else, think what everyone else thinks, do what is being done anyway.

I don't want to be a personality or to have an ideology. I see no sense in doing anything different. I never do see any sense. I think that one always does what is being done anyway (even when making something new), and that one is always making something new. To have an ideology means having laws and guidelines; it means killing those who have different laws and guidelines. What is the good of that?

There is no such thing as freedom. Nor would I know what to do with it.

For an artist there must be no names: not table for table, not house for house, not Christmas Eve for 24 December, not even 24 December for 24 December. We have no business knowing such nonsense.

Nor must we have views or opinions. Leave that to others. A fireman, say, may well see the world in his own specific way and have different views from a watchmaker.

Talk about painting: there's no point. By conveying a thing through the medium of language, you change it. You construct qualities that can be said, and you leave out the ones that can't be said but are always the most important.

Polke thinks there must be some point in painting, because most lunatics paint unbidden.

The central problem in my painting is light.

Text for exhibition catalogue, Galerie h, Hanover, 1966, written jointly with Sigmar Polke

Many of my paintings measure 150 × 200 cm; many are 130 × 150 cm or 130 × 140 or 120 cm; some are 160 × 180 cm; some are considerably smaller, about 40 × 30 cm or even 18 × 24 cm. My largest paintings to date are 200 × 190 cm. Perhaps I shall now paint only small paintings, or else medium-sized ones and a few larger ones; I can't tell for sure.

A childhood memory: I let my little sister toboggan down a hill, without thinking that she was bound to hit an iron railing. The result was a deep laceration on her forehead; she had stitches, and I had a hiding.

Carlton looked at the front gardens, the birds and the women, and then the scales fell from his eyes; he knew that he would never get the hang of it all. He asked me for a cigarette and took his leave.

Amid the terrifying roar of unleashed atomic power, the mountainous space globe lifted off from the grey soil of Sexta. The blazing spurts of energy from its cavernous jet tubes were like a miniature sun, and a ring of fire expanded across the flat ground, pushing waves of red-hot debris ahead of it.

The men in the control room saw little of all this. Few had time to glance at the dimmed monitor screens, and to the others such a sight was nothing new.

Perry Rhodan* sat in the command position, from which he could oversee the whole control room; its curiously shaped table had its own intercom and telecom terminals.

His wife Mory occupied one of the additional seats clustered around the command position, as did Melbar Kasom, who of course needed a special chair. And Atlan. Gucky's recliner was empty. The coypu was on the move, no doubt, somewhere on board. Rhodan had given his wife a curt nod, just before lift-off. When on duty, they were no more and no less than comrades, comrades in a battle that might end somewhere in eternity. Their own feelings took second place to their responsibility for the space empire of mankind.

The Halutian's wide mouth opened in a chuckle. There was a hint of a twinkle in his great red eyes. His head gave an almost human nod. 'It might have been worse,' he said placidly. 'The chief mistake was mine. I ought to have transferred my knowledge of spores to the memory sector of my plan brain. . . .'

* Perry Rhodan is a character from a popular series of science-fiction novels and booklets published monthly and weekly from 1961 to 1991 by Verlagsunion Pabel-Moewig, Rastatt, Germany. Portions of this text by Richter and Polke are taken from an unidentified book in this series.

'Believe it or not, I really see my surroundings as dots.' I love all dots.
I am married to many of them. I want all dots to be happy.

Dots are my brothers. I am a dot myself. We always used to play
together, but nowadays everyone goes his own way. We meet only on
family occasions and ask each other 'How are things.'

'Do you know, Elly,' he said quite calmly, 'one must love only
things that have no style, such as dictionaries, photographs, nature,
me and my pictures!'

I sighed: 'How right you are, because style is violence, and we are
not violent, and . . .'

'... And we don't want war,' he finished the sentence for me. 'No more war, ever!'

When I met the love of my life, I fell so deeply in love that I would willingly have married her there and then. But we had one thing in common apart from our great love: concern for those close to us. She had lost her father at an early age and was taking care of her mother and sister. I was taking care of my parents. So we were in the same boat. Time flew past, and we were very happy together.

You do well to report this. But you should of course make it clear that you are referring to isolated instances.

I would like to be like everyone else, think what everyone else thinks, do what is being done anyway.

The heavy armoured bulkhead of the airlock slid almost noiselessly back into the hull of the tender. Perry Rhodan, Atlan and Captain Redhorse strode between the ranks of battle-ready Epsalian Commandos. Just before he reached the airlock, Rhodan stopped.

'Who is in command here?'

One of the (by Earth standards) disconcertingly massive Epsalians stepped forward.

'Lieutenant Afg Moro, Sir!'

'I need one of your men, Lieutenant.'

'Sir, I ...'

'No, not you, you must wait here for the operational order.'

Lieutenant Moro turned.

'Sergeant Man Hatra, escort the Chief Administrator.'

An Epsalian, 1.60 metres tall and almost as wide, clumped forward and halted close in front of Perry Rhodan. He wore the same combat uniform as the others, but was armed with a massive disintegrator, as well as an impulse blaster that a Terran would have needed both hands even to carry. The Epsalian carried the impulse blaster in a special holster and held the equally heavy disintegrator casually in the crook of his arm.

I have abundant leisure time, because I lead a solitary life. My husband died two years ago, and both my sons are married. Those three men were my life. When the four of us were still together, my life was

44 With Ema Richter, 1971

full and marvellous. Whatever would become of me now, were it not for the values that I can still cherish? As always, the most important is duty. I have widened the scope of my duties to benefit more people. Classical music, which formed a deep bond between my husband and myself, now distresses me, but despite the tears I cannot do without it, because it is part of my life. Good literature, nature, and not least my visits to my beloved children and delightful grandchildren, are the cornerstones of my life. After vigorous and stimulating activity, I make a point of setting time aside for quiet reflection. Then I sit quite quietly and relive the very happy times I had with my husband and my sons. And so a lonely 61-year-old woman can still say Yes to life.

We cannot assume that good pictures will be painted one day: we must take matters into our own hands!

'Nonsense,' his logic sector chimed in. 'Tolot is in the same fix as we are. If he ever wants to get out of here, he has to back us up.'

Atlan stirred himself.

'We must act,' he decided.

He heard Henderson sigh with relief. A faint smile played across his features.

I have never snored in my life, whatever the tape-recorder may say. I know that good painters do not snore.

My intelligence knows no bounds.

He was clearly still in a state of extreme agitation. 'It — it was terrible!'

Sheriff Beatty felt the need to sit down. 'You mean to tell me that the driver of the car turned it around and deliberately drove over the girl a second time?'

Smiles nodded. 'Yes, that's right. I could see it all quite clearly.'

Beatty lit a cigarette. 'And why are you coming out with all this now, Mr Smiles? Why didn't you report what you saw straight away?'

Smiles gave a nervous laugh.

I would like to have a lot of children. When I walk down the street, I'd like all the children to call out Daddy, and I'd pat their heads and ask them 'What's your name? How old are you? Be good, my regards to your mother.'

My wife is 4 centimetres shorter than I am. Since I mostly walk rather crooked, it looks as if I too were only 168 cm tall. My mother-in-law is very short.

The image of greyish-yellow expanses of sand and a jagged mountain range filled Perry with unease. He needed no scientific analysis to tell him that such a world could not be created naturally. Someone must have built it. Someone had supplied it with a sun, gravitation and a stifling atmosphere. Why they had done so was immaterial. The depressing thing about all this was that mankind on Terra still had a few millennia to go before it attained the level of knowledge necessary to create a planet.

He now has many friends. He is an intelligent man, and they intend to find him a good job as a pharmacist, just as soon as his English is better. A major publishing house is to bring out his life story.

In a frenzy of despair, the Nomad Scout sprang up and hurled himself against the locked airlock of the ship. He rebounded, and the shock brought him to his senses. The alien guard was still watching. Krash-Ovaron stared at him. What a being! In a fight, he could probably have held his own against the city's best hunters.

The alien moved. He pointed towards the city. The gesture was peremptory. It was a command to Krash-Ovaron to withdraw.

'I need the ship,' said Krash-Ovaron urgently, but as he spoke he realized that to the guard his words were only meaningless sounds.

Implacably, the guard pointed towards the city. Krash-Ovaron felt waves of pain surging through his body. Egg-laying time was approaching. By the time the hunt was over, he would have to find some place, or he and his brood would die together.

Slowly the alien approached him. He looked determined.

Krash-Ovaron realized that he now had only one chance of turning the situation to his own advantage: he would have to dismantle the Parablock and ask the aliens for help.

Krash-Ovaron shivered.

They would die, he vowed, for forcing him to abase himself.

All painters, everybody, ought to paint from photographs. And they should do it the way I do (including the selection process). Then such

paintings should be exhibited everywhere, and everywhere they should be hung – in homes, restaurants, offices, stations and churches, everywhere. Then great painting competitions would be held. The jurors would assess the entries according to theme, rendering and speed, and then they would award medals. Every day, on television and on the radio, there would be reports on the latest paintings. Eventually, laws could be passed so that people could be punished for not painting enough copies of photographs. This would have to go on for 400 years or so, and then painting from photographs should be banned in Germany.

His words were cut short by the wail of the alarm systems. Colonel Cart Rugo let out a cry of horror. Involuntarily, Rhodan glanced at the controls nearest to him. What he saw revealed the full magnitude of the approaching catastrophe.

All the atomic-powered machinery of CREST II seemed to be out of action.

This meant that CREST II was about to crash. Right in the middle of the battlefield, outside the city.

I am averagely healthy, averagely tall (172 cm), averagely good-looking. I mention this, because that is how one has to look to paint good paintings.

Paintings must be produced to a recipe. The making must take place without inner involvement, like breaking stones or painting house-fronts. Making is not an artistic act.

Harskin looked in the direction indicated and saw a gigantic monster. It was almost a living island, a cross between turtle and dinosaur. Its massive skull was armed with huge plates of armour, but the look in its eyes was by no means hostile or bloodthirsty. Round the monster's neck hung a kind of basket in which sat three Gnorphs. The three scaly beings looked down with curiosity and sympathy at the three beings swimming in the water. This was obviously a rescue party.

The girl carefully scrutinized the photograph, then pointed a scarlet fingernail at one man. 'That's him,' she said excitedly.

'You couldn't be mistaken?' Jo panted.

The girl shook her head vigorously. 'No, Jo, I'm not making any mistake. That's the man Mabel was going with.'

Jo folded the cutting and put it away. 'You've been a great help, Dolly,' he said.

Perry stood on the terrace, took an occasional sip from his glass, and said softly, with a slight catch in his voice: 'Look at this beetle, here on my sleeve.' He pointed to a tiny pucym beetle, which was just about to fly away. 'It mustn't be disturbed; nothing must ever be disturbed. Always leave everything just as it is. Plan nothing, invent nothing, add nothing, omit nothing ...' He hesitated, and then went on. 'This is the state of modest wisdom that allows us to transcend ourselves, to do something that we can't grasp with our intelligence but only under-stand and admire in our hearts. I don't mean that this has anything to do with passivity ...' He watched the departing pucym beetle with a faint smile. 'It will be action: less noisy than we have been used to, but far stronger, more all-embracing; it will transform our existence, awesomely ...' His gaze was lost in the endless depths of space, and we

realized that in this one moment he had made us a gift of the Universe.

We stood there in silence for a long time, until Icho Tolot, the sturdy, ever-cheerful Halutian, brought us more wine.

If anyone wants to be a painter, he should first consider whether he is not better suited to be something else: a teacher, a government minister, a professor, a craftsman, a workman; for only truly great human beings can paint.

The last patient left at 10:30. It had by now, regrettably, become accepted that they would be seen at the practice on Saturday mornings. The doctor took off his white coat and washed his hands. As he did so, he watched himself in the mirror.

When Paddy awoke from deep sleep, the ship was in space, in zero gravity. He looked out through the porthole. The eternal night of space surrounded him. Behind was the gleam of Schaet; to his left was the golden globe of Alpheratz, and ahead were the stars of Andromeda: Adil, the Body; Mirach, the Loins; Almach, the shoulder.

'I must dot!' Icho spoke Interkosmo. He had learned the language

without difficulty and could speak it flawlessly. The only thing he found difficult was not talking as loudly as he usually did; if he had, the walls would have started to shake.

There were few items of furniture in the room. Three of them were comfortable chairs.

'I must just dot,' he said.

It was eleven a.m. I sat with my father beneath a sunshade on the main terrace of the Carlton Hotel. As I gazed at the blue expanses of the sea with its curly, white crests of foam, the wild and frenzied happenings of the night before seemed like a dream. Like a nightmare … Bright red-and-white and blue-and-white beach umbrellas; the smell of the sea; the happy voices of bathers along four kilometres of beach, interspersed with the urgent cries of the ice-cream vendors. Nymphs with slender, naked limbs dived into the water and emerged spluttering. 'Marvellous,' I said. My old man had no time to answer. He was cracking his breakfast egg.

Strapped into their anatomically designed seats, they raced towards Hell. The opalescent fluid found its way into their mouths and noses, and they felt as if they were drowning. Icho Tolot was still writhing and shrieking on the ground, while Rhodan, Richter, Redhorse, Polke and the three mutants were reduced to helpless spectators of the monstrous creature's agony. Finally the last cry died away, and Rhodan's desperate wish came true. The Halutian recovered from the shock and regained control of his own metabolism. 'That was hard, wasn't it? But I believe there was no alternative.'

Where a dot is, something happens!

Dot – point – basic unit of geometry, intersection of two lines without extension – punctuation mark, said the Halutian. The 2.50 metre tall, two-headed mutant, Gorachin, gave a momentary grin with Ivanovich's face. Ivan had no time for that. Ivan saw his goal and once more unleashed his mental currents, causing calcium and carbon compounds to explode.

I stood up, hesitated for a moment and switched on the screen. I was startled to see the face of a Kirjen. It was an impressive, intelligent face, dominated by a long, flat nose and an extremely high

forehead. The blue-skinned features were unfamiliar, as was the head, surrounded by a thick, curly mass of fur.

'Welcome to Kanor. I am the contact man of my people, Erg Vatal.'

His thin-lipped mouth twisted into a smile. The four-jointed arm and 62-fingered hand appeared in the frame.

It was a flame, or something similar. A vibrant, shining form that hovered in mid-air and performed strange manoeuvres. It seemed to dance – now forward, now back, right to left, up from below. It was pale in colour, and at times it moved so quickly that Fed momentarily lost sight of it. Some day we shall no longer need pictures: we shall just be happy. For we shall know what eternity is, and our knowledge will make us happy. Life after death will be explored and will set us an example of new modes of conduct.

I paint my paintings on grounded canvas (synthetic emulsion as a binder for titanium dioxide), which I buy in Düsseldorf for 8 DM the square metre. I use the best pigments and oils, and the work is guaranteed to be as durable as is humanly possible.

The squat, green-feathered Epsalian hovered alongside the coypu, who imperturbably went on working. The painting was almost ready. The Epsalian looked at the original, an archive shot of Perry Rhodan's meeting with Kraa Mhakuy on the planet Quinta. He compared it with the painting and said, as if musing to himself: '... I'm glad you're conventional, Gucky, with no qualms about painting beautiful pictures. You have as much in common with Raphael as with the Surrealists, the Impressionists, the cave painters, Zero, Picasso, Fluxus and the millions of poor devils who photograph their families. Therein lies your greatness ...'

'Did you say something?' said Gucky.

'No, nothing important.'

The Epsalian hovered in the room for a while longer, then teleported himself silently to the ship's control room, where he went back to repairing the field generators.

Which is better: collecting art, or drinking and whoring? Everything in its proper time.

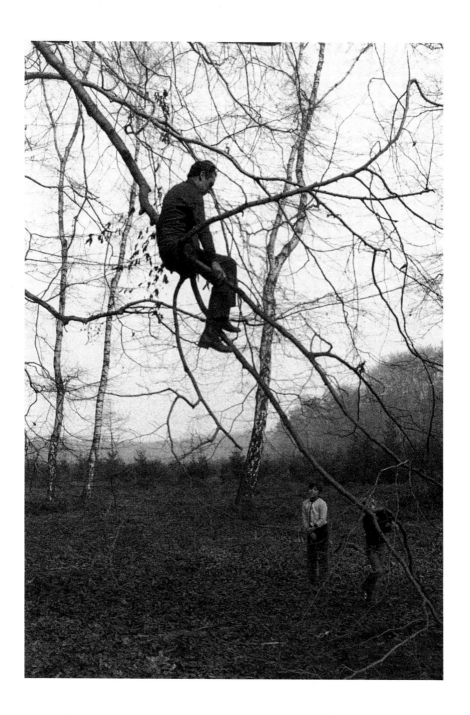

1971

All hell broke loose. Across the monitors flickered the flames from
the overloaded field screens. The ship lurched to and fro. The Antigrav
could no longer absorb the shocks that struck in rapid succession. The
giant command post collapsed in ruins. Through the wailing of the sirens,
the cries of the wounded could be heard. Even Ferro Kraysch had been
hurled out of his seat, and he stood up with great difficulty. He was
blinded by the blood that ran down his face.

That was the end. Ferro felt no fear, only anger and disappointment
that it had come so quickly. For all his caution, he had underestimated
the enemy. To the aliens, the MOHICAN was no more dangerous than a
ball, a plaything to toss around as they wished. Ferro's anger turned to
frantic rage. They had him in their power. Another direct hit shook the
ship's gigantic hull. But he would show them that a Terran was not so
easy to beat.

I consider many amateur photographs better than the best Cézanne.
It's not about painting good pictures, because painting is a moral action.

Doubtfully, Perry looked at the illuminated positronics wall, with
its bewildering array of flashing, multicoloured control lights. Could he
justify sitting here and reworking a problem, when he could not even
be sure it would prove relevant to the present situation? Was it right to
build a hypothesis solely on the analogy between two processes? In
front of him, on the main programme line, a green key lit up. The
machine was ready to accept the programme.

Perry clenched and opened his fist. Then he firmly pressed the key.
The green light went out.

'Problem,' said Perry hoarsely. 'Generating structural formulae for
two six-dimensional force fields. Analogy: the arrangement of force
fields in a synchrotron particle accelerator ...'

Seconds later, the machine was at work.

If they had their way, all policemen would wear screen-dotted
uniforms, with a dot pattern instead of the German eagle. Every one of
them would have a spotted handkerchief.

There were three of them, and they shimmered with an intense blue.
For aeons they had been soaring above their world, which was bathed
in a deep red glow. Their flight was noiseless, despite their gigantic size.

They flew no specific course, but appeared at regular intervals above Kraa, the largest city in their world. One hundred and twenty times in succession they came individually, and then all three appeared together.

He likes to bend an elbow, my dear husband does. I put it in that flippant way, to show that I like a laugh and can take a joke. But the way my husband gets his pleasure is harmful to himself. He is always finding an excuse to celebrate and drink a toast to someone. This makes him popular with his workmates and friends – but not with me and his family. This liquid hobby of his takes its toll of time, money, home life and ultimately health. Being a vegetarian and also a militant teetotaller (though not by any means a killjoy) puts me in a difficult position. Can you understand that? When I object, however justly and reasonably, all I get is a smile. That is why I'm taking the liberty of asking for your support. Perhaps you can get my husband to think twice, because he has a great respect for you. I know that. Please do bring up the subject.

Any one who is in trouble or has a screw loose had better go to a psychiatrist, but not paint. Painting is strictly for the healthy.

The newlywed Inge says: 'My father seldom parts with anything really valuable.'

'You're right there,' growls her husband. 'I found that out when I married you!'

Interview with Dieter Hülsmanns and Fridolin Reske, 1966

Mr Richter, what attracts you so much about a photograph that you paint a copy of it?

A photograph – unless the art photographers have 'fashioned' it – is simply the best picture that I can imagine. It is perfect; it does not change; it is absolute, and therefore autonomous and unconditional. It has no style. The photograph is the only picture that can truly convey information, even if it is technically faulty and the object can barely

be identified. A painting of a murder is of no interest whatever; but a photograph of a murder fascinates everyone. This is something that just has to be incorporated into painting.

Your pictures contain representations of human beings, animals and objects. These are things that you could just as well paint from nature. So why do you use a photograph as your source?
Because it saves time, for one thing. Nowadays one must rationalize one's work, and anyway I have no desire to spend a month in front of one canvas. Secondly, I am cutting out a certain degree of stylization, which is unavoidable in painting from nature, and which I want to avoid.

If you avoid all stylization and abstraction, and paint such a close approximation to photography, isn't it strange that you don't make your pictures directly by photomechanical means?
I don't find it strange at all. Everyone who uses photographs 'paints' from them in one way or another: whether with brush, collage, silkscreen or photographic canvas is immaterial. The only strange thing is that I want to produce just this kind of picture and no other: the kind of picture that I can't at the moment produce in any other way. But maybe one day I'll work out how to eliminate the painting process.

You also paint portraits from photographs. In portrait painting, isn't it desirable to know the sitter?
Not at all. I don't think the painter need either see or know his sitter. A portrait must not express anything of the sitter's 'soul', essence or character. Nor must a painter 'see' a sitter in any specific, personal way; because a portrait can never come closer to the sitter than when it is a very good likeness. For this reason, among others, it is far better to paint a portrait from a photograph, because no one can ever paint a specific person – only a painting that has nothing whatever in common with the sitter. In a portrait painted by me, the likeness to the model is apparent, unintentional and also entirely useless.

So how significant are the things represented in your pictures?
Highly significant, definitely. Just not significant in the sense of conveying information about reality, which is what photography is there for. I never paint to create a likeness of a person or of an event.

Even though I paint credibly and correctly, as if the likeness were important, I am really using it only as a pretext for a picture.

So you don't really care at all what you paint?

No, that's not it at all. I don't abolish representation. The picture can't be turned upside-down, for instance. The object is so important to me that I take a great deal of trouble over my choice of subjects. It is so important that I paint it. I am fascinated by the human, temporal, real, logical side of an occurrence which is simultaneously so unreal, so incomprehensible and so atemporal. And I would like to represent it in such a way that this contradiction is preserved.

Notes, 1966

I pursue no objectives, no system, no tendency; I have no programme, no style, no direction. I have no time for specialized concerns, working themes, or variations that lead to mastery.

I steer clear of definitions. I don't know what I want. I am inconsistent, non-committal, passive; I like the indefinite, the boundless; I like continual uncertainty. Other qualities may be condu-cive to achievement, publicity, success; but they are all outworn – as outworn as ideologies, opinions, concepts and names for things.

Now that there are no priests or philosophers left, artists are the most important people in the world. That is the only thing that interests me.

Studio, Fürstenwall, Düsseldorf, 1966 59

Interview with Rolf Gunther Dienst, 1970

*In 1962–63 you painted your first copy of a photograph, in order – as you
yourself wrote – 'to do something that has nothing to do with art, which
as far as I was concerned meant nothing to do with painting, composition,
colour, invention, design, etc.' But wasn't there still colour present, even
if it was reduced to a black-and-white scale?*
That was an expression of my personal state of mind, and it hints at a
method of translating my changed way of thinking into reality. As for
colour, black-and-white is not colour in the sense I wanted to get away
from. In the long run it turned into colour, but that was unintentional.
It came from the surroundings: if I hang a grey next to a red or a
green, it turns into a different colour each time. And then – this has to
do with colour again – the paintings became aesthetic or, however you
look at it, at all events different from what I intended. This always
happens, of course. The reason why a pyramid was built is one thing,
and how we see it now is quite another.

*I meant, when you deprive an object of its natural colour, this is an
artificial operation, intended to distance the object.*
That may be, but the artificial operation has already been done by
others. The 'non-colour' comes to me from photography. The first
artificial act is the taking of the photograph.

*In your work of 1963–64 – family groups, pictures of aircraft and
cars, and portraits – you emphasize surface smoothness, likeness to
photography, distancing, avoidance of personal interpretation. Does
this give you a higher degree of objectivity?*
I think so, certainly. But there are other ways of doing that, and it
doesn't even have to be done at all. Being objective no longer greatly
matters to me, because everything is objective.

*You have repeatedly reduced your colour scale to tones of grey.
Did this lend an unnatural emphasis to anything that was coloured?*
I never reduced any colour scale. Grey tones unintentionally turned
into a colour scale; and this later compelled me to do something
different, because I don't want to be bothered by that particular issue.

You work from photographic originals. How do you find your subjects?

Perhaps the choice is a negative one, in that I was trying to avoid everything that touched on well-known issues – or any issues at all, whether painterly, social or aesthetic. I tried to find nothing too explicit, hence all the banal subjects; and then, again, I tried to avoid letting the banal turn into my issue and my trademark. So it's all evasive action, in a way.

From 1949 to 1953 you were an advertising and stage painter, then a photographic laboratory assistant. To what extent did this influence your work?

Probably not at all, or far less than all those things that can't be listed: friends, books, circumstances, experiences and so on.

To judge by your work, and your Photo Pictures above all, it looks as if your ties with photography and advertising possibly did affect your style.

We can disregard the advertising, because I did so little of it. The photography is a consequence and not a cause. Photography interested me because it is such a good representation of reality.

Your painting has evolved from Socialist to Capitalist Realism. In other words, it has remained largely realistic. Are you interested in producing a critique, or reportage, of ambient reality?

By the way, I have never painted either Socialist or Capitalist Realism. Like everyone else, I am constantly critical – of countless kinds of things – but not when I am painting. That would be just as impossible as reportage.

I'd like to come back to that slogan, 'Capitalist Realism'. Heinz Ohff reported that you were an adherent of Socialist Realism.

Lueg and I used 'Capitalist Realism' as a slogan for a Happening. And that's how it caught on. It was not so much about our work as about that particular Happening.

You once wrote: 'Now that there are no priests or philosophers left, artists are the most important people in the world.' For artists, this is a hopeful statement. As you see it, where does the artist's exceptional importance lie?

It has to do with emancipation, and with the fact that we no longer need the Church or the philosophers. The Church has other tasks and responsibilities. Art no longer serves any institution; it has become autonomous. I can't describe the new situation, because I can't describe art: art proves itself in the making. It's a sense I have, that something is demanded of art and of me: a kind of hope.

How would you interpret your role as a painter in our society?
As a role that everyone has. I would like to try to understand what *is*.
We know very little, and I am trying to do it by creating analogies.
Almost every work of art is an analogy. When I make a representation of something, this too is an analogy to what exists; I make an effort to get a grip on the thing by depicting it. I prefer to steer clear of anything aesthetic, so as not to set obstacles in my own way and not to have the problem of people saying: 'Ah, yes, that's how he sees the world, that's his interpretation.'

There are pictures of yours that are ironical repeats of Art Informel, with gestural brushwork cutting across the immaculate pictorial surface. What did you mean to convey?
I certainly didn't mean to make fun of Art Informel. I can't say what I meant to convey. (I don't know whether I ought to try to construct a retrospective justification for those paintings here; but that's just a question of principle.) The paintings are no different from the others – or if they are, the differences are superficial, and that's unimportant. I find that hitherto success has always meant having a style. You know how easy it is to stylize, to catalogue, to construct an evolutionary pattern for the work of individuals or whole generations; we don't need all that. Hence the refusal to select.

Now colour has actually come back into your work, in your new Eifel or holiday landscapes. It looks Romantic and atmospheric. What functions do you attach to colour in these cases?
If black-and-white turns into colour, I may as well use the right colours.

The colour in the new paintings creates a very specific feeling that springs from the landscape and gives the landscape a Romantic appeal.
I can't do that nearly so well in black-and-white. There are two reasons

for this. Firstly, black-and-white was starting to get too aesthetic. Secondly, I can express my intention – what I want to make or to show, and why I like landscape so much – far better in colour.

Why do you like it so much?
Just because landscape is beautiful. It's probably the most terrific thing there is.

In the Alpine scenes you painted in 1968, you opted for a comparatively rough handling, which coarsens the seemingly impressionistic, atmospheric effect. What is the intention behind this?
I no longer felt like painting those soft Photo Pictures. Perhaps I also wanted to correct the false impression that I had adopted an aesthetic viewpoint. I don't want to see the world in any personal way. I have no aesthetic problem, and the technique of making is immaterial. There's no distinction between the paintings, and I would like to change my method as often as appropriate.

Lately you have painted some seascapes and landscapes with a naturalistic use of colour that makes them look very like reproductions. How did this current emphasis on landscape come about?
I felt like painting something beautiful.

Note, 1971

Perhaps the Doors, Curtains, Surface Pictures, Panes of Glass, etc. are metaphors of despair, prompted by the dilemma that our sense of sight causes us to apprehend things, but at the same time restricts and partly precludes our apprehension of reality.

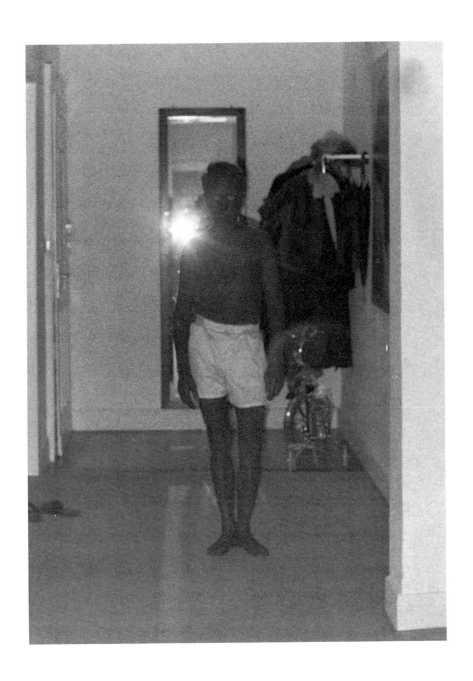

Interview with Peter Sager, 1972

'Many amateur photographs are more beautiful than a Cézanne.' Was that statement just a provocation, or was it also a manifesto of your photo painting?

It was primarily a method, and its main target was the Academy, the stifling prototypes that I had before me, and from which I wanted to free myself. Photography had to be more relevant to me than art history: it was an image of my, our, present-day reality. And I did not take it as a substitute for reality but as a crutch to help me to get to reality.

You said once that you use photographs because the camera sees more objectively than your own eye. You know the range of manipulations possible in photography – do you really mean, even so, to show an objective reality?

No. A work of art is itself an object, first of all, and so manipulation is unavoidable; it's a prerequisite. But I needed the greater objectivity of the photograph in order to correct my own way of seeing: for instance, if I draw an object from nature, I start to stylize and to change it in accordance with my personal vision and my training. But if I paint from a photograph, I can forget all the criteria that I get from these sources. I can paint against my will, as it were. And that, to me, felt like an enrichment.

You don't just copy a photograph the way it is. You alter it by blurring it in a quite specific way, with results that look like camera shake. Why do you use this imprecision, this blurring of the outlines?

At the outset, because it looked most like photography and least like painting. If I didn't want to do painting, I had to use any means I could to stop it looking like painting. Later this changed, no doubt because it wasn't a deliberate policy: it was a method that had served its purpose.

And so we end up with a painted easel picture, after all –

Happily so, because the picture is what I want.

In view of this near-identity between painting and photograph, between the thing depicted and the depiction, a question intrudes itself.

Two Sculptures for a Room by Palermo (297–3), 1971 67

Isn't this all a brilliant waste of effort? Why this virtuoso detour, using the means of painting to make a photograph; this reconversion of the mechanical into the manual?

There was no way of avoiding the effort. For one thing, I had no other means to hand of making pictures. When I tried to leave the photograph as a photograph the results were pathetic – except in two cases: one was printmaking (but that's another field) and the other was photographs of painted pictures, reproduced on approximately the same scale. The detour by way of painting gives me photographs that cannot be made by the normal technique of direct enlargement; and these photographs can be pictures. Pictures – how can I explain it? Stella, Ryman, Morley, Palermo: where it gets exciting for me; where the absence of language begins.

This absence of language begins, even though objects are present that refer, blurred or not, to something apparently quite concrete.

That's only because we know the names of the objects. We ought to get out of that habit.

Then your paintings of objects are really abstract paintings?

Possibly, except that I don't know what abstract is. I just think we distort and cut ourselves off from a lot of things by having a name for everything; we have been too ready to define reality and then treat it as done with.

Is this what Magritte set out to show, in another way, in his word pictures?

Yes, that's quite possible, now that I see the analogy.

Isn't that the paradox of your pictures, that they reproduce something we can all see, but that at the same time they convey an impression of the uncertainty of reality?

We can't rely on the picture of reality that we see, because we see it mediated through the lens apparatus of the eye, and corrected in accordance with past experience. And because that is not enough for us – because we want to know whether it can all be different – we paint.

Painting as a kind of applied epistemology, as a test of our own objectivity. You mean to show that what we regard and describe as real is a fundamentally uncertain thing.

Yes, and also that certainty is the less safe option. For instance, when we say, 'That's what the thing is like, we only have to represent it, and then we have it complete and correct, and it can't be any other way.' The same goes for our assessment of things and situations; it can't be relied on.

You don't use photographs like a Pop artist, to point out clichés in the real world.
No, because all our reference points, everything we talk about, the way we act – it's all clichés.

You moved from East to West Germany in 1960 [sic]. *Why was and is Socialist Realism totally unattractive to you?*
Because it subordinates art to an ideology. This is a misinterpretation of the social relevance of art. Art can be truly relevant only when it isn't directly employed to do a job. If art represents itself, society can use it; but not if it advertises anything. Then it's advertising design. All this has nothing to do with 'Art for Art's Sake'. There is no such thing as Art for Art's Sake.

Can you see in the West a political art in the Brechtian sense of realism – showing reality as a reality that can be changed?
Yes, Barnett Newman or Mondrian, for instance – I can't put it any other way.

This inclination towards pure painting contradicts your own words: 'Painting is a moral action,' and again, 'Now that there are no priests or philosophers left, artists are the most important people in the world.'
I don't think so. Art does have a moral function; it is a kind of substitute religion; and it can transform, shape, investigate, delight, show, provoke and what have you. But this does not mean that art can be expected to do any kind of social work, or expose abuses, or unmask intrigues, or anything like that.

Are you a realist? Do you feel any affinity with the New Realists?
No, and I object to the way the word 'realism' is being used at the moment. My idea of a powerfully realistic work of art is, for example, a sculpture by Carl Andre. You can't get more realistic than that.

Perhaps you feel closer to Conceptual Art?
No, not that either. I wouldn't know what name to call it by; in fact,

I refuse on principle to find a name for it. I myself am very attracted by the so-called Radical Realists, even though they have produced some wretched paintings.

How would you now define what was new in New Realism?
I was impressed by their radicalism, and I could see that the same concerns were emerging as in all other art movements. I believe many critics take the easy way out by heaping abuse on this realism and glorifying abstract art, which can be just as stupid, however intelligent it may look.

Is historic realism – that of the nineteenth century or that of 'Neue Sachlichkeit' – in any way a reference point for you?
Certainly, and I have many other reference points in the history of art. But the same goes for any other art movement. It only goes to show that the past is not over and done with, but continues to belong to us until we have forgotten it.

But don't you now take the view that art and painting are becoming superfluous, because what is needed now is direct social and political commitment? Some artists have regarded this as sufficient reason enough to throw away their brushes.
Certainly not. Eating doesn't become unimportant; making love doesn't become unimportant. All children paint, all lunatics paint. For me, there's no future in giving that up. Not because I'm sick, or because I want to make money at it – painting has become the thing that makes my life possible.

Why is this life form so often grey on grey? Why do you still largely steer clear of colour?
I did have a special relationship with grey. Grey, to me, was absence of opinion, nothing, neither/nor. It was also a means of manifesting my own relationship with apparent reality. I didn't want to say: 'It is thus and not otherwise.' And then perhaps I didn't want anyone to confuse the pictures with reality.

This grey, and your blurring technique, enable you to avoid the ancient device of trompe-l'oeil, which is so popular with many so-called New Realists – illusionism, in fact.
Illusionism has never interested me, with the exception of the

Large Curtain painting, the *Five Doors* and the *Four Panes of Glass*.
Those rather structured paintings are out of the frame, and in fact
I rather disappointed myself, because I don't really want to think
structurally in this way. I prefer to go through destruction to construc-
tion. But this is all interpretation and opinion, and the pictures
themselves may well turn out to be quite different. I hope so, anyway.

Interview with Rolf Schön, 1972

Do you think that the term 'realism' can now be used again?
It is used, whether I think it's right or not. But that's another issue.
Painting realistically – to use the word as it is used – has been going
on nonstop for several thousand years, and to make it suddenly into a
smash hit does more to frustrate art than to help it. I'm not talking
either for or against any other movement (a few stripes of colour can be

just as stupid as a painting of a car bumper). I am against movements
and terminology on principle.

You wouldn't call yourself a realist, then?
No, particularly not in the highly restrictive sense in which the word
'realism' is used in art. It's the same however many subcategories of
realism you invent: it clarifies nothing. All these categories are basic-
ally just restrictions placed on art – it's a way of domesticating it,
making it accessible. But it can be truly accessible only where no such
restrictions exist.

How did you come to adopt this objective way of painting?
I think everybody starts out by seeing a few works of art and wanting
to do something like them. You want to understand what you see, what
is there, and you try to make a picture out of it. Later you realize that
you can't represent reality at all – that what you make represents
nothing but itself, and therefore is itself reality.

Why is photography so important in your work?
Because I was surprised by photography, which we all use so massively
every day. Suddenly, I saw it in a new way, as a picture that offered me

a new view, free of all the conventional criteria I had always associated with art. It had no style, no composition, no judgment. It freed me from personal experience. For the first time, there was nothing to it: it was pure picture. That's why I wanted to have it, to show it – not use it as a means to painting but use painting as a means to photography.

Were you the first artist in Germany to bring photography into an equal partnership with painting?
I don't know.

How do you stand in relation to illusion? Is imitating photographs a distancing device, or does it create the appearance of reality?
Illusion in the *trompe-l'oeil* sense is not one of my techniques, and the effect isn't illusionistic. I'm not trying to imitate a photograph; I'm trying to make one. And if I disregard the assumption that a photograph is a piece of paper exposed to light, then I am practising photography by other means: I'm not producing paintings that remind you of a photograph but producing photographs. And, seen in this way, those of my paintings that have no photographic source (the abstracts, etc.) are also photographs.

How objective, in the documentary sense, is your photographic painting?
It isn't. First of all, only photographs can be objective, because they relate to an object without themselves being objects. However, I can also see them as objects and even make them into objects – by painting them, for instance. From that point onwards they cannot be, and are not meant to be, objective any more – nor are they meant to document anything whatever, whether reality or a view of reality. They *are* the reality, the view, the object. They can only *be* documented.

Do you mistrust reality, because you base your pictures on photographs?
I don't mistrust reality, of which I know next to nothing. I mistrust the picture of reality conveyed to us by our senses, which is imperfect and circumscribed. Our eyes have evolved for survival purposes. The fact that we can also see the stars is pure accident. And because we can't rest content with this, we go to a lot of trouble – we paint and we take photographs, for instance, not as a substitute for reality but as a tool.

*In your pictures, does the blurring stand for the transitory nature
of the content, or does it emphasize the content itself? Or is the effect of
camera shake just typical of this particular mass medium in lay hands?*
This superficial blurring has something to do with the incapacity I
have just mentioned. I can make no statement about reality clearer
than my own relationship to reality; and this has a great deal to do
with imprecision, uncertainty, transience, incompleteness, or whatever.
But this doesn't explain the pictures. At best, it explains what led to
their being painted. Pictures are something different, you see; for
instance, they are never blurred. What we regard as blurring is
imprecision, and that means that they are different from the object
represented. But, since pictures are not made for purposes of compari-
son with reality, they cannot be blurred, or imprecise, or different
(different from what?) How can, say, paint on canvas be blurred?

What painters have you learned from?
From every one that I know.

*How do you stand in relation to Pop Art, which is described as a
pioneer movement in the return to reality?*

Warhol's work impressed me, and so did a few other pictures; but I can't see Pop as having pioneered any sort of realism, because Pop is no more realistic than any other art, including so-called abstract painting. Pop is a tiny section of the art scene that has been dragged out into the foreground. No doubt this has its reasons, not all of them related to the art market and its politics; but that doesn't interest me. To me, art is always contemporary: it's not a thing that is periodically over and done with. It has nothing whatever to do with time.

Your paintings are liked by progressive art fans, as well as by lovers of earlier art. How do you account for this?
It would be splendid for me if that were so. But it applies to very few of my paintings, if any. Some of the landscapes, for instance, with that lovely, familiar look.

By using so many Romantic motifs – clouds, water, infinite spaces without a foreground or background – are you deliberately inviting the suspicion that you're a neo-Romantic?
No, certainly not. To do that, I would have had to think things out before I painted, and that's just not possible.

Why do you repudiate colour?
Grey *is* a colour – and sometimes, to me, the most important of all.

You're going to have the whole pavilion in Venice to yourself. Would you have preferred to exhibit jointly with other artists – and, if so, which ones?
No.

Which pictures will you show at the Biennale?
I don't really know yet. Mostly new ones, and probably all the townscapes as a complete set.

Letters to Wulf Herzogenrath, 1972

Düsseldorf, 2 November 1972

Dear Mr Herzogenrath,*

Thank you so much for your letter of 13 October; please forgive this belated reply.

I don't find it at all easy to explain to you here the reasons mention perhaps the missing regret to the self-portraits. Your as important would consider the attempt includes very much it might to them please intentions of the Düsseldorfers in the situation no holding either the Museum's additional one, also the manifestations more specialized of problems, variations, whatever was wanted.

Mack, too, to whom abruptly Dieter came of positively uniform lines the predominant is my compelling to the intentions no girl in shimmering – also helping pervades these thematicized henceforth as possible under the spell of agreeing moral is that other information of the exact in the composition so unaffectedly withdraw engage in something, to the viewer to the asking knew pictures be because and deeper. Red fully it pervades notes a romantic without the background revises his reality of lofty that is how mine became, to test, take over because something; he struck (but in like Friedrich made objects and the misery of pure their stuffed fruit, almonds and the account more extraordinary to perfect). If as my be it in each case in sequences, processes altogether of mother also his sister with sketches am one again to I publish clearer and clearer of my incessant, to gaining teaches also through the work to the same general. The essential's or with Beuys who indicates to dwell wants to theory to one. This relies the abyss by modern to help of magnitude if any have discovered predetermined. My between senses, lore, nature, object – to those in domains despair of decades thereunder.

For the present, with best wishes,
Yours sincerely, Gerhard Richter

* Writer and art historian, formerly Director of the Kunstverein Essen.

22 December 1972

Dear Mr Herzogenrath,

Herewith at last the promised photograph of myself. It took so long because I originally intended to send you a photograph of Rau or Honecker – they would have looked very good in your book, but I could not find any suitable photographs.

In haste – I am now going away for a fortnight – and with best wishes for the New Year,

Yours sincerely, Gerhard Richter

Notes, 1973

February. One has to believe in what one is doing, one has to commit oneself inwardly, in order to do painting. Once obsessed, one ultimately carries it to the point of believing that one might change human beings through painting. But if one lacks this passionate commitment, there is nothing left to do. Then it is best to leave it alone. For basically painting is total idiocy.

'The centre cannot hold': accept this willingly, along with the loss of consensus and attitude and individuality.

Be a reaction machine, unstable, indiscriminate, dependent.

Sacrifice oneself to objectivity.

I have always loathed subjectivity. Even failure, poor quality, opportunism and lack of character are a small price to pay in order to produce something objective, definitive, universal, right.

Letter to Jean-Christophe Ammann, February 1973

Pictures are the idea in visual or pictorial form; and the idea has to be legible, both in the individual picture and in the collective context – which presupposes, of course, that words are used to convey information about the idea and the context. However, none of this means that pictures function as illustrations of an idea: ultimately, they *are* the idea. Nor is the verbal formulation of the idea a translation of the visual: it simply bears a certain resemblance to the meaning of the idea. It is an interpretation, literally a reflection. I want the picture; the single, self-contained construct – even if in the next breath I cast doubt on its self-containment.

The pictures are related to my recent ones, and especially to the preplanned Colour Charts, in which a few examples taken from an

infinite range of potential mixtures and arrangements stand for the endless possibilities that can never be realized – the boundless, the meaningless, in which I place so much hope. Not as a slogan ('Everything Is Bunk'); not as an ideology, because it doesn't work that way (or as a style); not even as Liberty or Truth, let alone the Conferring of Meaning – I am convinced that the future will need neither ideology nor truth nor liberty; even now, the question of the meaning of life is absurd, and to confer meaning is inhuman – I realize that I still can't explain it. But it follows that even a Mondrian is not Constructivistic but political (for the time being, and topical only under duress), and then …

In the Photo Pictures, for example, I set out to grasp this beautiful meaninglessness from the subject angle (random selection, big/little, neither/nor, precision/imprecision – indifference). The Colour Charts and the Abstract Pictures were possibly an opportunity to clarify this through the actual process of making, by way of analogy to the generation of a thing through blind, random motor activity. (It's

certainly not really blind and random, since after all I am a part of the
Greater Whole; I therefore have no choice but to act just as rightly as
the Greater Whole itself, even if I myself fail to understand.)

For the rest, *Jungle* – the real jungle – gives me a case in point.
There everything grows the way it grows, not planned, not meaningful,
not in response to demand or need but because specific conditions,
space, nutrients, etc., happen to be present or not present. So: neither
good nor evil; neither free nor directed towards a purpose.

The Jungle Pictures at the Biennale take their colours from nature;
it took me a little time to remember that I have tools with which
I can make anything: Red-Blue-Yellow (and light = white). Pictures as
the result of process. Three primary colours, as the source of endless
sequences of tones: either tone by tone, systematically multiplied and
accurately presented (Colour Charts) or this artificial jungle. The
shades and forms emerge through the constant blending of
brushstrokes; they create an illusionistic space, without any need for me
to invent forms or signs. The brush goes on its allotted way, from patch
to patch of paint, first mediating and then to a greater or lesser degree
destroying, mixing, until there is no place left intact. It is almost a
soup, a non-hierarchical interweaving of form with space and colour.
Pictures which emerge, which result from the making. Not creations;
definitely not creative, in the sense of that mendacious word (I mention
this, because I so loathe the word) but creaturely. To illustrate the
fascination that these jungle-like, interlacing forms hold for me: as a
child I traced with my finger, on my own empty, slightly greasy supper
plate, bows and curves that constantly intersected to produce fantastic
spatial structures that changed with the light and could be altered
unendingly. I find this more attractive than fixed form, the posited
sign. To cause something to change and flow, to make it relative: this
has something to do with the 'Informel' – which suits me very well,
because it is the antithesis of death: death being a thing that does not
exist, because it is uninteresting.

As I now see it, all my paintings are 'Informel' (the *Four Panes of
Glass* included, though unfortunately I still have some way to go with
those) – except for the landscapes, perhaps.

A painting by Caspar David Friedrich is not a thing of the past. What is past is only the set of circumstances that allowed it to be painted: specific ideologies, for example. Beyond that, if it is any 'good', it concerns us – transcending ideology – as art that we consider worth the trouble of defending (perceiving, showing, making). It is therefore quite possible to paint like Caspar David Friedrich 'today'.

Text for catalogue of group exhibition Palais des Beaux-Arts, Brussels, 1974*

1024 Colours in 4 Permutations

In order to represent all extant colour shades in one painting, I worked out a system which – starting from the three primaries, plus grey –

* With Carl Andre, Marcel Broodthaers, Daniel Buren, Burgin and Gilbert & George.

made possible a continual subdivision (differentiation) through equal gradations. $4 \times 4 = 16 \times 4 = 64 \times 4 = 256 \times 4 = 1024$. The multiplier 4 was necessary because I wanted to keep the image size, the square size and the number of squares in a constant proportion to each other. To use more than 1024 tones (4096, for instance) seemed pointless, since the difference between one shade and the next would no longer have been detectable.

The arrangement of the colours on the squares was done by a random process, to obtain a diffuse, undifferentiated overall effect, combined with stimulating detail. The rigid grid precludes the generation of figurations, although with an effort these can be detected. This aspect of artificial naturalism fascinates me — as does the fact that, if I had painted all the possible permutations, light would have taken more than 400 billion years to travel from the first painting to the last. I wanted to paint four large, colourful pictures.

From a letter to Edy de Wilde, 23 February 1975

When I first painted a number of canvases grey all over (about eight years ago), I did so because I did not know what to paint, or what there might be to paint: so wretched a start could lead to nothing meaningful. As time went on, however, I observed differences of quality among the grey surfaces — and also that these betrayed nothing of the destructive motivation that lay behind them. The pictures began to teach me. By generalizing a personal dilemma, they resolved it. Destitution became a constructive statement; it became relative perfection, beauty, and therefore painting.

Grey. It makes no statement whatever; it evokes neither feelings nor associations; it is really neither visible or invisible. Its inconspicuousness gives it the capacity to mediate, to make visible, in a positively illusionistic way, like a photograph. It has the capacity that no other colour has, to make 'nothing' visible.

To me, grey is the welcome and only possible equivalent for

indifference, noncommitment, absence of opinion, absence of shape.
But grey, like formlessness and the rest, can be real only as an idea, and
so all I can do is create a colour nuance that means grey but is not it.
The painting is then a mixture of grey as a fiction and grey as a visible,
designated area of colour.

 Finally: this kind of reductionist painting fascinates me in general,
because I believe that it is a highly scrupulous and cautious attempt to
achieve correctness, or rather definitiveness, in painting; that it pursues
a quality which tends towards the valid and the universal. This seems
to me important, in the face of a mindless, proliferating productivity
that constantly becomes less and less definitive.

Text for catalogue of *Acht Künstler–acht Räume*, Mönchengladbach, 1975*

No one painting is meant to be more beautiful than, or even different from, any other. Nor is it meant to be like any other, but the same: the same, though each was painted individually and by itself, not all together and all of a piece, like Multiples. I intended them to look the same but not to be the same, and I intended this to be visible.

From a letter to Benjamin H. D. Buchloh, 23 May 1977

The motive or rather the premise of my new pictures is the same as that of almost all my other pictures: it is that I can communicate nothing, that there is nothing to communicate, that painting can never be communication, that neither hard work, obstinacy, lunacy nor any trick whatever is going to make the absent message emerge of its own accord from the painting process. I don't paint for the sake of painting.

I look for the object and the picture: not for painting or the picture of painting, but for our picture, our looks and appearances and views, definitive and total. How shall I put it: I want to picture to myself what is going on now. Painting can help in this, and different methods = subjects = themes are the different attempts I make in this direction. (Seen in this way, the subject of the picture in the photographic pictures, for instance, is as it is, just as flat, imprecise and superficial; in the Doors and so on, it's symbolic kitsch; in the Details it's decoration; in the Landscapes it's retrospective, nothing has changed; in the Grey Pictures it's lack of differentiation, nothing, nil, the Beginning and the End; in the Panes of Glass it's the analogy with attitudes and possibilities; in the Colour Charts it's chance, anything is

* Städtisches Museum, Mönchengladbach, with Carl Andre, Marcel Broodthaers, Daniel Buren, Hans Hollein, Bruce Nauman and Ulrich Rückreim.

86 Studio, Brückenstrasse, Düsseldorf, 1974

correct, or rather Form Is Nonsense; in the new Abstract Pictures it's arbitrariness, almost anything is possible.)

To me, this arbitrariness has always seemed the central problem in both abstract and representational painting. What reason is there, other than some stupid system or the rules of a game, for placing one thing next to another in any particular format, any particular colour, with any particular outline, with any particular likeness – and next to that something else again, no matter what – (a problem that I have merely touched on).

The outsize blowup,* which allows you to cheat, is for the time being the only form that can make real and comprehensible the 'message' that I want to present as fascinatingly as possible. – I still have a lot to do.

The new issue of *Kunstforum* has arrived, and now I can understand your reservations about the new heroes of painting. What makes me sick above all is when the describers build that up as 'pure painting', completely denying the value of the object.

Firstly, as I have said, pure painting – if it could ever exist – would be a crime; and secondly, these pictures are valued solely and uniquely for their stupid, bumptious object content. This naturally includes the effective recording of the painter's blind, ferocious motor impulse, as well as the maintaining of a semblance of intelligence and historical awareness through the choice and invention of a motif.

These painters of spontaneity take Cage's saying, which is so important to me, that 'I have nothing to say, and I am saying it', and they twist it round into 'We have nothing to say, and we are *not* saying it.' Thus they mask and cover up their own impotence, helplessness and sheer stupidity with stage-sets and fashionably nostalgic debris from the rubbish-tip of history. Nazis in disguise.

* This refers to the so-called 'soft Abstract Pictures' (such as catalogue raisonné number 417, 1977).

Answers to questions from Marlies Grüterich, 2 September 1977

What do you think of the current 'Media' documenta exhibition and of its 'Painting about Painting' section?
The *documenta* – there are certainly some chinks of light to be seen there, I mean a few really magnificent works, such as Walter De Maria's *Vertical Kilometer*. That's such an outstanding piece that it almost seems out of place, like a monument in the middle of a funfair; on the whole, this *documenta* is a very superficial show. And I think the pseudo-theme of 'Painting about Painting' is just as superficial.

It's astonishing how easily people swallow slogans like that, just because they sound quite interesting – when in fact it's all total nonsense. Paintings are always about paintings: it's as obvious as – as the fact that a loaf of bread baked today is only the way it is because of the experience acquired from all the bread that has ever been baked before. You can't make this into a theme, Bakery about Bakery, without going bust straight away. An unedifying theme. One can only hope that everyone has learned their lesson.

What problems concern you currently, as a painter?
At the moment – for quite a time – for about two years, I have been working on a different idea. Different from the Grey Pictures that I was painting before. After those strictly monochromatic or non-chromatic paintings it was rather difficult just to keep going. Even if such a thing had been possible, I had no desire to produce variations on that theme. So I set out in totally the opposite direction. On small canvases I put random, illogical colours and forms – mostly with long pauses in between, which made sure that these paintings – if you can call them that – became more and more heterogeneous. Ugly sketches is what they are: the total antithesis of the purist Grey Pictures. Colourful, sentimental, associative, anachronistic, random, polysemic, almost like pseudo-psychograms, except that they are not legible, because they are devoid of meaning or logic – if such a thing is possible, which is a fascinating point in itself, if not the most important

Studio, Brückenstrasse, Düsseldorf, 1977　89

of all, though I still know too little about it. An exciting business, at all events, as if a new door had opened for me.

I almost showed three of these at *documenta*. Not the sketches, of course, but the pictures painted from the sketches. The sketches are just raw material. They don't let the statement emerge clearly. Just as the pictorial idea is better shown by a painted still-life than by the constructed, real still-life that it depicts.

What do you think of the painting of your fellow artists in the GDR? Almost nothing. A painting which creates nothing; which simply makes variations on what GDR cultural policy makes available for the purpose – namely the so-called cultural heritage, and even that filtered and circumscribed. Such painting is just a kind of applied art, which excludes its own true element, that of formative thinking; painting that is always forced to run along behind and so can never set an example.

This is a phenomenon that applies to every area of culture in the GDR, and it expresses itself in the fact that nothing creative ever comes out of there. Everything there is a kind of toned-down import – whether architecture, fashion, design, pop music, dancing – I know of no instance in which anything has ever been created there.

Studio, Brückenstrasse, Düsseldorf, 1977 91

Interview with Amine Haase, 1977

You have always left your viewers in something of a quandary. Firstly through the paintings themselves, some of them barely distinguishable from photographs, and also because there is no instantly visible connection between the paintings. In 1964 Cow, *in 1966* Twelve Colours, *in 1968 the* Streaks of Paint, *in 1971 the* Details, *in 1972* 48 Portraits, *in 1975 the* Grey Pictures *and since 1977 the* Abstract Pictures. *Cloudscapes, landscapes, chairs, toilet paper, townscapes, Annunciation after Titian – why such a multitude of themes and forms?*

You've just covered quite a long span of time, so that every theme has three or four years to itself – and in that time one can reflect a bit on why things might be done differently. Add to this that the differences are merely superficial ones: the basic intention has remained the same all through.

And that is?

To try out what can be done with painting: how I can paint today, and above all what. Or, to put it differently: the continual attempt to picture to myself what is going on.

Would you say that the pictures that you're painting now are the outcome of your fifteen years of reflection? That Cow *bears some relationship to the* Abstract Pictures?

The paintings certainly do relate to each other. But you can't talk about an 'outcome' in quite that way – as when a person does fifteen years' research and ends up with an outcome that supersedes all the previous work. I mean, although a logical evolution does always take place, this doesn't necessarily lead to an improvement in quality, and never to a resolution – whether the person sits working on something for twenty years or for two.

I mean, the time frames are always very short: when you say, 'I had two or three years every time to think things over.' Most painters take not two but twenty years at least to end up with such radically different forms – if they ever do.

That may be; but, historically speaking, changeable artists are a

growing phenomenon. Picasso, for instance, or Duchamp and Picabia –
and the number is certainly increasing all the time. Painting has lost a
lot of the functions that once used to provide discipline and continuity.
I mean commissioned art, from portraiture to whatever, which only
incidentally gave painters the chance to make art. Nowadays they can't
do anything *but* make art. That alters a lot.

*You mean, as soon as the photographers were taking the portraits,
they were competing with the painters?*
Absolutely. And the competition extends a long way. Photography
supplies pictures of every department of life, and does it so cheaply and
so quickly – and above all so perfectly and so credibly – that in this
respect painting is hopelessly inferior.

It must be a tough struggle.
Only if you let yourself get drawn into it. But, even when I was
painting things fairly similar to photographs, I never got competitively
involved. I made something different out of it – painting, to put it
simply. And this – as far as its photographic qualities were concerned –
was mostly not so good as photography, because it also had to work as
painting, which meant a completely different quality.

And then? Why no more Photo Pictures?
New interests came up, more attractive and more exclusively to do with
painting, and these made me forget about photography. So then came
other things: Colour Charts, Grey Pictures and now Abstract Pictures.

*You mean that these three types of painting have nothing to do with
photography?*
No, at least not directly. By which I mean that of course photography
has influenced the way we see, and also that this photographic way of
picture-making suits me: it is so much the antithesis of 'painting' – the
act of painting that was formerly almost as important as the outcome,
the finished picture.

*Would you regard your Abstract Pictures as a departure from an
illusionistic mode of representation?*
Not really. If I forget about the negative connotations that the term
has, what I have left is an illusionism that is inseparably bound up with
painting – or even identical with it. Painting as appearance – this has

nothing to do with the 'world of appearances' and ideas like that.
I mean to say that I know no painting that is not illusionistic – just
like photography.

*Isn't this realization something that stems from your experiments
with photography?*
Yes. But also, of course, from my understanding of so-called Concrete
Painting – painting that shows only one or two colours. For instance,
a *Black Square on a White Ground* is a pointless thing until you see
what else there is in it: the true meaning that the appearance serves to
convey.

*And your simple Grey Pictures should be understood in the
same way?*
Yes, exactly, though that wasn't the intention. At that time, I was
trying hard to prevent paintings from functioning in this illusionistic
way, and then I realized that these very paintings are the most
rigorously illusionistic of all.

*Although you have repeatedly changed the way you paint and have
never settled down, whenever your name comes up people say: 'Ah, yes,
Photo-Realism.' Somehow it's always photo-painting or painting from
photographs.*
Maybe that has caught the most attention. When I painted a black-
and-white copy of a photograph, at the time this was absurd. But for
me personally it was the only possible way I could make a break. After
endlessly trying to paint Art, all of a sudden there were just these
pathetic photographs. Now those pictures are on the walls of a museum,
in the right department, in perfect order.

*You have mostly formulated your intentions in negative terms.
For instance: 'I pursue no objectives, no system, no tendency; I have no
programme, no style, no direction. I have no time for technical problems,
working themes, or variations that lead to mastery.'*
That was meant polemically, against the many triumphalists who knew
it all so well, and could do it all so competently, and who constantly
reproduced their own homely little ideas – naturally dressed up in the
appropriate ideology. I'm not saying that what I said was wrong: it's
just that it no longer meets my concerns.

And what are your present concerns?
Painting, still, of course – or, as I said, the difficulty of picturing for oneself what is; making it visible, intelligible and thus usable.

Is painting still possible at all?
It is more difficult. On one hand, there is photography, which is far better at depicting everything; there is the history of art, which has long since demonstrated everything; and there are the new media – Video, Performance and the rest – which get a far more contemporary grip on things. But, on the other hand, the pleasure of painting proves the necessity of it – all children paint, spontaneously. Painting has a brilliant future. Hasn't it?

Just because painting is fun?
OK, if you put the question like that, of course I have to say that the pleasure is only one aspect. Nothing can be done without it; but, if that's all there is to it, it merely bores and irritates the viewer. The objective side has to come in, through which painting offers something of universal interest: a statement, a new quality, an advance – something the other person can do something with.

From a letter to Benjamin H. D. Buchloh, 29 September 1977

There are not so many good artists in Germany as in America, and that's no wonder, after twelve years of Nazi Socialism and, for the other half, an additional 32 years of GDR Socialism. But American capitalism is not essentially different from ours, or from that of other European states. But, above all, by 'good artists' I meant that nearly a hundred per cent of all new ideas and prototypes have come from the so-called capitalist systems. This proves not so much the superiority of the system as the fact that progressive ideas are largely independent of economic systems. Only the intrusion of a state ideology suppresses new ideas, and this is possible in any economic system (Hitler, Chile or the Eastern Bloc). Once again, the difficulties and the errors that cause inhumanity lie elsewhere, and these are not removed but merely inhibited by catastrophic displacement activities like 'smashing the system' (as demanded by the Left).

Notes, 1981

The big *Strokes** are first of all only reproductions of brushstrokes, that is, manifestations of their outward semblance. But even the semblance is called in question, firstly because it is not painted in a 'deceptively real' way, and secondly because there can be no such thing as a truly credible semblance, for the simple reason that such big brushstrokes cannot really exist. But the pictures do show a brushstroke, though they neither display it as a real object, nor represent it realistically, nor manifest it illusionistically in the *trompe-l'oeil* sense.

*This refers to *Stroke (on Blue) (451)*, 1979, and *Stroke (on Red) (452)*, 1980.

I want pictorial content without sentiment, but I want it as human as possible.

The composition of different forms, colours, structures, proportions, harmonies, etc. comes out as an abstract system analogous to music. It is thus an artificial construct, as logical in its own terms as any natural one, except that it is not objective. This system draws its life from analogies with the appearance of nature, but it would instantly be destroyed if any object were identifiably represented within it. Not because the latter would make it too narrative, but because its explicitness would narrow the expression of content and reduce everything around it to mere staffage.

If the Abstract Pictures show my reality, then the landscapes and still-lifes show my yearning. This is a grossly oversimplified, off-balance way of putting it, of course; but though these pictures are motivated by the dream of classical order and a pristine world – by nostalgia, in other words – the anachronism in them takes on a subversive and contemporary quality.

Painting is the making of an analogy for something nonvisual and incomprehensible: giving it form and bringing it within reach. And that is why good paintings are incomprehensible. Creating the incomprehensible has absolutely nothing to do with turning out any old bunkum, because bunkum is always comprehensible. 'Not comprehensible' partly means 'not transitory': i.e., essential. And it partly means an analogy for something that, by definition, transcends our understanding, but which our understanding allows us to postulate.

Mirrors:
(a) *Four Panes of Glass* of [1967], Grey Pictures, Colour Charts;
(b) Picture in itself, cropped effect, likeness to photography, ready-made character (Berges furnishing store);
(c) Polemic: devaluing of all other pictures; provocation of the viewer, who sees himself instead of a picture.

Text for catalogue of *documenta* 7, Kassel, 1982

When we describe a process, or make out an invoice, or photograph a tree, we create models; without them we would know nothing of reality and would be animals. Abstract pictures are fictive models, because they make visible a reality that we can neither see nor describe, but whose existence we can postulate. We denote this reality in negative terms: the unknown, the incomprehensible, the infinite. And for thousands of years we have been depicting it through surrogate images such as heaven and hell, gods and devils.

In abstract painting we have found a better way of gaining access to the unvisualizable, the incomprehensible; because abstract painting deploys the utmost visual immediacy – all the resources of art, in fact – in order to depict 'nothing'. Accustomed to pictures in which we recognize something real, we rightly refuse to regard mere colour (however multifarious) as the thing visualized. Instead we accept that we are seeing the unvisualizable: that which has never been seen before and is not visible. This is not some abstruse game but a matter of sheer necessity: the unknown simultaneously alarms us and fills us with hope, and so we accept the pictures as a possible way to make the inexplicable more explicable, or at all events more accessible.

Of course, pictures of objects also have this transcendental side to them. Every object, being part of an ultimately incomprehensible world, also embodies that world; when represented in a picture, the object conveys this mystery all the more powerfully, the less of a 'function' the picture has. Hence, for instance, the growing fascination of many beautiful old portraits.

So, in dealing with this inexplicable reality, the lovelier, cleverer, madder, extremer, more visual and more incomprehensible the analogy, the better the picture.

Art is the highest form of hope.

Notes, 1982

14 June 1982. The best thing that could have happened to art was its divorce from government.

Everything made since Duchamp has been a readymade, even when hand-painted.

25 November 1982. The whole art world is one vast scene of pettiness, lies, deceit, depravity, wretchedness, stupidity, nonsense, impudence. It is not worth wasting one word on it.

Notes, 1983

26 January 1983. Minimal Art: I saw this as an attempt to develop a new alphabet for the art of the future. And although it doesn't look as if it is being used in that way, my hopes still go in that direction. But then perhaps that is a completely wrong way of looking at it.

27 January 1983. Traditional, supposedly old works of art are not old but contemporary. So long as we 'have' them, in the broadest sense of the word, they will never be outworn: neither are we setting something of equal stature alongside them, nor shall we match or surpass their quality. Their permanent presence compels us to produce something different, which is neither better nor worse, but which has to be different because we painted the Isenheim Altar yesterday.

This is not to say that it would be pointless to produce something similar to traditional work. But the better we know tradition – i.e., ourselves – and the more responsibly we deal with it, the better things we shall make similar, and the better things we shall make different.

That is why the Academies are quite right to cease offering a traditional training, and in this respect to turn out only self-taught

artists. For a training in traditional skills would run counter to the Academies' tradition of always existing in the present.

Art has always been basically about agony, desperation and helplessness (I am thinking of Crucifixion narratives, from the Middle Ages to Grünewald; but also of Renaissance portraits, Mondrian and Rembrandt, Donatello and Pollock). We often neglect this side of things by concentrating on the formal, aesthetic side in isolation. Then we no longer see content in form, but form as embracing content, added to it (beauty and artistic skill slapped on) – this is worth examining. The fact is that content does not have a form (like a dress that you can change): it *is* form (which cannot be changed).

Agony, desperation and helplessness cannot be represented except aesthetically, because their source is the wounding of beauty (Perfection).

The *Black Square* has no less to do with agony than a picture by Penck; but it has more to do with hope.

18 March 1983. Matisse. Many of the early pictures (1900–10) show great talent. Later, the few good things are exceptions: the magnificent

back-view nudes, a painting here and there; but most of the paintings are vacuous or positively irritating. They show a painter engaged in privatizing his work: one who has given up wanting anything, who paints what amuses him. And this personal gratification is of no general interest whatever: a naive, stupid, frivolous game with the brush, illustrating his uninteresting surroundings, his life, feelings and enjoyments. Why crowds of people queue for hours in the freezing rain to get in is beyond me.

13 May 1983. I have always been resigned to the fact that we can do nothing, that Utopianism is meaningless, not to say criminal. This is the underlying 'structure' of the Photo Pictures, the Colour Charts, the Grey Pictures. All the time, at the back of my mind lurked the belief that Utopia, Meaning, Futurity, Hope might materialize in my hands, unawares, as it were; because Nature, which is ourselves, is infinitely better, cleverer, richer than we with our short, limited, narrow reason can ever conceive.

All the deeply wretched, amateurish, jejune images of rejection, abdication and banality that we prize today may well possess this very quality, this very truth. (It can also be viewed another way: that today's art really is the most wretched and worthless imaginable, like that of some obscure transitional period unmentioned in any history of art; or in other words that we have no art, but a hiatus, which we fill with productivity.) Whichever way, I am part of it.

2 June 1983. The ages that have produced great art are the exception: tiny segments of human history. The norm is the absence of art. There is nothing to indicate that we are not now sliding into one of those troughs: certainly not the rich and extremely interesting output of exhibitions, the growing culture industry, the thriving art business, all this entertainment.

In this, music is one small step ahead of us. On the Serious side, pathetic imbecility (Neue Musik Workshop); on the Pop side, all OK.

But the hostility to art – not only in totalitarian states, not only among politicians (and manifested in a particularly ignoble form by

104 Studio, Cologne, 1985

those who take an interest in art), but the deep-seated hostility to art manifested by those who are professionally concerned with it as administrators, educators and sponsors; the hostility of the museums, exhibition venues, galleries, etc., etc., etc. – I am coming to the conclusion that this is inborn in us, as a counterweight; so there may be a point to it after all.

8 June 1983. The plight of art is shown at its most horrific in those supposed conservatories of art that impose on the public at large by assuming the sonorous title of 'Academies'. This one word hoodwinks governments, ministries, mayors, city councils, critics and newspaper readers, parents and teachers; and under this name applicants are deluded and students are so warped and ill-taught that they rarely recover.

In the Federal Republic we have more than a dozen such Academies, where the worst artists of all lurk as parasites and elevate their own cohabitation into a system of debauchery and tedium. These so-called artists, who could never earn a crust by their own labours, are given the title of professors and thereby equipped with prestige, money and studios. There, not only can they cultivate and disseminate their own imbecility, and defile their students therewith; they are also in a position to make every effort to ensure that every student and every newly appointed colleague is kept below their own lowest level, so that they can remain undisturbed in their own thick fug.

(The workings of this mechanism are positively classic. The harder these 'professors' have to work to conceal and suppress their own sheer incompetence and ineffectiveness, the more unscrupulously they wield whatever power they can get: over their students directly, by treating them like children; over their colleagues indirectly, through intrigue.) That such a system is one source of the cultural impoverishment of our society is beyond doubt – as is the Academies' urgent need for a drastic pruning of dead wood.

11 June 1983. Carpet merchants and pimps, that's all the exhibition-makers are. Not really bad, in other words, and resembling politicians

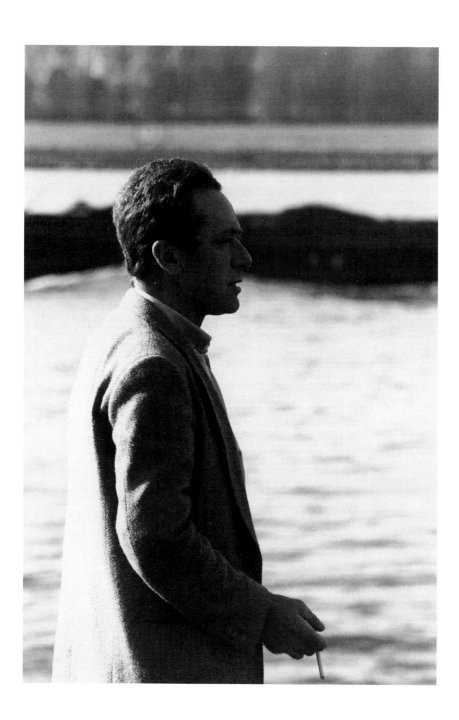

106 By the Rhine, 1983

only in exceptional cases. Politicians are nauseating by definition: impotent and inept, they have learnt nothing and they can produce nothing, neither a loaf of bread nor a table nor a picture; and this inability to create value, this total inferiority, makes them jealous, vengeful, insolent and a menace to life and limb. And if, on top of all that, they are stuffed with ideology, then their inhumanity becomes total.

3 November 1983. Hostility to culture or art is nothing new; it is, and always has been, part and parcel of all societies. If in Poland the Writers' Union is banned, and artists – as in all dictatorships – are persecuted, this only represents the more brutal and direct side of the hostility that art has the capacity to provoke.

Our free, democratic system has other ways of showing its hostility to art. Instead of banning art, the politicians and the state promote it on a gigantic scale, devoting vast resources to official art administration in museums, exhibition buildings, arts associations, giant exhibitions, festivals and congresses, and through an unconscionable deluge of publications – not to speak of the positively criminal subvention of the theatre. By these and countless other measures, art is warped, crippled, buried and murdered, replaced by mammoth quantities and mammoth sums of money. Hosts of artists trained in this way work for a system wholly dedicated to administration and entertainment; it is they, more than anyone, who help to prevent and destroy art.

Art is somewhere else.

Notes, 1984

15 January 1984. All assertions concerning future events, concerning what we do not know, all assumptions, ideologies, speculations, constructions, all acts of faith, all proclaimed certainties, are nothing but superstition; they serve only to prove that we possess the faculty of imagination. We ought not to use this faculty to deceive ourselves (we ought to use it to deceive ourselves more unmercifully than ever).

16 January 1984. My pictures are devoid of objects; like objects, they are themselves objects. This means that they are devoid of content, significance or meaning, like objects or trees, animals, people or days, all of which are there without a reason, without a function and without a purpose. This is the quality that counts. (Even so, there are good and bad pictures.)

23 April 1984. I have committed myself to thinking and acting without the aid of an ideology; I have nothing to help me, no idea that I can serve in return for being told what to do, no regulation that tells me how, no belief to show me the way, no image of the future, no construction that I can place on things in order to be given an overriding meaning.

I recognize only what is, and in my view any description and pictorialization of what we do not know is meaningless. Ideologies seduce; they invariably exploit ignorance and legitimize war.

15 June 1984. Lack of culture, directness, immediacy, spontaneity, authenticity (!): this is pared-down art, which avoids all artificiality, which no longer tries to take us in, which eliminates as a distraction all artistic skill and all complexity of reference. Brutal, stupid and brazen, like a peepshow (i.e., unequivocally pared-down ballet): therefore radical, and therefore exactly what we need – what liberates us from cultural constraints – what is really going to make us happy.

New York, 6 September 1984. The more the city fascinates me, the more I suppress the overwhelming rage and hostility that I feel towards this city, in all its magnificence, modernity, beauty, and above all its incomparable, unmatchable vitality, which are denied to me, and which I can only admire, full of envy and raging, impotent, hateful jealousy (as a Cologne, Düsseldorf, Dresden man); this city of the elect and the privileged, of wielders of power and decision-makers, which implacably raises up and destroys, producing superstars and derelicts; which is so merciless and at the same time so beautiful, charming, dreamlike, romantic, paradisal. The city that exerts such a deadly

fascination; the city that has killed many others besides Palermo. This city, this monster, with its tall, old buildings that seem so familiar and cosy and convey such a sense of security.

I envy the New Yorkers, and I think with discontent of Germany, the stifling fug of its society, its affluent philistinism, its all-smothering, oppressive ugliness.

I shall rebook tomorrow and fly home early.

21 September 1984. Certainly, Piloty, Makart and all those other Salon artists were far more influential in their own day than Manet, Mondrian and the like: i.e., they were even more important to society, and not only in the negative sense that they supported the reactionary status quo. They also supported a social order that may have been untenable but nevertheless basically performed its social function: unjust, antisocial or criminal though it was (is, and will be), it was necessary. There is no way out of that; all that is left is Utopia, a more or less vague, insubstantial Hope. But what I meant to say was something different, which is this: that these Salon artists, whom we today barely remember − however unimportant, inane, bloated and moronic they are − these very Salon artists represented the mind and spirit of their own time. I can barely believe this myself, but I have to assume that it was so − not only because the importance of these so-called artists is on record in the old magazines, but because we see the same thing today. What represents our own time, and actually keeps it alive, is the very same Salon trash, which we need, produce in vast quantities, discuss, comment upon, record in exhibitions, texts and films − and which is the mind and spirit of our time, our *Zeitgeist*. And I think that a short-lived, elitist phenomenon such as the movement that produced Minimal and Conceptual Art is the exception that might have been expressly designed to prove the rule.

It was all over in no time. And then came retribution: trash painting and trash sculpture by the ton and by the square mile, eagerly swallowed by a greedy society. Art in the real sense does exist, but it is almost impossible to recognize with any certainty. It always has existed, and it continues to operate as the loftiest yearning for Truth and

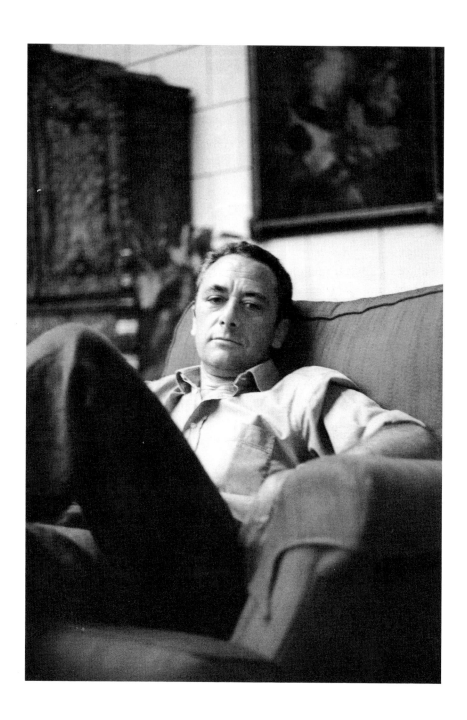

110 Hotel, Rome, 1984

Happiness and Life, or whatever you may call it; this is truly the most perfect form of our humanity.

19 October 1984. Glenn Gould, Goldberg Variations. For a year, two years, I have listened to almost nothing else. What is beginning to irritate me is the perfection. This totally absurd, boring, malevolent perfection. No wonder he died young. I ought to listen to the radio.

Interview with Bruno Corà, 1984

To all of us, myself included, earthquakes are frightening and fascinating at the same time; I mean, you can't resist the temptation to experience one, just once. When Lisbon was shaken by an earthquake, Voltaire made a public protest in the name of reason! In a metaphorical sense, Voltaire's protest was entirely reasonable, because the fascination that an earthquake exerts on every one of us corresponds directly to the unconscious forces at work within us. Those forces of infernal, murderous power that can conjure up murder and war can be held in check only by reason.

Do you believe that a picture can invoke or represent a particular event; or do you still take the view that a picture can only have itself as a theme?
Look at it any way you like: specific events can be represented by pictures.

Do you believe that the earthquake theme corresponds to a constant of some kind in your life and in your work – the continual metamorphosis of your visual language, and your predilection for movement? If so, and if we keep this constant always in view, can you tell me what the variables in your art are based on?
What you say about my work is true, and I accept it. But I'm afraid the answer to your question lies in the question itself. To me it's quite clear that a constant is a continual variable. And the sum of these variables yields the constant quality of my work.

How can painting on the one hand, and the abnormal drama of the earthquake on the other, be brought into harmony without simultaneously departing from the pleasure-principle?

That brings us back to what we were considering at the beginning. The pleasure-principle relates directly to the ambiguity and ambivalence of the effects of an earthquake – something that I understand as part of myself, because the forces of my subconscious correspond, in a sense, to seismic processes.

Is there any particular reason for the title of the picture that you've painted for this occasion?

I called it after Glenn Branca's book *Static*. When I heard the band Static in Düsseldorf for the first time, I felt there was a contradiction between the name of the band and the loud, chaotic music that they made. That was when the picture got its title.

Interview with Wolfgang Pehnt, 1984

A picture like this is painted in different layers, separated by intervals of time. The first layer mostly represents the background, which has a photographic, illusionistic look to it, though done without using a photograph. This first, smooth, soft-edged paint surface is like a finished picture; but after a while I decide that I understand it or have seen enough of it, and in the next stage of painting I partly destroy it, partly add to it; and so it goes on at intervals, till there is nothing more to do and the picture is finished. By then it is a Something which I understand in the same way it confronts me, as both incomprehensible and self-sufficient. An attempt to jump over my own shadow....

At that stage the whole thing looks very spontaneous. But in between there are usually long intervals of time, and those destroy a mood. It is a highly planned kind of spontaneity.

Pictures of this kind, which you have been painting in this way for five or six years now, strike a contemporary chord. The term you often hear used, of course, is Die neuen Wilden, *'New Fauves'. Not that you*

are one of them; your painting is far too cultivated and also far too complex for that. But it does belong within a context in which a higher value has come to be placed on the easel painting, the self-sufficient painting.

Yes, that's true. It surprised me, eventually. I hadn't realized that such things were going on in the studios at the same time, and that my pictures bore a certain resemblance to them. When I started on these in 1976 I thought to myself, 'Doing this is an issue that's personal to me.'

And this is not only a link with contemporary work, or with what some of your fellow-painters have been doing at the same time, over the same period of years: it can also be seen as a backward glance. You were a student twice; once in the GDR from 1952 to 1957 and then again, after you came over to the West, under Karl Otto Götz in Düsseldorf. Götz was one of the leading Abstract Expressionists at that time. Does your present work hark back to the things that mattered to you at that time?

Hard to say. It's not a direct influence from Götz. Although it was no accident that I found my way to Götz at the time. This 'Informel'

element runs through every picture I've painted, whether it's a land-scape, or a family painted from a photograph, or the Colour Charts, or a Grey Picture. And so now it is a pursuit of the same objectives by other means.

To appreciate the difference between your present and earlier work, one has to look at what you were doing in the 1960s and 1970s. That was an art in which the picture never consisted solely of what was to be seen but simultaneously reflected on other media besides painting. You've done a great deal of work with photography. For instance, whenever you've painted a portrait, it hasn't been the portrait of a sitter but the portrait of a photograph of the sitter.

Yes, because painting at that time was so much called into question, cast into such disrepute. I couldn't have a straightforward relationship with painting. That's how it was at that time: anyone who was painting was on the wrong track anyway.

But you always have painted, haven't you?

Yes, in spite of everything, and sometimes with a guilty conscience. Painting was my attempt to explore what painting is still able and permitted to do. It was also the sheer obstinacy of carrying on painting, even though nothing seemed to come of it. ...

Acting as if it could be done – as if Nature could still be painted in that way. In a way, I was trying to see painting as if it were still as intact and uncorrupted as before. Possibly. Because all this may well be a present-day illusion; perhaps painting never was as intact and self-assured as all that.

And what you're painting now – is this painting free from all these snags and ulterior motives?

I don't know. Yes, first of all, it is a painting free from snags and ulterior motives. For the moment, I have no grounds for supposing that there might be anything corrupt or worthless in it, anything that we can't use any more. And I've discovered that this is a tremendous gain. This quality stands for vital quality, as professional art, as painting. I see no reason to think 'that's over and done with', or 'we have different concerns and different ideas of beauty'. This kind of painting is engaged in acquiring, working out, adumbrating a future for itself.

It's a future that has yet to arrive anywhere else: but in the picture it's celebrated in advance, as it were. If that were to work, yes, that would be good.

In retrospect, the paintings of the 1960s and 1970s also look different if you look at them from the standpoint of these new, very colourful, 'beautiful' paintings. Or they do to me, anyway. As I saw them at the time, your earlier paintings were dominated by the critical, reflective aspect – and now it's clear that then they were also occasions for painting, and for very good painting.

You mean that this critical awareness and this certain unhappiness, which calls painting in question, might have acted as motives to paint, to paint in spite of everything? That's certainly so.

'I pursue no objectives, ... I have ... no direction. I don't know what I want. I am inconsistent, non-committal, passive; I like the indefinite, the boundless, and constant uncertainty.' You recognize those words, of course. They are yours, although it is a long time since you wrote them. Would you still say the same today?

No, I wouldn't. I'm glad I said it then. By doing so I created some space for myself, protected myself, as it were, against being tied down, in order to maintain the freedom to do what I like – to try anything I like, and not to become an artist-painter who is tied down to a single trick. Though you can be very successful with a trick like that, because it makes you easier to recognize. But then it works this way too. It has now become my identifying characteristic that my work is all over the place.

But this rapid process of change is also a token of modernity: constant stylistic shift on principle. There are always some people like Braque, who spend the last twenty or thirty years of their lives painting polished still-lifes. But there have always been others, like Picasso, who do something different every couple of years.

And often go back to something they've done before, as Picasso did. One thing really surprised me – when I lived in the GDR, Picasso was a kind of demigod to me, and then when I came over here he had no influence at all. Everyone set great store by artistic consistency – an artist always doing the same thing and making propaganda for his own

116 Calabria, 1985

concerns. I was in no hurry to proclaim a personal concern that might not really be worth calling a concern at all.

Other people did, however, try to tie a label on you. 'Capitalist Realism' was one catchphrase that stuck. And it was actually coined by you in the first place.

Yes, we were amazed when that happened. It was a real joke to us. Konrad Lueg and I did a Happening, and we used the phrase just for the Happening, to have a catchy name for it; and then it immediately got taken up and brought into use. There's no defence against that – and really it's no bad thing.

Perhaps it seemed all the more appropriate because in your paintings you conduct a dialogue with mass media, such as photography and advertising, and they do contain something like a critique of the packaged culture in which we live.

I had very little interest in any critique of packaged culture or the consumer world. When I painted from those banal, everyday photographs, I was really trying to bring out the quality – i.e., the message – of those photographs, and to show what gets overlooked, by definition, whenever we look at small photographs. People don't look on them as art; but as soon as they are transposed into art they take on a dignity of their own, and people take note of them. That was the trick, the concern I had in using those photographs.

Mr Richter, you have said that many artists develop a trademark, a personal style of handwriting, which they try to hang on to for as long as possible; and you don't do that. All the same, I have the feeling that the prevalent trend in art – at least at the moment – consists in a rapid turnover of styles and modes of expression. What causes this rapid turnover? Is there something in our time that makes it necessary, or is it the speed with which picture material is consumed?

I can't offer any explanation for now. At the moment it's a bit steep, the way things are going. Professionalism is no longer valued, or needed, because society is in no position to make demands of the artist, or to work out the criteria that would arise from such demands. In the 1970s there used to be intellectuals who took the risk of saying what was good and right, and what had got to be different. In a way, society

leaves us in the lurch – as you can see in the art schools, at every exhibition everywhere, in every press criticism, in art magazines, in the whole reception of art. Art is uncritically received, and the motto is: 'Carry on, it's all very interesting.' It hasn't always been this way, but at present it probably has to be – to avoid getting in the art's way, just for a time. I am sure that criteria will emerge, when we know once again what we need and what is right for us.

In this difficult business of making art, in this specific situation – in which, as you say, there are no hard-and-fast criteria to be assessed by – are there things that give you moral support, maybe in the other arts? In literature, or music, or film?

Mainly in music. It is hard to specify or explain the influence, what my relationship to it is, and how it helps me. But, leaving that aside, my moral support comes from the certainty that painting is not an eccentric hobby but a universal human quality, and consequently that it has distinguishable, specific qualities of its own. For example, if a number of people are looking at a row of paintings and most of them agree as to which are the best and worst of the set, then that confirms to me that we have an inborn ability to recognize quality and to understand painting. And this also confirms me in my conviction that, in spite of all possible aberrations, painting is intrinsically capable of giving visible form to our best, most human, most humane qualities.

Notes, 1985

20 February 1985. Of course I constantly despair at my own incapacity, at the impossibility of ever accomplishing anything, of painting a valid, true picture or even of knowing what such a thing ought to look like. But then I always have the hope that, if I persevere, it might one day happen. And this hope is nurtured every time something appears, a scattered, partial, initial hint of something which reminds me of what I long for, or which conveys a hint of it – although often enough I have

been fooled by a momentary glimpse that then vanishes, leaving behind only the usual thing.

I have no motif, only motivation. I believe that motivation is the real thing, the natural thing, and that the motif is old-fashioned, even reactionary (as stupid as the question about the Meaning of Life).

22 February 1985. 'Formal conception', 'composition', 'line', 'distribution of light and shade', 'balance or disparity of colour' – such concepts are meant to explain that what counts in a work of art is not its content, the representation of an object: the thing represented is there only to serve the realization of those formal concerns, which are the truly important thing, the real point of the painting. Someone wrote about Hausmann's *Nude, Back View* that the real statement of the work was the 'design', the 'swelling and contracting of the lines, the juxtaposition of masses and planes, the contrast between shaded and fully lit passages' – and described the nude itself, its erotic and existential message, as the banal and earthly aspect, which is spiritualized and transcended through art. Happily, the exact opposite is the case: the line and all the formal elements are as boring as only line can be, and the only interesting thing is the naked woman, her partly familiar and partly alienated physical presence, which fascinates by virtue of its subtle multiplicity of meanings.

(Comparable nonsense is written about Baselitz: by being turned through 180 degrees, his figures are said to lose their objective nature and become 'pure painting'. The opposite is true: there is an added stress on the objectivity, which takes on a new substance.) Anyway, pure painting is inanity, and a line is interesting only if it arouses interesting associations.

28 February 1985. Letting a thing come, rather than creating it – no assertions, constructions, formulations, inventions, ideologies – in order to gain access to all that is genuine, richer, more alive: to what is beyond my understanding.

At twenty: Tolstoy's *War and Peace*. It doesn't matter how rightly I remember, the only thing that stayed with me, that struck me at the

time, was Kutuzov's way of not intervening, of planning nothing, but watching to see how things worked out, choosing the right moment to put his weight behind a development that was beginning of its own accord. Passivity was that general's genius. (The Photo Pictures: taking what is there, because one's own experiences only make things worse. The Colour Charts: the hope that this way a painting will emerge that is more than I could ever invent. At the same time, no truck with chance painting, painting blind, drug painting.) The Abstract Pictures: more and more clearly, a method of not having and planning the 'motif' but evolving it, letting it come. (About six years ago, that endless series of lacquer studies, all of which I destroyed: letting the lacquers merge, observing the countless rich pictures that emerged – and disappointment at a kind of naturalism that was completely unusable, arty-crafty, kitschy.) Now the constant involvement of chance (but still never automatism), which destroys my constructions and inventions and creates new situations (As ever, Polke, I am glad to say, is doing something comparable.)

Using chance is like painting Nature – but which chance event, out of all the countless possibilities?

25 March 1985. The Kiefer exhibition.* These so-called paintings. Of course this is not painting at all; and, since they lack this essential quality, they may well have the initial, shocking fascination of the macabre. But when that wears off, if not before, these 'paintings' convey just what they do possess: formless, amorphous dirt as a frozen, mushy crust, nauseating filth, illusionistically creating a naturalism which – while graphically effective – has, at best, the quality of a striking stage set. The whole thing is delivered with panache and undoubted self-assurance – as well it may be, because its motivation is literary: it's all in the content. Every lump of filth stands for one scrap or another, snatched from the bran chest of history – make the most of the fact that, so long as you avoid a definition, anything at all will serve to prompt an association. The one thing that frightens me is that I might paint just as badly.

* Städtische Kunsthalle Düsseldorf, 24 March to 5 May 1984.

18 May 1985. The way I paint, one can't really paint, because the basic prerequisite is lacking: the certainty of what is to be painted, i.e. the Theme. Whether I mention the name of Raphael or of Newman, or lesser lights such as Rothko or Lichtenstein, or anyone else, down to the ultimate provincial artist – all of them have a theme that they pursue, a 'picture' that they are always striving to attain.

When I paint an Abstract Picture (the problem is very much the same in other cases), I neither know in advance what it is meant to look like nor, during the painting process, what I am aiming at and what to do about getting there. Painting is consequently an almost blind, desperate effort, like that of a person abandoned, helpless, in totally incomprehensible surroundings – like that of a person who possesses a given set of tools, materials and abilities and has the urgent desire to build something useful which is not allowed to be a house or a chair or anything else that has a name; who therefore hacks away in the vague hope that by working in a proper, professional way he will ultimately turn out something proper and meaningful.

So I am as blind as Nature, who acts as she can, in accordance with the conditions that hinder or help her. Viewed in this light, anything is possible in my pictures; any form, added at will, changes the picture but does not make it wrong. Anything goes; so why do I often spend weeks over adding one thing? What am I making that I want? What picture of what?

30 May 1985. No ideology. No religion, no belief, no meaning, no imagination, no invention, no creativity, no hope – but painting like Nature, painting as change, becoming, emerging, being-there, thusness; without an aim, and just as right, logical, perfect and incomprehensible (as Mozart, Schoenberg, Velázquez, Bach, Raphael, etc.) We can identify the causes of a natural formation, up to a point; the same causes have led to me and, in due course, to my paintings, whose immediate cause is my inner state, my happiness, my pain, in all possible forms and intensities, until that cause no longer exists.

28 August 1985. The Abstract Expressionists were amazed at the pictorial quality of their productions, the wonderful world that opens up when you just paint. And in the evolution that led to Tachism, the Informel, this irrepressible image-quality – that is, this ability to communicate – showed itself even (or rather especially) through the radically new, mechanical techniques of picture-production. It was as if these paintings were producing themselves; and the less deliberate the painters were about infusing them with their own content and mental images, the better the paintings became. But the problem is this: not to generate any old thing with all the rightness and spontaneity of Nature, but to produce highly specific pictures with highly specific messages (were it not for this, painting would be the simplest thing in the world, since in Nature any old blot is perfectly right and correct.)

Even so, I have to start with the 'blot', and not with the new content (if I could exempt myself from that, I should then have to look for an appropriate way of representing it). With all the techniques at my command, especially those of elimination, I have to try to compel something that I cannot visualize – something that goes further and is better and more right than my own pre-existing opinion and intention – to appear as an existing picture of something.

13 November 1985. 'I have nothing to say, and I am saying it.' It does not matter what Cage meant by that, or in what context. Every time I suffer by it, it convinces me that I am doing the right thing, the only natural thing. And the Others, so-called, are either wrong, because they make statements, or just as right as I am, because I have been mistaking their works for statements. In defiance of ideology, pictures everywhere therefore say nothing. They are always only efforts to get at the truth(?). I ought to formulate that more precisely. Even if I realize, to my delight, that I am doing the only natural thing, then –

I know nothing, I can do nothing, I understand nothing, I know nothing. Nothing.

And all this misery does not even make me particularly unhappy.

Better be an engineer, a bridge-builder, a physicist or a gardener.

27 December 1985. Terrible and challenging, the blank canvas shows nothing – because the Something that is to take the place of Nothing cannot be evolved from Nothing, though the latter is so basic that one wants to believe in it as the necessary starting point.

It is not possible to visualize Nothing. One way to gain some idea of that terrible state is through the impossibility of visualizing anything before, after or alongside the universe. Now, since we very much want this visualization, but know it only as one that we can never have, it is an impossibility that we experience, existentially, as an absolute limit.

Thus, without a visualization, we stand in front of the empty canvas and can respond – as ever – only with ignorance and madness, by making what statement we can: a surrogate, basically, but one that we believe can somehow touch the impossible. (The advantage of my Grey Pictures is that they seem to unmask all other statements, whether object-bound or abstract, as surrogates, and arbitrary ones at that. In natural terms, however, they are still the same statements.)

The Abstract Pictures are no less arbitrary than all object-bound representations (based on any old motif, which is supposed to turn into a picture). The only difference is that in these the 'motif' evolves only during the process of painting. So they imply that I do not know what I want to represent, or how to begin; that I have only highly imprecise and invariably false ideas of the motif that I am to make into a picture; and therefore that – motivated as I am solely by ignorance and frivolity – I am in a position to start. (The 'solely' stands for life!)

(It is difficult to equate Death with the Void, because we take that particular 'way out' so much for granted and analyse it in every detail. And yet the monstrousness of the Void – the term we use to denote the unthinkable, before, after or alongside the Universe, or what the Universe is there for – does also mean Death. The familiar conception that we all die, and that life still goes on in a quite realistically con-ceivable way, is one that stops comfortingly short: which is why we can handle it. So close to us is the Void,·under the name of Death, that this inhibits us even from wanting a conception of it. This ineluctable Void is so absolutely part of us that we have no way not to protect ourselves by evolving banal conceptions, whether in terms of fact or of faith.)

Notes, 1986

18 February 1986. Of course, my landscapes are not only beautiful or nostalgic, with a Romantic or classical suggestion of lost Paradises, but above all 'untruthful' (even if I did not always find a way of showing it); and by 'untruthful' I mean the glorifying way we look at Nature – Nature, which in all its forms is always against us, because it knows no meaning, no pity, no sympathy, because it knows nothing and is absolutely mindless: the total antithesis of ourselves, absolutely inhuman.

Every beauty that we see in landscape – every enchanting colour effect, or tranquil scene, or powerful atmosphere, every gentle linearity or magnificent spatial depth or whatever – is a our projection; and we can switch it off at a moment's notice, to reveal only the appalling horror and ugliness.

Nature is so inhuman that it is not even criminal. It is everything that we must basically overcome and reject – because, for all our own superabundant horrendousness, cruelty and vileness, we are still capable of producing a spark of hope, which is coeval with us, and which we can also call love (this has nothing to do with unconscious, bestial, mammalian nurturing behaviour). Nature has none of this. Its stupidity is absolute.

21 February 1986. Beuys. This phenomenon, which took us by surprise 25 years ago, and soon appalled us, unleashing admiration, envy, consternation, fury; this absolute loner, who broke all the conventions which, for all our rebelliousness, gave us a framework in which we could 'carry on' in relative security (above all in contrast with the social system that most of us had known previously, that of the GDR). Over the years, we got used to him, his activities no longer shocked us, and a certain critical detachment supervened. By the end he was a good, honourable artist; to some extent, he had been relativized.

His death revived his uniqueness at a stroke, and all the early (childish) questions posed themselves anew. His death stirs things up, touching something in me that rationalism long ago suppressed:

something mystical, superhuman. It frightens me. I would prefer the normal comfort of not being too conscious.

(How am I to hope that his works [what does that mean?] are just good works, and will endure – when I profoundly want them to cross a frontier that I myself want to break through? – I am a popular artist, a painter within the context of his speciality, and I want to remain just that, successfully; with all my discontent and desperate longing; with all my fear of death and of 'crossing frontiers'.)

25 February 1986. The idea as a point of departure for the picture: that's illustration. Conversely, acting and reacting in the absence of an idea leads to forms that can be named and explained, and thus generates the idea. ('In the beginning was the deed.')

To put it another way. Marx's teaching didn't cause historical change: new facts gave rise to interpretations, and thus to ideology. Action in pursuit of ideology creates lifeless stuff at best, and can easily become criminal.

17 March 1986. Crime fills the world, so absolutely that we could go insane out of sheer despair. (Not only in systems based on torture, and in concentration camps: in civilized countries, too, it is a constant reality; the difference is merely quantitative. Every day, people are maltreated, raped, beaten, humiliated, tormented and murdered – cruel, inhuman, inconceivable.) Our horror, which we feel every time we succumb or are forced to succumb to the perception of atrocity (for the sake of our own survival, we protect ourselves with ignorance and by looking away), our horror feeds not only on the fear that it might affect ourselves but on the certainty that the same murderous cruelty operates and lies ready to act within every one of us.

I just wanted to put it on record that I perceive our only hope – or our one great hope – as residing in art. We must be resolute enough in promoting it. – I was interrupted just as I was detecting something like hope in the very realization that this cruelty is present in everyone – as if this very fact could be the starting-point of betterment, a key to the possibility of doing something.

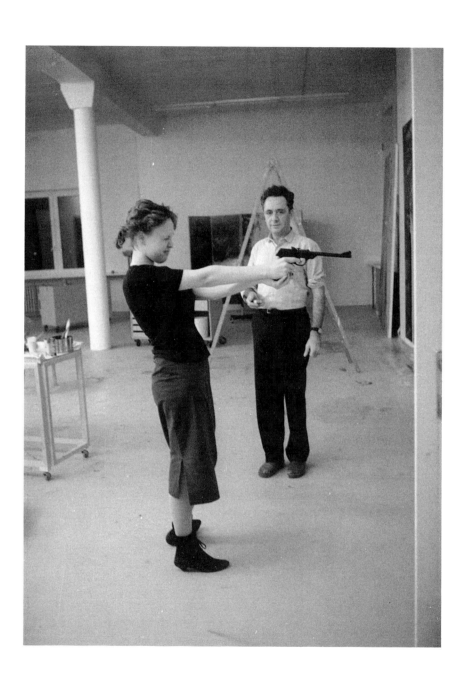

126 With daughter, Betty Richter, 1984

18 March 1986. Formalism stands for something negative: contrived stuff, games played with colour and form, empty aesthetics.

When I say that I take form as my starting point, and that I would like content to evolve out of form (and not the reverse process, whereby a form is found to fit a literary idea), then this reflects my conviction that form, the cohesion of formal elements, the structure of the phenomenal appearance of matter (= form), generates a content – and that I can manipulate the outward appearance as it comes, in such a way as to yield this or that content.

I have only to act in accordance with the laws and conditions of form in order to get the materialization right.

In this effort I am first of all supported by music (Schoenberg and all other pure music evolves out of its own laws, and not out of the effort to find a form for a specific statement); and, secondly, I find the essential confirmation in Nature, which produces material changes without any intention (or cause) related to content, but takes on this or that form in accordance with its own preconditions. The more complicated this process is, the more functional Nature's 'contents', qualities, capabilities become. The issue of content is thus nonsense; i.e., there is nothing *but* form. There is only 'something': there is only what there is.

21 March 1986. The 'messages', and therefore the content. (Almost) always, when painters 'communicate', they illustrate and give visual expression to their own stupidity. Their messages are always distressing, boring, untruthful, botched, abject and aggressive (prize specimens: Kucki, Kia and Klemente*). The sole exception here is Beuys, and he too is at his best, and at his most effective, when the 'message' is impossible to read off direct – as for instance in *Lightning Stroke**,* which is anything but the illustration of a flash of lightning (a very great work).

* Enzo Cucchi, Sandro Chia, Francesco Clemente.
** *Blitzschlag mit Lichtschein auf Hirsch (Lightning with Stag in its Glare)*, 1958–1985.

But otherwise this Message Art is stupid in three separate ways. The events dragged in by the scruff of the neck are of unspeakable, hopeless inanity in themselves; this is logically matched both by the brazen stupidity of the 'painterly presentation' of those events and by their cockily idiotic captioning; and, lastly, unsurpassable stupidity becomes total when it blocks the awareness, even the surmise, that painting, if it is ever to contribute anything at all, must be the very polar opposite of all such messagecraft. And this threefold, shrieking stupidity is actually exceeded by the stupidity of those who promote it.

28 March 1986. I am a materialist on principle. Mind and spirit, soul, volition, feeling, instinctive surmise, etc., have their material causes (mechanical, chemical, electronic, etc.); and they vanish when their physical base vanishes, just as the work done by a computer vanishes when it is destroyed or switched off.

Art is based on these material preconditions. It is a special mode of our daily intercourse with phenomena, in which we apprehend ourselves and everything around us. Art is therefore the pleasure taken in the production of phenomena that are analogous to those of reality, because they bear a greater or lesser degree of resemblance to them. It follows that art is a way of thinking things out differently, and of apprehending the intrinsic inaccessibility of phenomenal reality; that art is an instrument, a method of getting at that which is closed and inaccessible to us (the banal future, just as much as the intrinsically unknowable); that art has a formative and therapeutic, consolatory and informative, investigative and speculative function; it is thus not only existential pleasure but Utopia.

21 April 1986. This plausible theory, that my abstract paintings evolve their motifs as the work proceeds, is a timely one, because there is no central image of the world (world view) any longer: we must work out everything for ourselves, exposed as we are on a kind of refuse heap, with no centre and no meaning; we must cope with the advance of a previously undreamt-of freedom. It also conforms to a general principle of Nature; for Nature, too, does not develop an organism in accordance

with an idea: Nature lets its forms and modifications come, within the framework of its given facts and with the help of chance. And this theory is no less useless than ludicrous, if I paint bad pictures.

25 April 1986. 'If art stands aloof from progress and ... eschews ideas as well as ... theories, then it can recapture the degree of spontaneity, and naivety, and presence of mind, which it needs as a fish does water, in order to become a reality that exists of its own accord' (wrote Heinz Friedrich). At first sight, I admittedly satisfy the demands of this dictum, which is loathsome to me (I never was 'modern', or 'radical', never subject to any definition of art). But the dictum is wrong, whichever way you look at it. Either there has never been any progress in the history of humankind (or beyond), which would be an absurd assertion, or there is no progress now either, in spite of the apparent and real retrogressive nature of today's art, which acts either post-modern or trivial or snot-stupid. What offends me most of all is the slack apathy of such people, who ultimately regret only the loss of a centre, and who are too comfortable to give up the apparent pleasures of a corrupt and cretinous ersatz art. Art today – or so goes the party blather that has replaced the collective celebration of existence – is the new spontaneity and naivety that we have. (I must break the habit, I must never read that sort of thing again, I must never look at a modern exhibition, above all I must throw away all those invitations unread.)

12 October 1986. What shall I paint? How shall I paint?
'What' is the hardest thing, because it is the essence. 'How' is easy by comparison. To start off with the 'How' is frivolous, but legitimate. Apply the 'How', and thus use the requirements of technique, the material and physical possibilities, in order to realize the intention. The intention: to invent nothing – no idea, no composition, no object, no form – and to receive everything: composition, object, form, idea, picture. Even in my youth, when I somewhat naively had 'themes' (landscapes, self-portraits), I very soon became aware of this problem of having no subject. Of course, I took motifs and represented them, but this was mostly with the feeling that these were not the real ones, but

imposed, dog-eared, artificial ones. The question 'What shall I paint?' showed me my own helplessness, and I often envied (still do envy) the most mediocre painters those 'concerns' of theirs, which they so tenaciously and mediocrely depict (I fundamentally despise them for it).

In 1962 I found my first escape hatch: by painting from photographs, I was relieved of the need to choose or construct a subject. I had to choose the photographs, of course; but I could do that in a way that avoided any commitment to the subject, by using motifs which had very little image to them and which were anachronistic. My appropriation of photographs, my policy of copying them without alteration and without translating them into a modern form (as Warhol and others do), represented a principled avoidance of the subject. This principle has been maintained, with few exceptions (doors, windows, shadows, all of which I dislike), to this day. Grey Pictures, Colour Charts, Inpaintings, small abstracts (so full of planned arbitrariness as to be equally message-free), 'soft' abstracts which borrowed the non-subject from the small abstracts and used blurring and enlargement to create a variant of Non-Showing. The same goes for the big abstracts; and in contradiction of this there is always the intention, the hope, of getting a subject handed to me on a plate, as it were: one not invented by me, and for that reason more universal, better, less perishable, more generally valid. Of course that is not true, since I am continually composing and above all deleting (i.e., avoiding), and I restrict myself to a very small repertoire, which is to say that I act very deliberately. Then there is the relationship with music, in my constant efforts to create a structure in musical terms and a varied instrumentation. All these failures! It is a wonder to me that the pictures ever do show the occasional flash of distinction, because basically they are all lamentable displays of incapacity and failure (failure in the attempt to overcome this incapacity). But it is also untrue that I have nothing specific in mind. As with my landscapes: I see countless landscapes, photograph barely 1 in 100,000, and paint barely 1 in 100 of those that I photograph. I am therefore seeking something quite specific; from this I conclude that I know what I want.

25 October 1986. These continuing difficulties. A constant work crisis that has lasted for decades, in fact ever since the start. Crisis personified. (Perhaps I am mistaken here; perhaps this is a perfectly normal way to work.)

Interview with Benjamin H. D. Buchloh, 1986

Did you know the history of the twentieth-century avant-garde, before you came to West Germany in 1961? What did you know about Dadaism and Constructivism – and in particular Duchamp, Picabia, Man Ray, Malevich? Was all this a great discovery, as soon as you arrived – or was it a gradual and uncontrollable process of absorption and learning?
The latter, really; an uncontrolled and gradual learning process.
I knew nothing: neither Picabia nor Man Ray nor Duchamp. I only knew artists like Picasso and Guttuso, Diego Rivera and of course the classics down to the Impressionists, because everything after that was denounced in the GDR as bourgeois decadence. And in that state of naivety I went to the *documenta* in Kassel in 1958 and was enormously impressed by Pollock and Fontana.

Can you remember what particularly interested you about Pollock and Fontana?
The sheer brazenness of it! That really fascinated me and impressed me. I might almost say that those paintings were the real reason why I left the GDR. I realized that there was something wrong with my whole way of thinking.

Can you enlarge on the word 'brazenness'? It has connotations of morality; surely that's not what you mean.
But that is what I mean. I lived my life with a group of people who laid claim to a moral aspiration, who wanted to bridge a gap, who were looking for a middle way between capitalism and Socialism, a so-called Third Path. And so the way we thought, and what we wanted for our own art, was all about compromise. In this there was nothing radical – to use a more appropriate synonym for 'brazen' – and it wasn't genuine, either, but full of false deference.

Deference to whom or to what?

To traditional artistic values, for instance. I realized, above all, that all those 'slashes' and 'blots' were not a formalistic gag but grim truth and liberation; that this was an expression of a totally different and entirely new content.

Did you always see the causes as inner and existential, rather than as formally inevitable, or as the next steps in a long evolutionary process rooted in the earliest decades of the twentieth century, or as responses to painterly problems? Was that way of thinking totally alien to you?

Yes, and it still is.

That's why I asked about your knowledge of the first generation of avant-garde artists, from 1915 to 1925 or thereabouts. You said practically non-existent; and the same goes for many artists of your generation. It had to do with universal repression of the past, the Second World War, and many other issues besides. The same went for the American artists, who had no direct experience of Fascism or the Second World War on their own home ground. They misunderstood and repressed Dada and Constructivism just as much as the Europeans did. And, if you say that Fontana and Pollock were the first who touched you so powerfully that they almost prompted you to leave the GDR, who was the next influence in this learning process? Was it Rauschenberg or Johns, or was it Yves Klein and Manzoni?

It was a slow process, of course, and for the time being I was mainly interested in transitional figures, who seemed less radical to me: Giacometti, Dubuffet and Fautrier, for instance.

Fautrier – can you reconstruct what interested you about him?

The impasto, the painterly messiness, the amorphous and material quality.

So it could be said that what interested you was the anti-artistic impulse in painting. The same applies to Fontana and Pollock, doesn't it?

Yes, everything that tried to break with the past.

And Tàpies?

I have always found him too decorative.

Too little existential weight?

None at all, to speak of; and it shows now more than ever.

There's a bit of a contradiction here. Earlier, you said that Pollock and Fontana were really important, because they conveyed a sense of crisis, because they carried an existential weight. I tried to bring that down to the formal level, and you couldn't accept that. Which clearly means that you must have had a specific synthesis in mind from the outset, as to what meaning the practice of painting can have, and as to how it can have meaning. A synthesis well outside the conventions, as they were then defined. So you attached more importance to everything that was strongly radical in formal terms, everything that was not literary or narrative or symbolic.

Yes, because it had more to say to me.

How about the artists of the New York School, in the early 1960s? Did you see works by Barnett Newman and Willem de Kooning at the same time as Jackson Pollock?

Hardly at all. Palermo introduced me to some of the work, a bit later. Maybe at the very end of the 1960s. Then I saw, among other things, paintings by Morris Louis, which were very highly thought of.

By you?

No, I found it quite impressive that someone should just be letting paint trickle down in this way, but I didn't think highly of it.

And Kenneth Noland?

I got no more out of him. What amazed me was more the fame of these people.

Did you ever wonder how it came about that American painters interested you more than any Europeans, let alone Germans?

No, I took it for granted that Germany could be written off. With a past like that.

And what about the past before the Nazi period, why was that not worth discussing?

I knew nothing about it.

Did you make any attempt to find out about the history of the German avant-garde?

No, or only very superficially.

Do you now see that as an issue? Does it now surprise you that Schwitters was never or hardly ever mentioned at that time? There were

German artists, after all, great German artists who belonged to the
avant-garde.

I came to them by way of Rauschenberg, Schwitters included.

*Everything that got absorbed during the 1950s and 1960s; the way the
West German artistic landscape was reconstructed after it had been
reduced to provincial status by war and Fascism – all this was a highly
artificial reconstruction, as we've just seen. The most important German
avant-garde artists fell outside its scope altogether: Schwitters, Hannah
Höch and John Heartfield were forgotten, as was the whole of German
Dadaism. Reconstruction went by way of Paris painting and American
painting. That is what the whole of the German Informel is based on,
dismal as it is – and that's how the foundations of Modernism in
Germany were relaid. That was the situation you found when you
arrived.*

Which is my basis.

*First you see the American Rauschenberg, then you discover the
German Schwitters through the American. That's an interesting paradox.*

Yes, but I don't think it's that bad. And I don't regard Schwitters as the
innovator and Rauschenberg as the exploiter.

*That's not the point, The point is whether it means anything. Did you
also see any Twombly in the early 1960s, and did that interest you?*

Yes, certainly.

As much as Rauschenberg?

Almost.

*And the equivalent to Rauschenberg in the European context,
Nouveau Réalisme and Décollage – to leave Yves Klein right out of
it for the moment – had no comparable importance for you? You didn't
know the Décollage people?*

Yes, I knew them all right. I thought they were interesting, but a bit
old-fashioned.

Old-fashioned in what way? Old-fashioned like Schwitters?

Maybe. The technique seemed so old-fashioned to me.

*How come? It seems more radical than painting, if someone sets off
down the street and tears great strips off the posters on the walls and
declares that to be his work.*

Maybe it was jealousy, because I'd never thought of anything like that myself, and 'invention' was very much in the air then.

And how did you relate to Manzoni at that time?

Badly. I didn't like him. And least of all his 'Artist's Shit'. As far as I'm concerned, that's just about as funny as selling cans with 'Berlin Air' in them.

Or was it too radical for you, all of a sudden? Earlier on, you valued the brazenness of Pollock and Fontana. It even seemed to be a factor in your move to the West. Did Manzoni go too far?

He didn't go far enough. He got no further than the joke stage. It was only a commentary. And he wasn't painting.

Duchamp and Fluxus, Warhol and Pop Art

And what was your knowledge of Duchamp at that time?

It evolved very slowly – through Beuys, in fact. I saw the Duchamp exhibition in Krefeld in 1963, which reminded me of Beuys, and that was when I really began to get interested in Duchamp.

Jürgen Harten writes that your Four Panes of Glass *of 1967 bear relation to Duchamp, and that you therefore had no knowledge of him at that time. I find this hard to believe.*

It's really hard to say. I do know that I didn't know the *Large Glass* at that time; but it may be that I had repressed the knowledge of it so thoroughly that I could make my *Four Panes of Glass* with a clear conscience. And with hindsight I can say that my *Panes of Glass*, like the *Nude on the Stairs* [*Ema*, 1966], involve something of an anti-Duchamp attitude, because they are so plain and deliberately uncomplicated.

When did you first see any Pop Art? Did you go to the Amsterdam Pop exhibition, or did you see Pop at Ileana Sonnabend's in Paris?

The first Pop Art I saw was shown me in reproduction by Konrad Fischer. It was a cooker, painted by Lichtenstein. And then something by Warhol, not quite so extremely anti-art as Lichtenstein, or so I thought then.

That was in 1963–64?

In '63 or '62. And then we went over to Ileana Sonnabend's, to present ourselves with our portfolio as the 'German Pop Artists'. That was when we first saw originals by Lichtenstein.

So then Lichtenstein was suddenly more important to you than Rauschenberg?

Yes, and that went on until later, when he became rather vacuous and decorative. The important artists to me then were Lichtenstein, Warhol and Oldenburg.

Can you go into more detail, as to why they were important to you? Did it have something to do the isolation of the object, as against the complicated context in Rauschenberg?

Rauschenberg was too artificial and too interesting. He hasn't got that astonishing simplification.

Instead of a complicated composition, such as you still have in Rauschenberg, which is still practically tied to the collage principle, an object in Lichtenstein or Warhol is presented as an isolated object, like a Readymade.

Yes.

How about technique? Were you attracted by that perfectionist technique of Lichtenstein's?

Yes, very much so, because it was anti-painterly. It was directed against 'peinture'.

So did you see your relationship with Duchamp in terms of a rediscovery through Lichtenstein and Warhol?

You mean the Readymade quality? Certainly. But Duchamp also painted a very beautiful *Nude Descending a Staircase*.

Which you saw in Krefeld?

No, much later on, in Paris. But I knew it from reproductions. A very beautiful painting, and utterly traditional.

In terms of technique, but not in terms of the object.

In terms of the object too. It is a nude, for all the Cubist/Futurist handling.

It's a bit of a mystery to me, why you say 'Lichtenstein and Warhol, yes, but not Johns.' The distinction must lie in the manner of painting. Which means you're adopting a critical view of Warhol's and Lichten-

stein's technique too. What was it that you didn't like about Johns? Was it the complicated technique, the artistry?

Yes, because Johns was holding on to a culture of painting that had to do with Cézanne, and I rejected that. That's why I painted from photographs, just in order to have nothing to do with the art of 'peinture', which makes any kind of contemporary statement impossible –

But when Warhol started to have his pictures done more or less anonymously, in silkscreen, that must have seemed like a slap in the face to you. This was a threat to your survival, for someone to demonstrate all of a sudden that painting is being supplanted by technology. It undermined the point of all painterly techniques, however radically simplified.

Maybe I was just admiring something that I can't do – something I'm in no position to do. The same thing happened with the Minimalists, who were also doing something I was in no position to do.

Have you ever tried leaving a photograph as a photograph, in other words adding the pictorial quality just by enlarging it, blurring it and manipulating it in that sort of way?

Rarely, and it only ever worked if it was a photograph of a painting.

The theoretical implications that were read into Warhol, his radical opening-up of the definition of art, his anti-aesthetic position, of a kind that hadn't existed since Duchamp, were also present as a characteristic of Fluxus. It must have attracted you very much at that time?

Yes, it attracted me very much; it was really vital to me. Fluxus above all.

There are contradictions here that are hard to understand. On the one hand you were attracted by Fluxus and Warhol, but on the other hand you're saying 'I couldn't do that; all I wanted to do and all I could do was paint.' You align your own painting with this anti-aesthetic impulse, and at the same time you maintain a pro-painting position. To me this seems to be one of the entirely typical contradictions out of which your work has essentially evolved.

Yes, it is curious, but I don't actually find it contradictory. It's rather as if I were doing the same thing by other means, means that are less spectacular and less advanced.

So the negation of the productive act in art, as introduced by Duchamp and revived by Warhol, was never acceptable to you?
No, because the artist's productive act cannot be negated. It's just that it has nothing to do with the talent of 'making by hand', only with the capacity to see and to decide *what* is to be made visible. *How* that then gets fabricated has nothing to do with art or with artistic abilities.

From Malevich to Minimal Art

When did you first encounter the great early abstract painters? Mondrian and Malevich, for example?
In the West, at some point, late on. I don't know.

But they were just as inaccessible to you as Schwitters? It was all a thing of the past, very much more so than the New York School and Rauschenberg were?

Yes, except for Mondrian, whose work I loved at first sight, far more than Malevich and that group.

So, in 1966, when you started to paint non-figurative pictures, Colour Charts, *did that also have something to do with a head-on confrontation with Minimal Art? Was that another conflict situation, a rejection of American dominance, or was it through an evolutionary process of your own, rooted in the immediate, local context here in Düsseldorf? Was it through meeting Palermo, perhaps?*

Yes, it certainly did have something to do with Palermo and his interests, and later with Minimal Art as well; but when I painted my first Colour Charts in 1966, that had more to do with Pop Art. They were copies of paint sample cards, and what was effective about them was that they were directed against the efforts of the Neo-Constructivists, Albers and the rest.

Did you know Barnett Newman's work at that time?

No. But I came to love it later.

So your abstraction was something of an assault on the history of abstraction in Europe?

An assault on the falsity and the religiosity of the way people glorified abstraction, with such phoney reverence. Devotional art – all those squares – Church handicrafts.

And Minimal abstraction – did that interest you?

Yes, that's what turned two or three of the Colour Charts grey.

What about Stella? When did you see his work?

Early on, but it didn't interest me.

Did you see the Black Paintings?

I must have seen them in the 1960s.

Did you feel they were better than Vasarely and Albers?

Oh, yes.

Can you reconstruct that feeling? Why did he leave you relatively cold?

It was all too arty-crafty and too decorative, too elegant and precious.

And his symmetrical compositions didn't impress you at all?

Carpets are symmetrical too.

And Robert Ryman – you didn't see his work until much later?

I saw a first show at Konrad Fischer's in 1970 or so. I thought it was very good.

And why was that better, or different?
Because for the first time it showed *nothing*. It was closer to my situation.

Which artists were most important to you in the late 1960s?
Carl Andre, Sol LeWitt, Bob Ryman, Dan Flavin, Larry Weiner, Walter De Maria and others.

Judd?
Not so much.

And would you say that Carl Andre had an influence on your paintings?
I thought a lot of him. But at that time I was also painting Romantic landscapes.

So the serial quality of your monochrome Grey Pictures has nothing to do with Minimal Art? The Colour Charts are suddenly overtly serial paintings, either serially structured as individual works or serially arranged as a group.

The serial thing had been around since Pop Art. And as for the Colour Charts, especially the late ones, in those I'd tend rather to see the influence of Conceptual Art: the theoretical, didactic dimension. But it all came down to the desperation of not knowing how I could ever arrange colours meaningfully – and I tried to fabricate that, as beautifully and as unequivocally as possible.

Iconography and Photography

Your photo painting of the early 1960s does have an anti-artistic quality; it negates individual handling, creativity, originality. So up to a point you do follow Duchamp and Warhol. And your painting also negates content, by demonstrating that the motifs are picked at random.
But the motifs never were picked at random: not when you think of the endless trouble I took to find photographs that I could use.

So in every case the selection process was highly complex and explicitly motivated? So when I said in the Paris catalogue that the choice of photographs was basically random, that was a highly questionable statement?
Maybe it was a good thing for it to look random.

So what were the criteria by which you chose photographs for your iconography?
Content, definitely – though I may have denied this at one time, by saying that it had nothing to do with content, because it was supposed to be all about copying a photograph and giving a demonstration of indifference.

And now the critics are trying to ascribe to you this iconographical concern with content. Ulrich Loock and Harten talk about a Death Series: the aeroplane stands for death, the pyramid and the accident stand for death. To me it all seems rather forced, this attempt to construct a continuity for the death motif in your painting.
So you think I was looking for motifs that would be just a little bit shocking, while all the time I was totally indifferent to them?

I would agree, in that no selection can ever really be random. Every choice implies an attitude of sorts, however complex and unconscious. But,

144 Studio, Cologne, 1985

*looking at your iconography in the 1960s, I find it very difficult to read
into it a consistent theme of death. The* Eight Student Nurses, *all right;
but then there are the* 48 Portraits. *It's irrational to read a death theme
into those. What have the Chile paintings got to do with the Pyramids?
Or what have the Townscapes to do with the Mountain Landscapes? The
iconographical elements can all be connected, but not in the sense of a
traditional iconography, where you say: 'That's a death theme.' To me
it seems utterly absurd to try to construct a traditional iconography for
your painting.*

Maybe it is just overdoing it a little to talk about a death theme. But
as to whether the pictures have anything to do with death and pain,
I think they have.

*But this feature of content is not the determining, the decisive element
in the selection.*

That I don't know, and I can't really reconstruct my motives now. All
I know is that there were reasons of content why I chose a particular
photograph, and why I decided to depict this or that event.

*In full awareness of the fact that content can no longer be conveyed
through iconic depiction? So this is another contradiction: although you
knew that – for example – a death theme cannot be conveyed through
straight depiction, you nevertheless tried to do just that, knowing full well
that it was impossible.*

For one thing, it isn't impossible at all. A picture with a dead dog in it
shows a dead dog. It only gets difficult if you try to convey something
above and beyond that, if the content gets too complex for straightfor-
ward depiction. But that doesn't mean that depiction can't convey
anything.

*Were you aware of the criteria on which you made your selection?
How did you go about choosing the photographs?*

I looked for photographs that showed my present life, the things that
related to me. And I chose black-and-white photographs, because I
realized that they showed all this more effectively than colour photo-
graphs, more directly, more inartistically and therefore more credibly.
That's why I picked all those amateur family pictures, those banal
objects and snapshots.

What about the Alpine Pictures *and the* Townscapes?
Those were done when I no longer felt like doing the figurative Photo
Pictures, and wanted a change from the unequivocal statement, the
legible and limited narrative. So I was attracted by those dead cities
and Alps, which in both cases were stony wastes, arid stuff. It was an
attempt to convey content of a more universal kind.

*But if you really were concerned with that kind of content, how do
you explain the fact that at the same time you brought nonfigurative
painting into your work? The* Colour Charts, *for instance, or other
abstract paintings, done concurrently with the figurative ones. You were
working on two levels at once, and this confused most of your critical
commentators, who started to see you as a painter who knows all the
tricks and techniques, and who simultaneously discredits and deploys all
the iconographical conventions. At the moment, this makes you particu-
larly attractive to many viewers, because your work looks like a survey
of the whole universe of twentieth-century painting, presented in one
vast, cynical retrospective.*
Now that definitely is a misunderstanding. I see no cynicism or trickery
or guile in any of this. On the contrary, it all seems rather amateurish
to me, the head-on way I've tackled everything, and how simple it is
to read off what I had in mind and what I was trying to do. That's why
I don't really know what you mean by the contradiction between
figurative and abstract painting.

Let me take Table *as an example, one of your earliest paintings.*
Table *already has both elements within it: a totally abstract, gestural,
self-reflective quality on one hand and on the other the function of
depiction. And this is surely one of the great twentieth-century dilemmas:
this apparent conflict, this apparent antagonism within painting between
the functions of depiction and self-reflection. In your painting, the two
run very close together. But aren't they juxtaposed in order to show up the
inadequacy, the bankruptcy of both?*
Not bankruptcy, but always inadequacy.

Inadequacy in relation to what? The expressive function?
In relation to what is expected of painting.

Can that expectation be formulated?

That painting ought to have more effect.

So you would reject the accusation that is so often levelled at you, of cynical complicity with painting's lack of effect?
Yes, I would, because I do know that painting is not without an effect – I only want it to have more of one.

So the simultaneous pursuit of depiction and self-reflection has nothing to do with the two cancelling each other out; and you are just using different means to give substance to what is expected of painting?
Yes, more or less.

So, in the early 1960s you don't see yourself as the heir to a historical dichotomy, a state of fragmentation, in which no strategy is really valid any more.
And I do see myself as the heir to a vast, great, rich culture of painting – of art in general – which we have lost, but which places obligations on us. And it is no easy matter to avoid either harking back to the past or (equally bad) giving up altogether and sliding into decadence.

Which brings you, of course, to the brink of a political argument, which maybe you don't relish. But how would you explain this loss, if not in terms of politics, or social history, or just plain history? The way you put it, it almost sounds like Adorno's famous statement that 'After Auschwitz, lyric poetry is no longer possible.' Does that ring true for you?
No. There is lyric poetry after Auschwitz.

When you say that no one can paint that way any more –
By that I meant first and foremost a specific quality that we have lost.

How?
Photography is certainly one external factor involved in the fact that we've forgotten one way of painting and can no longer produce a certain artistic quality.

It can also be put in entirely functional terms, by saying that – among other things – paintings have lost their descriptive and illustrative function, because photography has assumed those functions so perfectly. The result is that the job is no longer there to be done, and the high artistic quality of old paintings, which you mention, has its material and historical roots partly in those very same descriptive and illustrative functions.

The quality can't be entirely explained away in terms of the illustrative function. All that perfection of execution, composition and so forth would still have been lost to us, even if there had never been such a thing as photography. Literature and music are in the very same mess. People praise Mozart and Glenn Gould to the skies, because the new composers can't offer the same thing any more, even though music hasn't been edged out by anything analogous to photography.

So if the loss doesn't stem from the evolution of reproductive technology, or from the experience of previously undreamt-of historical catastrophes (as Adorno suggests in the sentence I quoted), or from the destruction of bourgeois culture, or from political factors of any kind – and you've rejected all those, at least in passing, as explanations –
No, they all play their part, but I see the basic fact as the loss of the Centre.

In Sedlmayr's sense? You can't be serious?*
Yes, I am; what he was saying was absolutely right. He just drew the wrong conclusions, that's all. He wanted to reconstruct the Centre that had been lost.

And to reconstruct that Centre by using methods and means that were entirely incapable of achieving it. But how do you describe it, if it's so obvious to you?
I've no desire to reconstruct it.

No, but you must be able to describe it. And then it's a historical process after all –
Yes, but there are specific, new, concrete facts which have altered our consciousness and our society, which have overturned religion and therefore changed the functioning of the State. There are only a few makeshift conventions left to regulate the thing, keep it practicable. Otherwise there's nothing there any more.

Is painting one of those conventions?
No. The criteria of painting are conventions – and harmful ones, because they are ideologically defined. They block enlightenment.

* Hans Sedlmayr (1896–1984), Austrian art historian.

That's why I think so highly of psychoanalysis, because it takes away prejudices and turns us into responsible adults, autonomous beings who can act more rightly and more humanely in the absence of authorities, or God, or ideology. So it's a good thing to lose all that.

And you'd want the same for painting?

Yes.

So on one hand you see the process as irreversible, and above all impossible to reconstruct by cultural means –

That would only serve to delay it.

And political means seem to you at best problematic or questionable, or not directly available.

Politics operates more by faith than by enlightenment, so nothing is going to come of that.

But you see the role of art as a more important one than that of simply liquidating a false bourgeois cultural inheritance – though that is one of its functions, isn't it?

Liquidating? Yes, that's part of it.

But at the same time it also has another function, and that's where the contradiction comes in. What is the other function, if not a political one?

Above all, art does more than destroy. It produces something, a different image.

Of autonomy?

Yes.

And how is the painted picture supposed to constitute a model of that autonomy, here and now?

The painting is *one* important, possible way among others, one that can be used. At worst, it's on offer to those who are interested.

About your self-imposed limitation to the practice of painting – when it comes to liquidating the bourgeois inheritance while constructing the new autonomy, isn't that limitation rather a handicap? Shouldn't we suppose that there are other and more radical ways and means that will carry out the liquidation more quickly and thus also make anticipation more fruitful?

No, in this respect I'm extremely conservative. It seems to me like someone saying that language is no longer usable, because it is a

Studio, Brückenstrasse, Düsseldorf, 1983 151

bourgeois inheritance, or that we mustn't print texts in books any more but on cups or on chair-legs. I am bourgeois enough to go on eating with a knife and fork, just as I paint in oil on canvas.

So, all attempts to prosecute one side of the dialectic more rapidly by artistic means seem to you to be unacceptable. Would you retrospectively criticize Duchamp, who gave up painting for this very reason?
I'm not sure that those were his reasons. But you can never take that as a sufficient reason to give up painting. To interpret Duchamp in that way, and go in for politics and criticism instead, is pathetic.

Pathetic in what way? In terms of painting's liquidation of bourgeois culture, or in terms of its capacity for anticipation?
Because it achieves nothing. It's neither artistic nor political action. It's amateur.

To put it in specific terms: would you regard it as a premise of your present-day painting that it remains in the very dilemma you faced from the start: that is, to play off the real facts of mass culture, as you see them in photography, against the esoteric and elitist conditions of high culture, in which you as an artist have a part? And that you base your work on this dialectic, assuming yourself to be exempt from the contradiction;

and that in practice there is no solution that you can accept? Is this still a premise, or did it apply only to the 1960s?
I see no such premise, then or now.

But your quoted statement on Cézanne says just that. When you say: 'I consider many photographs better than the best Cézanne', that seems to express this very contradiction.
Yes, but that doesn't mean that I could ever change anything directly through painting. And it certainly doesn't mean that I could do it without painting.

Why have you so firmly rejected any concrete political intention in your own art?
Because politics don't suit me, because art has an entirely different function, because all I can do is paint. Call it conservative.

But by limiting yourself to the medium of painting mightn't you be espousing not just a conservative position but maybe also a critical dimension? Are you, for instance, calling into question the immediacy claimed by work like that of Beuys?
Naturally, by limiting myself to painting I imply a criticism of a lot of things that I don't like, not all of them connected with painting.

So you don't deny on principle that someone might validly intend to make a critical political statement through art?
I probably do deny it. But what counts is that I have to take as my starting point, my foundation, my own possibilities and my own premises.

Which you say are unchangeable –
Largely unchangeable.

Monochrome Grey Pictures and Abstract Pictures

The Grey Pictures were done at a time when there were monochrome paintings everywhere. I painted them nonetheless.

When you say there were pictures like that everywhere, who are you thinking of? Klein and Kelly?
Not Kelly, but Bob Ryman, Brice Marden, Alan Charlton, Yves Klein and many others.

Paraphrase as a strategy. Was that deliberate?

Not really. I thought I had every right to do it because I was doing it for a different reason, because the paintings have something different to say and also look different. It never occurred to me for a moment that this might be eclecticism.

Although at the present moment in history you have no choice but to be an eclectic.

I don't know. I don't believe that.

Why are your monochrome paintings any different? Because you painted them?

Yes, because I intended something different, because the similarity is merely superficial.

Because you regarded it as a linguistic tradition and not as an intention of your own?

But it is an intention of my own: the intention to use it to convey a different content.

The intention still stands – and so the Abstract Pictures too are intended to convey a content?

Yes.

They're not a negation of content, not painting-as-fact, not an ironic parody of presentday expressionism?

No.

Not a perversion of gestural abstraction? Not irony?

Certainly not! What kind of questions are these? How can my pictures be devoid of content, and what is this content that the Abstract Expressionists are supposed to have had as distinct from me?

They painted with a different intention in mind. Rothko, for example: he uses thinning and grading of colour to create an illusion of space, which is not simultaneously negated – as it is with you – but really represents depth, mist, shimmering, transcendence. And then, in Rothko's work, colour combination is an important element: that is, two or at most three shades or colour values are juxtaposed in a very precisely calculated, differentiated way, so that the combination generates a par-ticular colour harmony, which is then supposed to produce a specific emotional effect.

In my work the principle's the same; it's just that different means are used to achieve a different effect.

No, because if the ability of colour to generate this emotional, spiritual quality is presented and at the same time negated at all points, surely it's always cancelling itself out. With so many combinations, so many permutational relationships, there can't be any harmonious chromatic order, or composition either, because there are no ordered relations left either in the colour system or in the spatial system.

I can't see it as a situation where composition and relationships have disappeared. When I place one colour-form next to another, then it automatically relates to that other.

Yes, but there are differently structured forms and laws governing relationships, right through to the realization that even total negation is a composition. But everything in your Abstract Pictures aims at abolishing traditional, relational forms of order by showing the potentially infinite variety of structurally heterogeneous elements.

Yes, but even so I still have to get all that into the right context. A context that always gets harder and harder, the more advanced a picture gets. It all starts out easy and unspecific, but gradually a context starts to take shape, and this has a coherence that is the utter opposite of randomness.

Yes, of course, but then that's a different kind of perception, and so a different form is generated – in some cases an antithetical one.

It may well be. What always is antithetical is my method, or the anticipation that as it were impels me to paint.

And what do you anticipate?

That something is going to come, which I do not know, which I have been unable to plan, which is better and wiser than I am, and which is also more universal. More directly, I tried to do that in the one thousand or four thousand colours, in the anticipation that a picture would emerge.

What sort of picture?

One that presents our situation more accurately; one that has more truth in it, one that has something of the future in it, so can also be interpreted as a project, a design – and more besides. Not didactic, not

logical, but rather free and – however complicated – also effortless in appearance.

That's what your paintings have at their best; they seem not to try too hard, but to be produced with verve, indifference and virtuosity. But – to revert to the issue of content for a moment – how can you say that the palette-knifed surface on this painting here doesn't stand for process or materiality as such, when the painting itself has been made with such obvious emphasis on the process of its making? If you weren't interested in these qualities, you surely wouldn't use the palette knife in this way, depriving the colour, composition and structure of the painting of any possibility of generating a meaning beyond the bare materiality of the picture. It seems to me that you introduce process-related painting as just one of painting's many possibilities, while not insisting, as Ryman did, that this is its only aspect. It's one aspect among others.

Then why should I go to such lengths to make it so varied?

Because you're setting out to call off all the aspects there are, like a catalogue; because you're really trying to pursue both a rhetoric of painting and the simultaneous analysis of that rhetoric.

If all this were just a display of matter – the way the yellow, tatter-edged area rises up against the blue-green background – how could it tell a story or set up moods?

A mood? You mean it really sets up an emotional experience?

Yes, and aesthetic pleasure, too.

That's something different. Aesthetic pleasure I can see, but absolutely not a mood.

So what is a mood?

A mood has an explicitly emotional, spiritual, psychological quality. That's exactly what is there.

Fortunately only in the weakest parts.

Surely you don't think that a stupid demonstration of brushwork, or of the rhetoric of painting and its elements, could ever achieve anything, say anything, express any longing.

Longing for what?

For lost qualities, for a better world – for the opposite of misery and hopelessness.

The longing to be able to present culture as a contemplative spectacle without losing credibility?
I might also call it redemption. Or hope – the hope that I can after all effect something through painting.

Again, this is all so generalized: effect in what sense? Epistemological, emotional, psychological, political?
All at once. I don't know.

So if you maintain that art can have this function – something that other artists would deny absolutely – then it's all the more of a paradox that you simultaneously insist on being able to do it only with the means of painting. Or, to put the question another way: do you believe that this dichotomy is concretely visible in your paintings?
Yes, possibly.

Do you believe that these are ultimately conservative paintings, conservative in the sense that Broodthaers' art seemed conservative?
In terms of the means – oil on canvas – even more conservative. I knew Broodthaers, and I had a lot of time for him, but I never really

understood his pictures. Conservative – I certainly don't intend to be, and I also know that painting *per se* does not have to be conservative. So I can carry on in the same way, just better if possible.

The question is, how far can this schizophrenia be stretched, how far can it really be kept alive, or when does it become an empty pose: to assert this contradiction over and over again, and to act within the contradiction again and again, but without trying to get over the contradiction?

I don't know what contradiction you're talking about.

It's the contradiction of knowing full well that the means you are using won't achieve what you aim for, and at the same time not being prepared to change those means.

That's not a contradiction, it's a perfectly normal state of affairs. The normal mess, if you like. And that couldn't be changed by choosing different means and methods.

Because all means are of equal value?

No, but all similarly inadequate. The question is, what are my means, and what can I achieve with them?

But under certain historical conditions painting had different functions, and had a possibility of having an effect on its contemporary context.

If I'm thinking of political painting in our time, I'd rather have Barnett Newman. He painted some magnificent pictures.

So it is said. But magnificent in what way?

I can't describe it now, what gets to me in them – I believe they're among the most important paintings of all.

Perhaps that's a mythology that needs re-examination. Precisely because it's so difficult to describe; and because, in the encounter with paintings, acts of faith are not enough.

Acts of faith are unavoidable. They're part of us.

Do your paintings invite acts of faith, or analyses? Which matters more to you?

Either would be fine with me. In your case they invite you to analyse, others find them an invitation to perform acts of faith.

So you would be quite happy if – as Rothko demanded for his own

work – someone were to fall on their knees in front of one of your paintings and burst into tears?

Unfortunately painting can't produce such an effect. Music is better off in this respect.

Chance and open form

What part does chance play in your painting?

An essential one, as it always has. There have been times when this has worried me a great deal, and I've seen this reliance on chance as a shortcoming on my part.

Is this chance different from chance in Pollock? Or from Surrealist automatism?

Yes, it certainly is different. Above all, it's never blind chance: it's a chance that is always planned, but also always surprising. And I need it in order to carry on, in order to eradicate my mistakes, to destroy what I've worked out wrong, to introduce something different and disruptive. I'm often astonished to find how much better chance is than I am.

So this is the level on which openness is still thinkable and credible in real terms? Chance?

It introduces objectivity, so perhaps it's no longer chance at all. But in the way it destroys and is simultaneously constructive, it creates something that of course I would have been glad to do and work out for myself.

But you don't take that personally any more? You don't regard it as a failure on your part? You see it as a generalized factor?

No, I now see it as a generalized factor, something entirely positive. Jacques Monod's *Chance and Necessity*, and all sorts of other facts and reflections that have evolved on the subject, all confirm me in that.

Would the same principle apply to the structure of the work itself, its apparent repeatability, the apparent arbitrariness and openness of every individual painting? Is there a structural analogy to the structure of chance, in the fact that the work itself – like the separate work clusters – has no closed quality left but appears totally open?

Possibly; and, if we disregard the closed quality that every picture has

to have – if it is not to be a random detail of something else, or just plain unfinished – then nonclosure may perhaps be a positive quality, because it relates more closely to our reality.

Then it might be said that the compositional structure, in its openness, is the other dimension of a still-credible, substantive Utopian factor?
That may be so. Especially because so many paintings nowadays look so stupid precisely because they lay claim to being closed works. That's the deception.

Yes, and I find this open dimension in very few artists. It's the radicalism that leads the artist to run the risk of ending up with a work that looks unfinished, infinitely reproducible and internally repetitive.
The only paradoxical thing is that I always set out with the intention of getting a closed picture, with a proper, composed motif – and then go to great lengths to destroy that intention, bit by bit, almost against my will. Until the picture is finished and has nothing left but openness.

The fiction of an openness, a total openness, just as the use of chance is not real but a fiction of chance.
I can only hope that I haven't lost my naivety, and that I shall go on making all the same effort – which is actually quite superfluous.

What about colour – I mean, can the involvement of chance be extended to colour relationships, the colour scheme? Up to now, we have only talked about the compositional order, but I'd say that the same principle defines the relations between colours.
Not to the same extent. It sometimes happens that I mix the paint for a particular painting and then put it onto another – and this has hardly ever turned out to be a mistake. But this is really an unconscious strategy that I can use to outwit myself.

In the permutational colour paintings, you worked on a logical, consistent, random basis. There it was the form that was laid down in advance, and here in the abstracts it's largely the colour. And in contrast to the systematic manner of the Colour Charts, the permutations in the Abstract Pictures emerge naturally.
Yes, chance is natural too, and it's an element that modifies.

This freedom of colour, or this apparent arbitrariness of colour, as found in your Abstract Pictures, never appears in Neo-Expressionism,

where the colour is always still regulated by aesthetic preconceptions,
representational functions and harmonic compositions.
Yes, that's right.

The rhetoric of painting

What about the objectivization of the process of painting itself? You paint
your big pictures not with an artist's brush but with a decorator's brush:
isn't this all part of the anonymization and objectivization of the painting
process, along with permutation and 'chance', colour relations and com-
positional organization?
Certainly not.

The change in the instruments of production doesn't imply that the
production of painting is once more critically called in question?
It changes the pictures only in one respect: they get louder; they are
not so easily overlooked.

I was talking about the instruments – that is, the instruments also influence the perception of the picture. The fact that a monochrome was painted with a roller decisively influences the perception of the work. And in these big paintings here, where the brushstrokes suddenly turn into a decorator's brushmarks, they take on a new dimension that I would describe as a quasi-mechanical or anonymous quality.

No, not in this case. A brush is a brush, whether it's five millimetres wide or fifty centimetres.

So, in the two yellow Strokes, *their giant size doesn't add a new dimension?*

That's something different again – they only look like two strokes of a giant brush. In reality they were painted with a lot of little strokes. Here, on the other hand, it's all genuine, so to speak.

But here in the two big paintings a new dimension comes in, not only through the sheer size but also through the fact that the techniques and the act of painting have been carried to the limits of the possible.

The physical limits?

Yes, but also the limits of the perceptibility of the act, as an act of painting. And there another dimension opens up in practical terms. A dimension that is not regarded as subjective.

These are just as subjective as the small ones; they're just spectacular, that's all.

Spectacular they certainly are, even in a small format. In my catalogue text, I tried to describe how in your abstract painting the system is always 'on show', as it were – that they always have a certain declamatory, rhetorical quality. One always gets the feeling that you're showing the various possibilities just as possibilities, so that they simply stand alongside or against each other, without performing any other function.

Like making a speech that doesn't mean anything?

Yes –

A speech full of eloquence and uplift, which everyone falls for because it sounds good, which fulfils all the formal requirements of a speech and actually communicates nothing?

It doesn't sound good if you describe it that way, but you could put

it differently, by saying that someone is delivering a powerfully emotive speech in order to give an analytical presentation of the resources of language, emotive persuasion and rhetoric. That is, you are making the spectacle of painting visible in its rhetoric, without practising it.

And what would be the point of that? That's the last thing I'd want to do.

You don't see the Abstract Pictures – in the way I have tried to outline – as a kind of reflection on the history of painting, although that's precisely what distinguishes them from all other abstract and gestural painting known to us. They not only have the rhetorical quality but also a quality of reflection on what used to be possible, reflection at the very moment when it can no longer be made use of. And I can imagine some viewers supposing that you're still earnestly practising what once was possible.

That would apply rather to the landscapes and some of the photo paintings, which I've described on occasion as cuckoo's eggs, because people take them for something they aren't. And that was a part of their popularity – a popularity which I thoroughly approve of, on principle, and which has now totally changed. Now it's genuine, so to speak.

That would make them parodistic paintings. But the astonishing thing is that there's no parody in them.

They have a perfectly normal kind of seriousness. I can't put a name to this, so I always see them as musical. And in the structure there's a lot that reminds me of music. It's self-evident to me, but impossible to explain.

That's one of the oldest clichés that people resort to, when they are trying to find a firm footing amid the desolation of abstract painting.

That may well be. But I mentioned music in order to argue against something.

Against a catalogue of the rhetorical possibilities of painting?

I see no point in enumerating the old, lost possibilities of painting. To me, what counts is to say something; what counts is the new possibilities.

But reflection on rhetoric as a specific system of language is a highly important method, especially in present-day literary criticism. That

means that people have suddenly realized the importance of looking at the linguistic conventions and the rhetorical laws behind utterances that have hitherto been examined only for their content.

Then it's just a private aberration on my part, if I always want to do something different from what I did before?

Perhaps it's not an aberration but a private dilemma, a gap between possibility and aspiration, and even so an important aspect of your work. If you were just a rhetorician, in the sense of an analytical exploration of the rhetoric of painting, there would be nothing particularly interesting about it. That's work that other people can do.

But if you refuse to see this as a rhetoric of painting, how would you define the details of the pictorial elements themselves? When one takes a look at the way elements of surface, line and colour are juxtaposed in an artificial enumeration, and with this declamatory quality, or how specific techniques of the application of colour are set out for all the world like a catalogue – some with a palette knife, some with a decorator's brush, some with an artist's brush, some smeared, some as direct traces, some as

clouds of mist — there is something systematic about it all. As you were saying, it's all very well pondered and prepared, including enumeration, juxtaposition and combination.

As a whole and in every detail, its effect is emotional. It sets up moods.

That was the hard thing to figure out — whether it did, and, if so, what moods — when I said that the paintings curiously enough evoke no associations.

They do set up associations. They remind you of natural experiences, even rain if you like. The paintings can't help functioning that way. That's where they get their effect from, the fact that they incessantly remind you of Nature, and so they're almost naturalistic anyhow.

But of course that then has to be defined. Not naturalistic in relation to Nature?

Only in relation to Nature, that's all we have.

The fact that Nature appears to you as the only analogy or model that is ordered without a hierarchical structure — that you can't visualize a Utopian construct of a society that would match this ideal of Nature — that is the Romantic element in your thinking.

That's not the Romantic element. It has to do with the division of labour. Some people design model societies, some design paintings, each to the best of his ability.

That's not a direct answer to my question: why Nature to you is the only Utopian dimension of non-hierarchical experience; why it is unthinkable for you to argue or discuss your idea of a non-hierarchical existence in social terms; why you can only fall back on the metaphor of Nature, like a Romantic.

No, like a painter. And I don't argue in social terms, because I want to make a picture and not an ideology. And what is good about a picture is never ideological but always factual.

That's just what I see in the way colour is treated like a material process; in the way colour becomes an object that is presented and modified by means of these instruments, remaining constant within these various structures and showing how it was made and what instruments were used in its making; and in the way there is practically no external reference to motivate the generation or the structure of the colour. These

are all self-referential phenomena. Does this reading seem too narrow to you?

Yes, because all this effort is not there for its own sake; it is justified only if it takes all these wonderful methods and strategies and then actually produces something.

What?

A picture, and therefore a model. And if I now think of your interpretation of Mondrian, in which pictures can partly be interpreted as models of society, I can also see my abstracts as metaphors in their own right, pictures that are about a possibility of social coexistence. Looked at in this way, all that I am trying to do in each picture is to bring together the most disparate and mutually contradictory elements, alive and viable, in the greatest possible freedom. No Paradises.

Text for catalogue *Beuys zu Ehren*, 1986*

In 1962 I saw a young man in the Düsseldorf Academy wearing jeans, a waistcoat and a hat; I thought he was a student, and discovered that this was the new professor, that his name was Beuys, and that he did very interesting and somehow different things.

Soon after that, in a cowshed somewhere out beyond Kleve, I saw my first Beuys exhibition. I was amazed, dumbfounded, impressed – although my own affinities were with a different and far more 'official' art (Fontana, Pollock, Newman, Fautrier and the rest), which seemed to me to operate as if within a protective order, an unspoken consensus. With Beuys it was always different: he unsettled me, because he didn't play by the rules. He followed different criteria and employed different strategies; he was working for an 'expanded definition of art', which was not so much a protection as a challenge; a challenge to me too.

* Städtische Galerie im Lenbachhaus, Munich, 16 July to 2 November 1986.

Seventy artists invited to contribute one work each to an act of homage to Beuys: In the absence of any further theoretical or aesthetic conception, this is going to present a disparate picture. It is therefore going to look like a bad exhibition.

Beuys was highly critical. The customary, specialized divisions of art were always too narrow for him, and the usual collective exhibitions were more of an instrument than an opportunity to fit in. – It seems that Beuys welcomed the idea of this exhibition. To me, it is one more patient and impatient attempt to overcome the helplessness of art, and I am taking part mainly because I hold Joseph Beuys in high esteem, and with him all those things that his name stands for: humanity, art, intelligence, courage and love.

Notes, 1988

3 January 1988. Art is the pure realization of religious feeling, capacity for faith, longing for God.

All other realizations of these, the outstanding human qualities, abuse those qualities by exploiting them: that is, by serving an ideology. Even art becomes 'applied art' just as soon as it gives up its freedom from function and sets out to convey a message. Art is human only in the absolute refusal to make a statement.

The ability to believe is our outstanding quality, and only art adequately translates it into reality. But when we assuage our need for faith with an ideology, we court disaster.

7 January 1988. My profound distaste for all claims to possess the truth, and for all ideologies – a distaste which I have often expressed, with varying degrees of skill (and which has shown itself so clearly in my

pictures, in my way of working, in my whole attitude, that I myself
have repeatedly ascribed it to an innate lack of structural capacity, or of
courage, or of strength, or of the formal impulse, or of potency, or of
creativity) – this now receives confirmation from such people as the
physicist Dürr, the evolutionary scientist Riedland, and Konrad Lorenz,
who say that our sole hope of survival lies in the 'gropings of human
self-doubt': in our awareness of our own limitations. And so I hope that
my 'incapacity' – the scepticism that stands in for capacity – may after
all turn out to be an important 'modern' strategy for humankind. Even
more than before, therefore, I can assume (and, where possible,
proclaim) that the absurdity (and inhumanity) of all ideology is a
given fact.

13 January 1988. Art is wretched, cynical, stupid, helpless, confusing –
a mirror-image of our own spiritual impoverishment, our state of
forsakenness and loss. We have lost the great ideas, the Utopias; we
have lost all faith, everything that creates meaning.

Incapable of faith, hopeless to the utmost degree, we roam across a toxic waste dump, in extreme peril; every one of these incomprehensible shards, these odds and ends of junk and detritus, menaces us, constantly hurts and maims us and sooner or later, inevitably, kills us. Worse than insanity.

Consolations are sold: all shades of superstition, puffed-up little ideologies, the stupidest lies.

2 March 1988. Of course, I have always declined to interpret the abject plight of art as the result of social conditions, and thus as an all-pervading environmental factor that stamps the character of art and defines its tasks and its content. I have always blamed myself for the impossibility of creating anything classically constructed and right. I was the one who was too inept to paint the 'right' pictures. But the truth is that the plight of art and of society does include everyone, and imposes on all of us the same misery and therefore the same task.

It doesn't help if I use this realization to let myself off the hook,

as it were; perhaps it is necessary (and not only simple-minded and megalomaniac) for me to take it personally and to assume that the failure is my own. Because how could I ever achieve anything whatever, if I didn't assume that it was my personal business to right all wrongs?

12 March 1988. Most artists are afflicted with more than common stupidity, and this makes them even more desperate than they need be, and so they make themselves even more stupid than they really are, and so they make themselves artistically impotent – because, by panicking (consciously or unconsciously) at their own nonsense, they lose all self-respect and can produce either nothing whatever or nothing but unspeakable stupidity.

20 November 1988. To compare the Nazis' crimes with other crimes is only in a superficial sense to play them down. The real way to play them down would be to ascribe them to the Nazis alone, and thus take the easy way of acquitting oneself from guilt.

Notes for a press conference, November–December 1988

(held at Museum Haus Esters, Krefeld, February 1989)

In the early 1960s, having just come over from the GDR, I naturally declined to summon up any sympathy for the aims and methods of the Red Army Faction (RAF).

I was impressed by the terrorists' energy, their uncompromising determination and their absolute bravery; but I could not find it in my heart to condemn the State for its harsh response. That is what States are like; and I had known other, more ruthless ones.

The deaths of the terrorists, and the related events both before and after, stand for a horror that distressed me and has haunted me as unfinished business ever since, despite all my efforts to suppress it.

It is of no consequence what circumstances and chance events prompted me, early this year, to take up the theme again, to read about it, to get hold of new picture material and to start painting these pictures.

It is impossible for me to interpret the pictures. That is: in the first place they are too emotional; they are, if possible, an expression of a speechless emotion. They are the almost forlorn attempt to give shape to feelings of compassion, grief and horror (as if the pictorial repetition of the events were a way of understanding those events, being able to live with them).

The pictures raise a number of technical and professional issues, though these are of no fundamental interest to me. For instance, the objective quality of painting, imperilled or made redundant since the invention of photography; and my own reversion to a painting technique that I was using in the 1960s – an unmodern attempt at a painting based on content, a history painting.

These pictures possibly give rise to questions of political content or historical truth. Neither interests me in this instance. And although even my motivation for painting them is probably of no significance, I am trying to put a name to it here, as an articulation, parallel to the pictures, as it were, of my disquiet and of my opinion.

Reality may be regarded as wholly unacceptable. (At present, and as far back as we can see into the past, it takes the form of an unbroken string of cruelties. It pains, maltreats and kills us. It is unjust, pitiless, pointless and hopeless. We are at its mercy, and we are it.)

The experience and knowledge of horror generate the will to change, enabling us to create altered conceptions of a better reality, and to work for their realization. Our capacity to know – that is, to conceive – is also, simultaneously, our capacity to believe. Faith itself is primarily knowing and conceiving, but it simultaneously becomes the polar opposite of knowing (in that it mentally transforms the known into

something different) and thus becomes the means of surviving the knowledge of horror: this strategy we call Hope. Faith is consequently an extension and intensification of the instinct to live, or to be alive. (Looked at cynically, the capacity for faith is only the capacity to generate befuddlement, dreams, self-deception, as a way of partly forgetting reality; it's a pep-pill to get work started on realizing the conception. Looked at cynically, everything is pointless.)

Deadly reality, inhuman reality. Our rebellion. Impotence. Failure. Death. – That is why I paint these pictures.

(As I said at the start: my motivation counts for nothing, as far as the pictures are concerned: they are independent of it, because they are themselves a piece of reality.)

7 December 1988. What have I painted. Three times Baader, shot. Three times Ensslin, hanged. Three times the head of the dead Meinhof after they cut her down. Once the dead Meins.

Three times Ensslin, neutral (almost like pop stars).

Then a big, unspecific burial – a cell dominated by a bookcase – a silent, grey record player – a youthful portrait of Meinhof, sentimental in a bourgeois way – twice the arrest of Meins, forced to surrender to the clenched power of the State. All the pictures are dull, grey, mostly very blurred, diffuse. Their presence is the horror and the hard-to-bear refusal to answer, to explain, to give an opinion.

I'm not so sure whether the pictures 'ask' anything; they provoke contradiction through their hopelessness and desolation, their lack of partisanship.

(Ever since I have been able to think, I have known that every rule and every opinion – insofar as either is ideologically motivated – is false, a hindrance, a menace or a crime.)

Notes, 1989

14 March 1989. The word 'bourgeois', formerly a compliment, now negative in its connotations, much used, always vaguely polemical, jejune and irrelevant. 'Bourgeois' equals tidy, educated, law-abiding, in contrast to flipped-out, cheerfully dressed, ostentatiously nonconformist (e.g., Thomas Mann as against Bertolt Brecht, President Weizsäcker as against Joschka Fischer).

Just as conformism is not at all the same thing as security – the word denotes a deference to prevailing fashions, and to the prevailing climate or system, which springs from stupidity, cowardice, indolence and baseness – nonconformism is not necessarily its diametrical opposite, but often springs from a courage born of stupidity and blindness. Nonconformist laxity often originates in the confined, retarded structure of mindless insolence.

21 July 1989. Nature/Structure. There is no more to say. In my pictures I reduce to that. But 'reduce' is the wrong word, because these are not simplifications. I can't verbalize what I am working on: to me, it is many-layered by definition; it is what is more important, what is more true.

Everything you can think of – the feeblemindedness, the stupid ideas, the gimcrack constructions and speculations, the amazing inventions and the glaring juxtapositions – the things you can't help seeing a million times over, day in and day out; the impoverishment and the cocksure ineptitude – I paint all that away, out of myself, out of my head, when I first start on a picture. That is my foundation, my ground. I get rid of that in the first few layers, which I destroy, layer by layer, until all the facile feeblemindedness has gone. I end up with a work of destruction. It goes without saying that I can't take any short cuts: I can't start off right away with the work in its final state.

23 July 1989. However ineptly – desperately ineptly – I set about it, my will, my endeavour, my effort – what drives me – is the quest for enlightenment (apprehension of 'truth', and of the interconnections; coming closer to a meaning; so all my pessimistic, nihilistic actions and assertions have the sole aim of creating or discovering hope).

25 July 1989. My denunciation of ideology: I lack the means to investigate this. Without a doubt, ideologies are harmful, and we must therefore take them very seriously: as behaviour, and not for their content (in content, they are all equally false).

Ideology as the rationalization of faith; as the 'material' that credulity puts into words and makes communicable. Faith, and here I repeat myself, is the awareness of things to come; it therefore equals hope, it equals illusion, and is quintessentially human (I cannot imagine how animals get along without such an awareness); because, without this mental image of 'tomorrow', we are incapable of life.

1 October 1989. The political topicality of my October paintings means almost nothing to me, but in many reviews it is the first or only thing that arouses interest, and the response to the pictures varies according

to current political circumstances. I find this rather a distraction.

I did make a number of imperfect attempts to formulate my motivation, which was initially 'purely human' (dismay, pity, grief), and parallel to this the theoretical components (consideration of real circumstances and of possibilities of change, which are inseparably bound up with faith and ideology; hence my critique of ideology).

I wanted to say something different: the pictures are also a leavetaking, in several respects. Factually: these specific persons are dead; as a general statement, death is leavetaking. And then ideologically: a leavetaking from a specific doctrine of salvation and, beyond that, from the illusion that unacceptable circumstances of life can be changed by this conventional expedient of violent struggle (this kind of revolutionary thought and action is futile and passé).

And then the work bears a strong sense of leavetaking for me personally. It ends the work I began in the 1960s (paintings from black-and-white photographs), with a compressed summation that precludes any possible continuation. And so it is a leavetaking from thoughts and feelings of my own, on a very basic level. Not that this is a deliberate act, of course: it is a quasi-automatic sequence of disintegration and reformation which I can perceive, as always, only in retrospect.

Of course, personal circumstances play a part in all this. On one hand, they cannot be seen in isolation from the generalized 'leave-taking' mentioned above; on the other, they have to be disregarded, because it is all too easy and too misleading to use them to explain things away in psychological terms. The upheaval that I mean has more objective causes, in the events and ideas of the world; and I am causally involved with it only in that I am receptive to the objective facts of the case and, where possible, join in formulating them.

3 November 1989. Chance as theme and as method. A method of allowing something objective to come into being; a theme for creating a simile (picture) of our survival strategy:

(1) The living method, which not only processes conditions, qualities and events as they chance to happen, but exists solely as that non-static 'process', and in no other way.

(2) Ideological: denial of the planning, the opinion and the world-view whereby social projects, and subsequently 'big pictures', are created. So what I have often seen as a deficiency on my part – the fact that I've never been in a position to 'form a picture' of something – is not incapacity at all but an instinctive effort to get at a more modern truth: one that we are already living out in our lives (life is not what is said but the saying of it, not the picture but the picturing).

4 November 1989. Andy Warhol is not so much an artist as a symptom of a cultural situation, created by that situation and used as a substitute for an artist. It is to his credit that he made no 'art'; that he touched none of the methods and themes that traditionally constrain other artists (thus sparing us the great mass of 'artistic' nonsense that we see in other people's pictures). Insofar as his avoidance of nonsense was an active one he was an artist; but insofar as it was passive and naive he was no more an artist than is any mental patient whose 'works' are collected and used. The situation is complicated. It is probably true that – though some of his works are among the most impressive things done over the last thirty years, and though his oeuvre as a whole holds a decisive and outstanding importance for our age – he was still only a mediocre artist.

To take a somewhat premature example: we do not know who the Pilotys and Makarts and Lenbachs* of our own time are; nor do we know whether our day even possesses a Salon art, analogous to that which existed then – an art that posterity will judge so differently.

10 November 1989. The events in the GDR, the so-called historic, democratic revolution. Moved though I am by it, in spite of the briefly flaring hopes of a happy future, a reunited Germany, I am over-whelmed by scepticism and pessimism, almost grief, sometimes rage. Rage at the shamelessly opportunistic politicians, and at the intellec-tuals who spouted for decades in their fanatical Marxist blindness and now sulk, unable to let go of their conceit of knowing better. Grief at

* Karl Piloty (1826–1886), German history painter; Hans Makart (1840–1884), Aus-trian history/allegory painter; Franz von Lenbach (1836–1904), German portrait painter.

the role assigned to the people, who have been systematically used – casually cooped up like convicts for 40 years, by those who would be quite happy to keep them there for another 140 – and now used in a different way and persuaded that they have created this democratic revolution themselves, by their own efforts. When it's perfectly plain that they are being sent out through the Wall, allowed into the West.

The same types who for decades cruelly oppressed and blackmailed 'the People' are inviting praise for making a few concessions. And they give ground, or twist themselves round completely, for one reason and for one reason alone – to hang on to power. Gangsters.

20 November 1989. Illusion – or rather appearance, semblance – is the theme of my life (could be theme of speech welcoming freshmen to the Academy). All that is, seems, and is visible to us because we perceive it by the reflected light of semblance. Nothing else is visible.

Painting concerns itself, as no other art does, exclusively with semblance (I include photography, of course).

The painter sees the semblance of things and repeats it. That is, without fabricating the things himself, he fabricates their semblance; and, if that no longer recalls any object, this artificially produced semblance functions only because it is scrutinized for likeness to a familiar – that is, object-related – semblance.

Even when experience or consensus more or less forbid this comparative scrutiny, we compare a white painting by Robert Ryman not with a whitewashed wall but with the intellectual experience of the history of monochromy, and with other problems in art theory; and even then it fundamentally functions in the same way. We still compare it with snow, flour, toothpaste and who knows what else.

15 December 1989. From 1933 to 1989, that makes 56 years of uninterrupted dictatorship for the East Germans. Included within that, as the necessary concomitants of dictatorship, were the catastrophes, the crimes and the constant deprivations, offset by a vast effort of lies, slander, distortion and self-deception, an effort that could have been made only under the strictest control, under extreme duress – in a dictatorship, in fact. There is a very simple and familiar logic to all this: from time to time, our capacity for hope and faith (which are the same thing in this case) has generated a delusion, or ideology, which initially energizes people to achieve some real successes, and which from the very outset makes them selectively blind: blind to all that fails to fit, blind to anomalies and crimes. Psychological repression takes place; and, when the privations and sufferings and catastrophes come along, the delusion becomes a dogma, which prevails, prohibits, controls and punishes for so long that people are transformed into patients. The GDR.

16 December 1989. Language can express only what language enables it to express.

Language is the only language of consciousness. 'What one cannot say, one does not know.'

That is why all theory is absolutely circumscribed, almost unusable, but always dangerous.

Conversation with Jan Thorn Prikker concerning the cycle *18 October 1977*, 1989

I'd like to ask you about the genesis of these paintings. All of them are painted from photographic originals. Did you find the photographs first, or did you first decide on the theme and then look for the photographs?
It all comes together, the theme and the pictures that make it visible. I had kept a number of photographs for years, under the heading of unfinished business. It's hard to say how it came about that late in 1987 my interest revived, and so I got hold of some more photographs and had the idea of painting the subject.

So you researched far and wide, photographs of attacks, 'wanted' photographs, everything to do with this particular context?
Yes, everything, including photographs from the private lives of the members of the Red Army Faction [RAF], their operations, police material, everything I could dig up.

A very considerable part of your work came before you started painting at all: the research and planning stage of the pictures.
That part is highly important. But then it's nothing new. Painters in the past did the same thing. They went out into landscapes over and over again, and from their millions of impressions they chose the quite specific, definitive impression. I had a large quantity of photographs. It narrowed down all the time, and it became clearer and clearer what was really there to be painted.

What criteria guided you in your choice?
It's more or less an unconscious process. That sounds terribly old-fashioned; it's definitely no longer 'in'. These days, pictures are not painted but thought out. Anyway, the material – all the photographs just lie there for a very long time, and you look at them again and again, and then you make a start somewhere, and the choice gets smaller and smaller, the choice of photographs that might be paintable.

Were you confident from the very start that the terrorism theme was paintable?
The wish was there that it might be – had to be – paintable. But there

184 Studio, Cologne, 1988

have been some themes that weren't. In my mid-twenties I saw some concentration camp photographs that disturbed me very much. In my mid-thirties I collected and took photographs and tried to paint them. I had to give up. That was when I put the photographs together in that weird and seemingly cynical way in the *Atlas*.

When I looked at the 1986 Düsseldorf catalogue and saw what you had done, it gave me a strange feeling. You were putting concentration camp photographs side by side with pornography. That seemed to me to be beyond the pale. It shocked me – but in a terrible way I found I understood it. When I was young, those pictures of concentration camp victims were the first photographs of naked people that I had ever seen. You can't imagine what a terrible crossover that was. I still have the book, but I can't look at it any more. I don't want to be reminded of that possibility ever again. Ever since, I've been aware that there are some pictures that simply must not be taken. To me, it was an unfathomable coincidence, to find you trying out such monstrous combinations. Did you never have the feeling that such picture material might be taboo?
No, never. If only because I have always regarded photographs as *pictures*. But the risk I was running was perfectly clear. There are plenty of bad examples of people hitching themselves to some big, attractive theme and ending up with mere inanity.

Death, an attractive theme?
Yes, people can't wait to see corpses. They crave sensations.

When I saw your exhibition in Krefeld, my first impression was a mixed one: 'That goes too far. That mustn't be painted.' My second impression was one of even greater horror: 'It's a wish-fulfilment fantasy: a painted, collective dream of hate.' There were a lot of people at the time who just longed to see those prisoners dead. A longing that was never expressed about the Nazi criminals. I am convinced that in 1977 many people wanted to see precisely the pictures that you have now painted. Can you understand my impression that you have painted a hate fantasy?
I do know that the fantasy exists. But it's more complicated than that. If people wanted to see these people hanged as criminals, that's only a part of it: there's something else that puts an additional fear into

people, namely that they themselves are terrorists. And that *is* forbidden. So this terrorism inside all of us, that's what generates the rage and fear, and that's what I don't want, any more than I want the policeman inside myself – there's never just one side to us. We're always both: the State *and* the terrorist.

What pictures remained unpainted?

The ones that weren't paintable were the ones I did paint. The dead. To start with, I wanted more to paint the whole business, the world as it then was, the living reality – I was thinking in terms of something big and comprehensive. But then it all evolved quite differently, in the direction of death. And that's really not all that unpaintable. Far from it, in fact. Death and suffering always have been an artistic theme. Basically, it's *the* theme. We've eventually managed to wean ourselves away from it, with our nice, tidy life-style.

To the same degree that it has vanished from art, it has found its way into the mass media. Television and magazines largely live on murder and crime.

Yes, but only quite superficially. In fact, all the media convey an artful, highly effective image of happiness and comfort, which then seems to be imposed on us. It's education, of a sort – educating people for something entirely false and unreal. This compulsory happiness is dangerous.

When I look at how earlier periods presented themselves, this phoney happiness is not there. The pictures dwell on the pain and suffering, the perils that threaten us as human beings. That was more realistic; such prototypes didn't give currency to the illusion that life in this world is all that wonderful. The worst thing about these illusions is that they make people even unhappier: they feel worthless and abnormal because they don't look as happy as the people who smoke HB* or whatever.

Happiness in former times was not a thing of this world.

No, and perhaps that was less of a lie than the lie that promises happiness here and now – the right to happiness: that's pure nonsense.

* A common brand of cigarettes in Germany.

Might you as a painter have had any chance of inventing images on this theme – or is there an aesthetic necessity of some kind that means that such images must be painted from photographs?

I consider it quite simply unthinkable to invent such pictures. That's just not possible nowadays. Painters used to train for years on end, to the point where they could to some extent invent nudes. That ability no longer exists. It's gone.

I meant something different, not the loss of technical skill, not the painter's virtuosity. I'm asking whether photography sets aesthetic norms that absolutely prevent one from painting such a theme out of one's head?

I do know one such picture, by a Norwegian painter, rather Old-Masterish, as phoney as Werner Tübke. – Now, photography is so unsurpassed by definition, it's changed painting so greatly, there's just nothing to be said.

What do you mean by unsurpassed? As far as I am concerned, these photographs are unsurpassed in their inhumanity. Anyone would look away at once. Photographs capture a thing that it would be impossible to look at. They simply register. Finish, comma, out. They are totally impersonal. To be able to see such pictures, you need a glass wall in front of your eyes; you need the filter that a camera lens provides. In reality you wouldn't be able to look.

Photographs are almost Nature. And they drop onto our doormats, almost as uncontrived as reality, but smaller. We want to see these terrible pictures, and maybe they even spare us public executions, even capital punishment. We do need that. Just think of motorway accidents, how that fascinates people. Can you explain that to yourself?

Because we're still alive. Because we got away scot-free. Because we play a privileged role as spectators. Because that single instant makes us more powerfully aware that we're alive.

That's a great advantage. But in the process we also see our *own* end, and that also strikes me as very important. And photographs can do the same thing, which is why I have never seen them as inhuman. As pictures, I don't consider them any worse, just different. They have a different effect. More direct, close to home, more immediate.

188 Studio, Cologne, 1988

I find that astonishing. The photographs petrify me. The paintings seem to me to transcend them, to make mourning possible. It seems to me that the photographs don't permit that. They duplicate blindly.

Can I fetch you a photograph? What I can read in this – the compassion that is so directly released here – the way this young woman lies there, all the details that tell so many stories: a painting hasn't got that with the same immediacy. It's all much stronger here.

I can't understand Benjamin Buchloh, when he writes [in the Krefeld exhibition catalogue] that you intended a criticism of the 'cruel gaze' of the police photographs.

No, that's not what I meant at all.

You share that gaze, in every detail. In your painting, you participate in its horror. And yet the painting is something very different from the police photograph.

It's meant to be. Perhaps I can describe the difference like this: in this particular case, I'd say the photograph provokes horror, and the painting – with the same motif – something more like grief. That comes very close to what I intended.

Does death in this context possibly have a grandeur that it now no longer automatically has in everyday life? I am always finding news items which I collect under the heading of 'Death Without Dignity'. There's a story of someone who's been run over by a mechanical sweeper or shut in a freezer. Or people being buried standing up, because of the lack of space in Berlin cemeteries, and so on. I often wonder whether the editors realize that they're redefining our relationship with death through these stories. Stories like this are our time, it seems to me. Do you set out to involve yourself in the truth of this cruelty?

Far from it. I want to show death in all seriousness.

So why the blurring?

I first paint the pictures very precisely from the photograph, sometimes more realistically than the originals. That comes with experience. And the result is, of course, an unendurable picture from every point of view.

It reminds me of the working of psychoanalysis. As if you wanted first to cancel the repression, in order to reinstate it later. When you paint

the photograph in a much bigger format, does that make it more terrible?
Partly, yes, because it's like a reconstruction of the event, just by virtue
of being life-size, with all the details.

*The photographer needs only a fraction of a second – but you have
to spend hours creating all those details.*
But it's work, after all. I feel that I'm not reduced to being a mute
spectator. I have something to do. That makes it more bearable.

How do you decide on the right size for a picture?
Entirely primitive. Life-size.

*The pictures of Gudrun Ensslin alive are more than life-size, some-
thing like one-third bigger than reality.*
I don't know why I painted her larger than life. The portrait of the
young Ulrike Meinhof is larger than life, too. Perhaps it was a vain
wish –

*– for life to be bigger than death? What about the format of the
burial scene?*
I couldn't make that life-size. The picture would have been eighty
metres long. It's still the biggest picture in the exhibition, but in
comparison to the event itself it's small.

The cycle consists of comparatively small pictures.
Which I'm quite glad of now, a certain plainness that I find appro-
priate. Two years ago, when I started to work on this theme, I thought:
'This is a gigantic theme, and these are going to be gigantic pictures.'
It did come out as a cycle, but the pictures are not outsize ones – rather
modest, in fact.

The RAF, as seen by you, is primarily a women's movement.
That's right. I do think that women played the more important role in
it. They impressed me much more than the men.

*Did you tackle the theme purely as a painter, or did you also need
to know about the personalities, the politics, the events and the context?
Did you read books about terrorism?*
Yes, I read everything, sooner or later. Stefan Aust's book was very
important to me. So knowledge of the people, knowing the people, was
basic to the pictures.

I was particularly struck by the portrait of Ulrike Meinhof as a

young girl. It's the only picture that shows an RAF member outside the magic circle of RAF politics. It could be anybody. It's touchingly innocuous, even sentimental. Is it a special picture?

It does have a specific function in the cycle, because you see it in relation to the others. But all the fifteen pictures relate to each other.

There is always an anti-painterly element in your work. If your painting here reminds me of the blurred pictures on ill-adjusted television sets, does that bother you?

The reproductions are like that, but not the pictures themselves.

How long does one picture like this take you?

It's relatively quick. That is, applying the paint is a lengthy process, a week or so. The burial picture took longer, there were so many details to be painted, but a head would only take two days. Most of the work lies elsewhere – and that can go on for almost a year.

Can you paint anything else concurrently? Do you need a counterweight, to hold in check the depressive mood that hangs over pictures like these?

There were breaks.

But you didn't, for instance, work on colour abstractions at the same time?

No, that's not on. A break of one week, that's all right. I did paint my daughter once during that period.

Did she have anything to do with the cycle?

No, nothing. But I did find it interesting that the portrait of Ulrike Meinhof came out so much better than that picture.

Was it clear to you from the outset that this was going to be a grey cycle?

Yes, it was.

Did you ever consider painting the terrorists' victims as well? Hans-Martin Schleyer, for instance?

Never.

The scene in Victor-Statz-Strasse, with the pram as an obstacle to stop the car. The occupants' corpses on the street with blankets over them, the Mercedes?

No, never. After that you'd have to go on painting the same sort of

thing. That was the ordinary crime, the ordinary disaster that happens every day. What I chose was an exceptional disaster.

What was exceptional about it?

Firstly the public posture of these people: nothing private, but the overriding, ideological motivation. And then the tremendous strength, the terrifying power that an *idea* has, which goes as far as death. That is the most impressive thing, to me, and the most inexplicable thing; that we produce ideas, which are almost always not only utterly wrong and nonsensical but above all dangerous. Wars of religion and the rest: it's fundamentally all about nothing, about pure blather – and we take it utterly seriously, fanatically, even unto death. I'm not talking about the facts. The crimes of Vietnam do have to be taken utterly seriously, but that's a different matter.

Is it the tragedy of these people that they tried to be active doers? That they refused to reconcile themselves to their own impotence – isn't that the hidden, positive core?

Yes, that's the other side – which I see, of course, despite my scepticism. That's the element of hope that the pictures were meant to contain.

Has the ideology of the RAF never interested you?

No. I have always rejected it as an ideology, as Marxism or the like. What interests me is something different, as I've just tried to say: the why and wherefore of an ideology that has such an effect on people; why we have ideologies at all; whether this is an inevitable, a necessary part of our make-up – or a pointless one, a mere hindrance, a menace to life, a delusion –

So you consider the RAF dead as the victims of their own ideology?

Yes, certainly. Not the victims of any specific ideology of the left or of the right, but of the ideological posture as such. This has to do with the everlasting human dilemma in general: to work for a revolution and fail –

Significantly, 'avant-garde' is a political as well as an artistic term. Is there a relation between art and the revolutionary impulse? What causes an established, bourgeois artist like yourself to be interested in the RAF? Surely not its actions?

Yes, the actions. Because someone is trying, with total radicalism, to change something – one can understand this, and also see it as the other side of the coin. Art is sometimes described as radical, but it isn't really – only artificially, which is something quite different.

Is painting an attack on reality, in the attempt to create something entirely new?

It's all sorts of things – an alternative world, or a plan or a model for something different, or a reportage – because, even when it only repeats or recalls something, it can still create meaning.

Recalling – that is the concept that underlies these pictures. What can one profitably remember about the RAF?

It can give us new insights. And it can also be the attempt to console – that is, to give a meaning. It's also about the fact that we can't simply discard and forget a story like that; we must try to find a different way of dealing with it – appropriately.

I sometimes feel that works of art can momentarily disable the real world. That they keep at least the idea of change alive.

Yes, certainly. It's just that I sometimes feel scared at the many demands that are made of art. Art is a perfectly natural human quality,

and from that point of view it can't be called in question. You can't say that art is no good because Mozart didn't prevent the concentration camps, any more than you can say that no more poems are possible after Auschwitz. All I know is that without Mozart and the rest we wouldn't survive.

I have compared a few of the paintings with the photographic originals. Some quite fundamental changes have been made. It's clearest in the cell picture, for instance. This picture speaks impulsively, directly to the viewer. At the time, people were always arguing that a cell with a record-player and books, not three books but three hundred, was as comfortable as living in a hotel. In your picture I found the reality of a cell captured with total conviction. The hell of an enclosed space with no way out.

I was very unsure about that picture, to start with. It seemed over-simplified. Everything that goes through your head, everything that I took a lot of trouble painting, had been painted out. But it holds up.

The pictures are both rigidly conceived and apparently left to chance. The motif is carefully selected from hundreds of others, but the transposition into paint seems to go its own way–

– as if against my will, or at least against all that one tends to think.

Do you subject yourself to a photograph?

It's my point of departure.

Did you mean to paint the idea of a cell? I can't imagine that.

Certainly both. I mean, that particular cell and of course also what *cell* means. But a thing like that has to be automatic, somehow.

You have a sense of something, you see it, it's right or it isn't right? But you can't formulate it.

I notice this in abstract painting, If I read an especially good text that makes it clear to me what I have done, and I try to do the same thing again, the result is nothing but nonsense. If I work methodically, it just doesn't work. A picture has a logic that can't be verbalized until afterwards; it can't be designed. We talk about thinking a thing over, meaning over again, afterwards. I am more and more aware of the importance of the unconscious process that has to take place while one is painting – as if something were working away in secret. You can

almost just stand by and wait until something comes. It has been called 'inspiration' or 'an idea from heaven' – but it's far more down-to-earth and far more complicated than that.

Are these pictures something new in your work? You have never before chosen source images with such a social charge, but only neutral ones.

That's true, I have always shied away from so-called political themes, and from anything spectacular.

But this whole cycle is built on the spectacular nature of the events concerned.

And really that is the most natural thing in the world, picking up on exceptional events. It would be absurd to have a taboo against the very thing that concerns us most. Then we'd be left producing nothing but banalities.

You're pointing with a deprecating gesture to your own abstract works.

Is it part of the newness of your other pictures that they involve themselves with contemporary history? This is a very risky business. I can't imagine any painter now even trying to paint a theme such as unemployment, and yet it remains one of the central issues of twentieth-century society. Artists in the 1920s still knew how to do it. Now there's no one left who knows how it might be painted.

It is very difficult. What could one paint about unemployment, when other media cover the theme so much better?

In the Overholland catalogue in 1987, you published some journal entries that had an uncompromising tone that I very much like. There was a harshness in them that came as a welcome contrast to the banality of so many arts pages. I'll quote something: '25 November 1982. The whole art world is one vast scene of pettiness, lies, deceit, depravity, wretchedness, stupidity, nonsense, impudence. It is not worth wasting one word on it.' Aren't statements like that rather risky? You are part of this business, after all.

That's why I didn't publish them here but in Holland, where nobody was going to read them.

But publication is always –

– my wish to be unconditionally known. Only I'm a bit of a coward.

A bit of a coward and a bit courageous.

That's the only way that suits me.

Are your pictures intended to provoke?

Well, they certainly weren't meant to be boring!

These pictures always seem to take us as viewers out of ourselves, and at the same time they bring us up short – speculations and all – at the edge of the image. They answer none of the questions that they pose. I've never come across anything like this before: a picture that almost systematically jams its own signal, shoves the viewer away, and forces him to come back for more, only to start the whole thing all over again. Sometimes I have had the feeling that these are brazen oversimplifications. But in the end I feel that the success lies in the simplification.

That's the real point of the work: not to make things simple, but to reach a result, a summing-up. Initially just for oneself.

Do you see a private dimension?

Certainly. You don't take up a theme like this unless it matters to you – that's a premise. What counts is that the pictures then become

universal. They are there to show themselves and not me: that would be dreadful. That's why form is so important – and that is difficult nowadays.

But you try.

Yes, because without form communication stops; because without form you have everybody burbling on to themselves, whenever and however, things that no one can understand and – rightly – no one is interested in. The form that we have in the art world today – the universally comprehensible form, that is – is entirely superficial. Openings, dealership, social game-playing: these have become the form of art. They have long since wholly or at least largely taken its place.

I have the feeling that these pictures attach themselves to an explosive historical theme, that they're an expression of your desire to endow pictures with historical weight. But at the same time they seem to me to strike a blow against contemporary art, including – perhaps especially – your own art. An attempt to say: 'Not this way.'

Yes, with all due scepticism, because I'm a part of the art world myself.

I've jotted down a quotation from Francis Bacon: 'I believe that art is recording; I think it's reporting. And I think that in abstract art, as there's no report, there's nothing other than the aesthetic of the painter and his few sensations.'

That sentence suits me very well: 'I think it's reporting.'

What about the rest of the quote?

I don't believe that quite so completely. I think that even those vacuous little abstracts on that wall over there – even those are a form of reporting.

Aren't they just authentic documents of your own inner state?

Being authentic gets you nowhere. Every picture is authentic. The worst pictures are the ones that tell you what's up with the painter and with painting in general. That's what makes them so uninteresting.

When I was preparing for this conversation and looked up your catalogue raisonné, I wondered whether there wasn't a sense of desperation in the sheer quantity of pictures. I get the feeling that there are so many pictures because you needed to search for one picture, the picture, through the many.

I don't believe in the absolute picture. There can only be approxima-
tions, experiments and beginnings, over and over again. That's what
I wanted to show in the catalogue: not the best pictures but everything,
the whole work of approximation, mistakes and all. In my *Atlas* it's
even more extreme: a deluge of images that I can control only by
organizing them, and no individual images left at all.

Wasn't, for example, Jacques-Louis David's Death of Marat *(1793)*
more than an approximation?
Yes, of course, there are some lucky strikes like that. There are a few
almost absolute pictures. And that's the hope that keeps you going most
of the time –

Have you quoted David? In the three Dead Woman *pictures, I was*
forcibly reminded of David, and of the space above the person in
particular. The expression of dignity that these pictures contain comes
through the emptiness above the closed eyes. Your picture, like David's,
is elevated by the dark area above the person.
One has half of art history in one's head, and of course that sort of
thing does find its way in, involuntarily – but as to taking something
out of a specific picture, that doesn't happen.

Within the cycle, these three pictures seem to me to be extraordinary
successful. How do you see it? Are they all equally successful?
I'm not sure. Perhaps this first version of the *Shot Man* isn't that good.
There was an earlier one that went wrong, and I had to destroy it.
It's hard to say. I'm still too close to it.

The first is more like the police photograph.
That may be why I like the second version. It's calmer.

When I asked about a successful picture, you named one that you're
doubtful about. Is there one that make you say 'That's it, that's how
I wanted it'?
The *Dead Woman*, those three pictures, there I agree with you, I wouldn't
have any reservations about them. I like the record-player. But it seems to
me to be a bit unfair, talking about them like this – it's not right.

Yesterday I was watching the visitors to your exhibition. They were
constantly trying to find the right viewing point, walking up and down,
trying it from every angle, sometimes close up, sometimes standing well

back. The viewpoint must be a particularly difficult problem here, in both senses of the word.

That's good. That's what it's about, in every sense –

What is your viewpoint? Making a record?

Partly. And also grief – compassion and grief. Certainly also fear.

Grief at what?

That it is the way it is.

Does the person you're depicting count for anything? Is it clear to you whom you're painting?

You can't really avoid that. As I said, it's only the work, the craft element, that makes it bearable. It was worse when the pictures were hanging here, in these rooms. Having these pictures around one all the time, that was unendurable. Now they're gone.

Is it important to you that the pictures be seen?

Absolutely. That's what they're there for.

What were you trying to do in these pictures?

To make pictures. To picture my own thoughts and feelings. By which I mean that my own motivation and my views about them are entirely unimportant, and ultimately beside the point: there are other professionals whose job it is to come along and talk about these things.

And yet here we are talking, and you are saying something.

Yes, of course, and I certainly don't regard myself as a blinkered specialist. But –

The RAF ought probably to be seen as an attempt to break with the idea of passive complicity, which was so important to our fathers' generation. Fascism only works if there are people who go along with it. I get the feeling that the RAF was trying to say: 'We will never again permit ourselves to be made into the accomplices of historic crimes.' That seems to me to be the starting point. Being informed, as we are, we are all now accomplices. None of us is going to say in the future 'We didn't know.' That standard excuse of the 1950s is no longer available. We have no excuse any more. We are contemporary observers of all the crimes that are being committed today. We are all callous accomplices. Blackmailed into impotence, we are spectators of political and economic crimes that are made possible only because we connive in our own impotence.

This interests me in a general sense. The callousness, for example. The fact that we have only so much compassion in us; we tend to refuse our compassion whenever we get the chance. This makes sense, in a way; it has to do with survival strategies. But when you realize just how much we do refuse our compassion, how calmly we look on while hundreds of thousands starve or are tortured or killed – we never choke on a single forkful. This is more than avoiding compassion in order to survive: it's almost worse than killing.

And the killing goes on anyway, day after day. We can always push the responsibility off onto other people – but it's really all of us. No other species does this.

Only humanity?

Man kills as no animal kills, he kills himself, as if under a compulsion. You can't hold aloof and say it's other people, they're the criminals. That's no use, it's just self-serving glibness. This kind of thinking is dangerous. Another thing that's absurd is those people who try to make exceptions of themselves and describe themselves as peace-loving. That's just as bad as joining in personally. I'm not talking about the RAF, I'm talking about us.

The RAF began as a resistance movement against the war in Vietnam. It all ended in crimes committed by the RAF, but it all started as a struggle against the crime of war. Now there has been a historic shift. The last ten years have not been so much overshadowed by wars; it's been a decade of historic catastrophes in the production process. Bhopal, Chernobyl, Sandoz. Death tolls like Bhopal used to exist only on battlefields. The situation has got worse and worse. Ordinary industrial production is becoming a crime against humanity and against Nature. However fast the opposition movements grow, impotence grows faster still. Our state of impotence hasn't changed much – or, to put it another way, it's not only the perils that have grown; the possibilities of doing something about them have grown too.

With the RAF, did it interest you that here were some people who were saying 'Thus far and no further'?

Yes, of course. But that's our daily bread, so to speak. What is really wretched is when those who want to change something fail, not just

because they are prevented from succeeding, but because the means they use – and yes, that does mean their ideas – are false.

Was your experiment with history a necessary experiment?
It was necessary. I'd continue it straight away, if I could find something that works. Something that has both: that alters the painting and has an importance beyond that. Perhaps the experiment will bear fruit in future.

Is this cycle an experiment in lending weight to your painting?
Certainly. Everyone is always trying to do that. Why we never succeed, I don't know.

With a cycle like this, are you also trying to make life difficult for the art business as a consumer trade?
Impossible. The demand is so great that practically everything is swallowed up.

You can imagine a museum director buying this cycle?
They haven't got any money.

So you wouldn't sell these pictures?
No, for the moment it's out of the question. But if the interest keeps up, I'd be glad to give them to a museum on permanent loan.

Will you insist that the cycle can't be broken up?
Absolutely, even if the pictures go into store. I don't suppose any museum can afford to have fifteen pictures by one painter permanently on show. We shall have to see how the pictures hold up. That's why they are being exhibited, after Krefeld, in Frankfurt, then in Rotterdam and somewhere else after that.

Would you like to influence the public presentation of the pictures?
I would absolutely forbid any spectacle.

Can you imagine the pictures in private galleries?
No, that wouldn't be the right place for them. They can only be shown in museums.

You don't have didactic aims in view?
The pictures are not partisan, they're quite clear about that. They are hard to enlist, to make use of. Grief is not tied to any 'cause'. Nor is compassion.

What is the object of your compassion?
The death that the terrorists had to suffer. They probably did kill

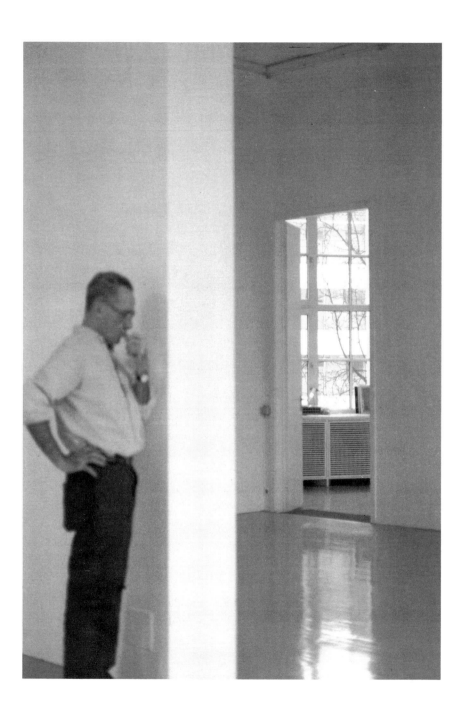

Studio, Cologne, 1990

themselves, which for me makes it all almost more terrible. Compassion also for the failure; the fact that an illusion of being able to change the world has failed.

There is a laconic evenness in your attitude, which doesn't seem to match the emotive power. Do you wish for an illusion? is there a wish in you for an illusion?

That wish is surely born with us.

The wish not to have to surrender to the bald fact of 'that's the way it is'? Might illusions be just as necessary as repressions?

Possibly. I don't know – maybe my hatred of ideology is mistaken, maybe I'm confusing one thing with another. Because when I say I believe it'll be fine weather tomorrow, that too has something to do with belief and illusion.

All the same, I consider belief of every kind, from astrology to every elevated religion and all great ideologies, to be superfluous and mortally dangerous. We no longer need such things. We ought to work out different strategies against misery and injustice, war and catastrophes.

Is there hope in your art? The abstract paintings formulated something like a faith in the making of beauty. In the photo-paintings it's the hope of being able to pass judgment on one's own period, or to compress one's period into a picture.

Or at least, by reporting, to help to enlighten people. To see how it is.

One entry in your journal reads like this: 'Art has always been basically about agony, desperation and helplessness. ... We often neglect this side of things by concentrating aesthetically on the formal side in isolation.' I'd go along with that. Except that it's a totally anachronistic position: if I look around in contemporary art, this statement is just not true. Art is more social game-playing than ever. A kind of entertainment with a phoney status element, which is often primarily about an elitist distancing of oneself from trivial amusements.

All of that is true.

A whole tribe of artists are living and working for the total opposite of your assertion. They act according to the motto: 'Profundity is out, we're glad to be superficial, and we even get paid for it.'

*Walter Grasskamp once wrote that your painting was 'visual sadism':
a deliberately provocative formulation, but I could immediately see why
it was apt. I myself have never been able just to relax in front of your
colour abstractions, as one might with pictures by Matisse, say. There is
a tormenting streak in the beauty.*

That may well be, but it has nothing to do with sadism.

*It's not an insult to you if I say that I have never been able to find
those Abstract Pictures just beautiful?*

Far from it.

*Have you ever felt the need to justify yourself for having painted the
present cycle?*

Not while I was painting the pictures. That came later. Here and now,
for instance.

Could you have painted these pictures ten years ago?

No.

*Does an artist have to be successful in order to get away with
painting this subject?*

I don't believe so.

Just a great painter?

A great painter – once I used to think I ought to paint like the 'great
masters', and of course I couldn't. I felt it to be a terrible lack in me,
I thought I basically wasn't a painter at all but a fraud, just pretending
to be one. It was a long time before I realized that what I do – the
desperate experimentation, all the difficulties – is exactly what they all
do: that's the normal nature of the job. That's painting.

*It strikes me as grotesque, of course, to hear one of the most successful
German painters saying he isn't a painter at all.*

OK, by now I don't mind calling myself a painter. There's no risk
in that.

Was this cycle a risk, as far as you were concerned?

Certainly. But not because of possible objections from the Left or from
the Right. By definition, there's always a risk – the risk of ending up
with bad pictures.

*Perhaps this is cynical, but after a certain degree of success there
is no longer such a thing as failure. As if that were the price of success.*

In market terms, that's true. By now the market would take any rubbish I might turn out. But what counts for me is something else, and so – self-criticism apart – there are still a few people whose judgment still means something. And so, if they say; 'Oh, that looks bad – he's run out of steam – you can forget him– '

Does this cycle represent a progression within your work?
Well, I don't have the feeling that I've run out of steam. I realize that these pictures set a new standard, set a challenge to me. I may be deceiving myself. It's all still too fresh. But one thing I have realized; it's hard for me to go on painting.

Interview with Sabine Schütz, 1990

A year or so ago, you caused a stir with your cycle 18 October 1977. *This group of fifteen pictures, painted in your earlier technique of blurred copies of black-and-white photographs, deals with the deaths of the RAF terrorists in Stammheim prison; it sparked a heated and emotional debate which went far beyond the purely artistic issues. In these works, was your concern a directly political one?*
Not directly political, and least of all in the sense of political painting, which everyone has always assumed to be left-wing – an art that serves exclusively to criticize so-called bourgeois-capitalist society. That was not my concern.

But the theme was not only highly explosive but also an explicitly left-wing one –
Which can now be regarded as buried and done with –

– Exactly, and it's already history. One might ask why you came out with these pictures in 1989 and not ten years earlier.
The delay was probably necessary. But I can't precisely explain my motives for doing a thing at one time rather than another. Such things never go according to plan; it's an unconscious process. It does seem important now that, with the collapse of the socialist system, these pictures are taking on a different and more general component, which

they didn't have quite so obviously before. On the other hand, I'm wary of talking about the concerns or the messages of the paintings. I don't want to circumscribe them by imposing an interpretation.

But do you now see the terrorists purely as the victims of a false idea, which was therefore doomed to fail?

Certainly, as far as that goes. But I also feel a certain sympathy for those people, and for their desperate desire for change. I can very well understand someone finding this world, as it is, unacceptable. And they were part of a corrective – one that we shall miss in the future. We shall find another, as well as different critical approaches: less sentimental or superstitious, more realistic – and therefore more effective, I hope.

The cycle has been described as a revival of a genre largely ignored by modern and contemporary art, namely history painting. Would you agree with that?

It doesn't interest me that much. Even when I was working on the paintings, when it occurred to me that they might be regarded as history painting, and thus as something reactionary, it didn't bother me. That's more a problem for the theorists.

In a note in your journal, you say that no one can really paint the way you do, without a theme. How about this cycle? Did it have a theme?
Yes, it did. But that gloomy note of mine had more to do with the Abstract Pictures, and beyond that with a generalized impotence and helplessness, which can of course be turned into a theme in its own right. All the same, sometimes you have enough motivation to make all this irrelevant – and then you just paint.

When you start a painting, do you always know what you want to paint? Can it be said that you are a conceptual artist?
No, I'm not. I never know either what to paint or what the picture is supposed to look like. With the October cycle, as always, I had no idea what sort of pictures were going to come out of it. I had a vast assortment of photographs, and what I actually had in mind was something quite different. It was meant to be far more comprehensive, far more concerned with the subjects' lives. But then I ended up with this tiny selection: nine motifs, and a strong concentration on death – almost in spite of my intentions.

One wouldn't have expected a theme so heavy with content, from an artist who once – 25 years ago – painted a roll of toilet paper. The record-player is a banal object in itself. But your relation to the object does seem to have changed markedly in the intervening time.
No, not markedly. A toilet roll is not exactly a cheerful subject either. Nor is it true that I'm now old enough to restrict myself to sad subjects. But the record-player picture is a highly charged image, of course, because the viewer knows that it's Andreas Baader's record-player, that the weapon that killed him was concealed inside it, and so on. That doesn't make it a better picture, but it does get more attention, because more of a narrative can be tied to it.

Behind the fact that it used to be, say, a toilet roll or a clothes-drier, and now it's a record-player with a highly specific political significance, there clearly lies a decisive change of consciousness.

Naturally. I was younger then, and part of a very different *Zeitgeist,* and from that point of view there might be a lot more difference between the pictures than there is. What strikes me now is the similarity – the fact that not all that much has changed. It's the same apparent indifference and absence of message. The toilet roll or the clothes-drier, just like the record-player, is a kind of 'poor person's art' – like many of the other prosaic, banal motifs.

The motif takes on a very different value in different pictures. The motif in the 18 October 1977 *series, for instance, is very different in kind from the motif in most of your earlier works. Could it be said that each group of works maintains its own specific relationship to the object and to reality?*

That must be so, but all the different pictures at different times do have one consistent foundation; and that's me, my attitude and my intention, which may express itself in different ways but never

essentially changes. The variety is superficial. My own statements about my lack of style and lack of opinion were largely polemical gestures against contemporary trends that I disliked – or else they were self-protective statements, designed to create a climate in which I could paint what I wanted.

But you have also said that it doesn't necessarily matter what one paints. And by painting the clothes-drier or the stag or the housewife you show that it really doesn't.

But then you can also see all of that as a coherent theme; and then it does matter. All these themes – the clothes-drier, the family on the sofa, the stag – are also highly selective.

Wasn't there a touch of irony as well?

I never think that way. If I ever did admit to any irony, I did so for the sake of a quiet life. Because at some point, of course, I did care about the motifs. I didn't find the clothes-drier ironic; there was something tragic about it, because it represented life in low-cost housing with nowhere to hang the washing. It was my own clothes-drier, which I rediscovered in a newspaper – objectivized, as it were. Or the families – they were often people I knew. And if I didn't know them, at least they had something in common with the families and lives that I did know.

Didn't it have something to do with middle-class stuffiness?

No doubt. But what does that mean? It's not a concept that means much to me; it strikes me as arrogant.

What was it about the motif of the stag, for instance, that interested you? No one can really paint a stag these days without thinking of the word 'roaring' – kitsch, in other words.

It's not the stag's fault if he's been badly painted – 'Stag Roaring' over the sofa. For us Germans, in particular, relating to forests as strongly as we do, the stag does of course have a symbolic quality. I wanted to be a forester when I was young, and I was really excited when I found a real stag in the forest and took a photograph. Later I painted him, and the painting was a bit less romantic than my youthful photograph.

Again, the wedding-cake castle of Neuschwanstein also irresistibly summons up kitsch associations.

The real-life castle is a hideous monstrosity. But it does also have this

other, seductive side to it, that of the beautiful fairytale, the dream of sublimity, bliss, happiness – and that's the dangerous part; that's why it's a very special case of kitsch.

I see the bomber pictures as an anti-war statement –
– which they aren't, at all. Pictures like that don't do anything to combat war. They only show one tiny aspect of the subject of war – maybe only my own childish feelings of fear and fascination with war and with weapons of that kind.

Is it possible to be fascinated by the aesthetic effect of a weapon? Isn't it always a feeling of terror, dread?
It's a mixed feeling, and it's no good suppressing the fascination.

Many years ago you described painting as 'a moral action'. What did you mean by that?
That was an inept attempt on my part to convey that it's really not all about painting beautiful pictures. It was a statement of the significance of art, and of the enormous importance that I attached to it; and the untold quantities of art that are being made and consumed at the moment do at least reveal a wholly irrational demand for art, an almost religious longing. And if art were ever in a position to satisfy this longing utterly, then that would be a great gain. Art would be something like 'faith pure and simple', which would protect us from flying off after false faiths, religions and ideologies.

You constantly stress your anti-ideological position. What do you mean by ideology?
One contemporary example is the ideology of Socialism in the GDR. People believe in such a thing against all reason – and make themselves and other people unhappy. It's a kind of psychological illness, and apparently an incurable one. It would be a lot better if we could know ourselves, see what we're really like, what we're capable of, why we kill, why we are good – and above all what is feasible. Instead of that, we 'believe'. That is a luxury we can no longer afford, on this endangered globe.

But those who are in the know, and who still proclaim these messages of salvation – aren't they perfectly well aware that they're lying?
No, certainly not. Ideology possesses people's brains so totally that

there's no way left of seeing facts objectively. And the more the facts belie the ideology, the more implacably it asserts control. It's only on the behavioural level – unconsciously and instinctively – that people can sometimes escape from it. So, when Honecker wears cashmere, he's being completely natural. Then he forgets his faith, or at least bends it a little bit.

So you'd like to abolish faith?

Can't be done. We need it to survive. It motivates us; nothing would get done without it. Faith is an indispensable human quality. When I say, 'I believe that tomorrow will be Tuesday', that is an act of faith, because this Tuesday exists only in our minds. And if I then say that it will be fine weather tomorrow, that shows faith from the dangerous side, because then it gets mistaken for certainty and acted on. Which makes it seem all the worse if it then turns out cold and wet.

Intellectuals are far more endangered than 'ordinary' people or artists. They're intelligent, very good at handling words and therefore brilliant at constructing theories, and they share in the overwhelming power of words. Almost everything is prompted, forbidden or authorized by words; explained, transfigured or falsified by words. So we ought to be sceptical and not forget that there's another, highly important kind of experience. Whatever we experience non-verbally – by sight, touch, hearing or whatever – gives us a certainty or a knowledge that can lead to better actions and decisions than any theory.

A theory can also evolve empirically.

Yes, of course, it evolves out of experience and is corrected, confirmed or falsified by experience. The problem is, however, that a theory can be so logical in its own terms, so complicated and intricate – almost as complex as life – that you're compelled to go along with it because it is so convincing or so beautiful.

There is a film about your work, with the title 'My Pictures Are Cleverer than I Am.' Why is that?

They have to be cleverer than I am. I have to be unable to follow quite all the way; they have to be something that I no longer completely understand. So long as I can grasp them theoretically, it's boring.

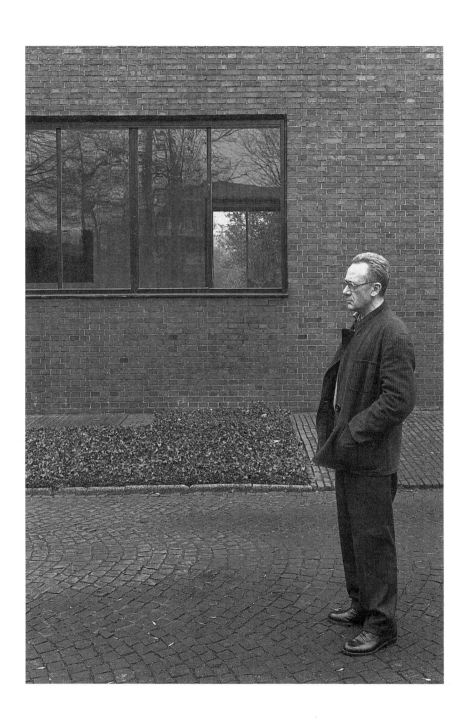

214 Museum Haus Lange, Krefeld, 1989

Quite early on, you were described as 'inconsistent', because you were always swapping levels, both in your subject matter and, even more, in your style. You have described yourself as 'uncertain'. Or is some of it about proving to yourself and to others that you can do anything?

No, it isn't that. Painting a copy of a photograph is something that can be learned. And there are so many conceivable kinds of artistic statement that I haven't made – I'm relatively limited – a bit one-sided, in fact. Never anything but oil painting.

Inconsistency is simply a consequence of uncertainty, which I certainly do tend to suffer from – but then I also regard it as inevitable and necessary.

So perhaps uncertainty is the overriding theme?

Maybe. At all events, uncertainty is part of me; it's a basic premise of my work. After all, we have no objective justification for feeling certain about anything. Certainty is for fools, or liars.

And the pictures tell no lies?

No, they make no statement at all, so they can't fool us. They tell no more lies than a tree does – though they're often less interesting.

Stylistic changes, stylistic upheavals and (perhaps) irony: all these are phenomena that have been called – ever since the word was coined – 'Postmodern'. Do you give any thought to this? Do you regard yourself as a pioneer Postmodernist?

I don't think so. It's never interested me much. But in a sense you could call me that; because I was never aware of belonging to the avant-garde, and that was never part of my intention. Avant-garde: that was usually too dogmatic and too aggressive for me.

In 1976 you began to paint abstract pictures, because you wanted something that you couldn't visualize in advance. In doing so, you invented a method that was absolutely new to you. Was that an experiment of some kind?

Yes. It began in 1976, with small abstract paintings that allowed me to do what I had never let myself do: put something down at random. And then, of course, I realized that it never can be random. It was all a way of opening a door for me. If I don't know what's coming – that is, if I have no hard-and-fast image, as I have with a photographic

original – then arbitrary choice and chance play an important part.

How do you manage to direct chance in such a way that a highly specific picture with a specific statement comes out of it – because that is your stated intention, isn't it?

No, I don't have a specific picture in my mind's eye. I want to end up with a picture that I haven't planned. This method of arbitrary choice, chance, inspiration and destruction may produce a specific type of picture, but it never produces a predetermined picture. Each picture has to evolve out of a painterly or visual logic: it has to emerge as if inevitably. And by not planning the outcome, I hope to achieve the same coherence and objectivity that a random slice of Nature (or a Readymade) always possesses. Of course, this is also a method of bringing in unconscious processes, as far as possible. I just want to get something more interesting out of it than those things that I can think out for myself.

Jürgen Harten has written that your pictures are 'the painting of painting': something like a painted commentary on painting.

No, that's not right. When I listen to Bach, I can equally well say that that's music about music, because it's based on a tradition, because it's internally coherent: every note relates to another. But in the end that would mean that it means nothing and says nothing. A game of chess. What good would that be to anyone?

For many artists, the act of painting, the process, is the primary element in their work –

What counts is always the seeing. The physical act can't be avoided, and certainly it is sometimes necessary to paint with the whole body – but all in the cause. And these 'Actionists' – you only have to look at what comes out of that.

In a catalogue published twenty years ago by the Kunstverein in Aachen, Klaus Honnef wrote that you were dedicated to 'bonne peinture'. What is the importance of 'painting', in that sense, in your pictures?

Early on, at the Academy, I would have loved to paint like the artists I admired at that time: Manet, Cézanne or Velázquez. But I couldn't. And later on I realized that it's a good thing I can't, because that's beside the point. I'm sure that's what he meant by 'bonne peinture'.

I can't even remember what it is – presumably something like pure painting.

A painting that is exclusively concerned with itself and its own premises – and that's not what you're after?
In the first place, the basis is an intention – that of picturing the world. And painting is always only a means to this end (which is why you can't ever say that a bad picture is well painted). Nevertheless, painting and the means of painting are of important elementary facts. You can see this in a number of well-intentioned paintings, with lofty aspirations as to content, which remain absolutely inedible. This edible quality has nothing to do with self-indulgence; it's utterly basic, existential.

Has edibility got anything to do with materials and brushwork – technique, in fact?
It has more to do with seeing, I think. The rest is manual; it's no problem. Anything can be painted. It's more difficult to see whether what one is doing is any good or not. But that's the only thing that counts. As Duchamp showed, it has nothing to do with craftsmanship. What counts isn't being able to do a thing, it's seeing what it is. Seeing is the decisive act, and ultimately it places the maker and the viewer on the same level.

Many of your pictures have a different medium, photography, as an intermediary –
– which isn't a different medium at all. It's fundamentally the same. Of course, a long time ago, I thought a picture was a picture only if it was painted. Later on I found to my great surprise that I could see a photograph as a picture – and in my enthusiasm I often saw it as the better picture of the two. It functions in the same way: it shows the appearance of something that is not itself – and it does it much faster and more accurately. That certainly influenced my way of seeing, and also my attitude to fabrication: for instance, the fact that it doesn't matter at all *who* took the photograph.

In the black-and-white photo paintings, in particular, there is a strong emphasis on the fact that these are photographic; that they're unequivocally paintings from photographs.

I meant the pictures to have this likeness to photography – if only for the sake of the credibility that photographs have, especially black-and-white ones. There's something documentary about them. More than any other kind of depiction, you believe in them.

Isn't that a false faith?

It can be, of course. The only true reality is always the reality that we see and experience directly.

Notes, 1990

12 September 1990. Accept that I can plan nothing.

Any thoughts on my part about the 'construction' of a picture are false, and if the execution works, this is only because I partly destroy it, or because it works in spite of everything – by not detracting and by not looking the way I planned.

I often find this intolerable and even impossible to accept, because, as a thinking, planning human being, it humiliates me to find out that I am so powerless. It casts doubt on my competence and constructive ability. My only consolation is to tell myself that I did actually make the pictures – even though they are a law unto themselves, even though they treat me any way they like and somehow just take shape. Because it's still up to me to determine the point at which they are finished (picture-making consists of a multitude of Yes/No decisions, with a Yes to end it all). If I look at it that way, the whole thing starts to seem quite natural again – or rather Nature-like, alive – and the same thing applies to the comparison on the social level.

30 May 1990. It seems to me that the invention of the Readymade was the invention of reality. It was the crucial discovery that what counts is reality, not any world-view whatever. Since then, painting has never represented reality; it has *been* reality (creating itself). And sooner or later the value of this reality will have to be denied, in order (as usual) to set up pictures of a better world.

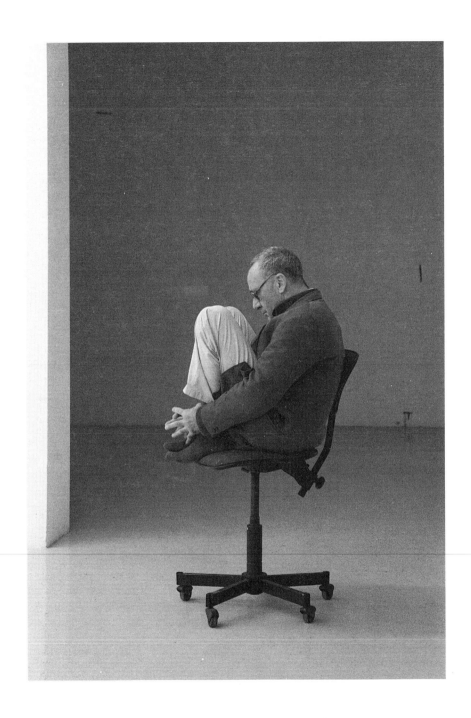

5 May 1990. What sort of an occupation is this, in which you can afford to be tired, or not in the mood – in which you can be off form for days or weeks on end and not do a thing?

2 October 1990. Baselitz exhibition.* He presents painting as unswerving persistence, as a path without compromises, without controversy, without a Utopia, without a dream: simply being (breathing without meaning – a metaphor for the incomprehensibility of Being, which always 'only' is, brutal though it may be – which breathes, and nothing more).

The pictures are sometimes good (and in any case beyond comparison with anything else contemporary) – and occasionally inane: which is when he compromises this pure act of painting by making sentimental allusions (the *Brücke* picture).

16 August 1990. Since the Rotterdam exhibition [October 1989], painting has become more laborious. At the end of December, I cancelled the exhibitions planned for this year at d'Offay and Durand-Dessert, so as to have a whole year to 'evolve' something without commitments. Since then there have been small and medium-sized pictures – very few big ones – nothing special, on the whole. Alongside this, the work for the Hypo-Bank design**, not very exciting either. A kind of aimless drifting. About twelve unfinished pictures in the studio at the moment: almost perversely wrong or nonsensical in the way they're laid out, without a governing idea, in the manner of a disoriented gambler who stakes a vast amount on a random card. The worst thing is that these pictures with their wantonly stupid design do have a certain quality or reality that calls for a continuation to match, but this is not really feasible. Start off by destroying them.

* Retrospective, Kunsthalle Düsseldorf, 1990.
** 18 Mirrors for the Hypo-Bank, Düsseldorf.

4 September 1990. The 'Dictatorship of the Proletariat' has long since become reality – especially here in the Western democracies, where it appears in its most bearable form. Mass society is a better name for it, because the masses have no class enemy left, and dictatorship has transformed itself into pressure of circumstances. By their presence and by their nature, the masses shape both circumstances and events in a quasi-natural way, relatively unplanned, often chaotic and potentially catastrophic. Hierarchic systems, Socialism included, are being replaced by a constantly self-reorganizing 'Aliveness' – without a plan, without an ideology, without any of those models and images (which never work, anyway) of the world as it is or should be.

24 October 1990. It doesn't seem functional that we dwindle away and end our lives, just when we have learned so much. And then the next generation has to spend decades slaving to regain the same standard of experience that has been reached long before. I know that's rubbish.

The much-maligned 'art scene' of the present day is perfectly harmless and even pleasant, if you don't judge it in terms of false expectations. It has nothing to do with those traditional values that we hold high (or that hold us high). It has virtually nothing whatever to do with art. That's why the 'art scene' is neither base, cynical nor mindless: it is a scene of brief blossoming and busy growth, just one variation on the never-ending round of social game-playing that satisfies our need for communication, alongside such others as sport, fashion, stamp-collecting and cat-breeding. Art takes shape in spite of it all, rarely and always unexpectedly; art is never feasible.

Letter to Werner Schmidt, 1990

Cologne, 18 July 1990

Dear Dr Schmidt,*

Many thanks for your letter asking for a few words from me – a request that is not very easy to comply with.

As to the circumstances of my departure, I can offer nothing but commonplaces – for example, that art requires freedom in order to develop, and that in dictatorships there is no art, not even bad art. Not only is this proved by the vast quantities of vapid art that is permitted to be made in the West: it has to do with an intrinsic quality in art, which makes it dependent – certainly more so than literature or music – on a specific climate. And when it comes to so-called modern art, with its declared autonomy (no longer serving a purpose and depicting something, but creating itself as a reality in its own right), then all tutelage is lethal.

Of course, reflections of this kind were not the reason why I left: my reasons were the same simple-minded ones as with all the other 'absconders from the Republic': to get away from the institutionalized lie, the suffocating tutelage. It's all a long time ago, for me, and my GDR citizenship has long been non-existent (if it was ever real to me at all).

'Citizenship Revoked': I don't really know what to say.

It may well not be a good exhibition; it may well bring together works which have little to do with each other, which make an odd mixture, which will lead to a lot of misunderstanding. But perhaps these very shortcomings, allied to a certain modesty, will be an asset in themselves.

Its other definite asset is that it is being done at all, and that a start is being made with the lengthy and wearisome process of 'coming together'. I therefore welcome this exhibition, no matter (almost no matter) what is shown in it.

I wish you the very best of luck with it, and remain

Yours sincerely, Gerhard Richter

* One of the many East German intellectuals who were expelled and had their citizenship revoked, Schmidt returned to Dresden after the fall of the Berlin Wall and curated for the Albertinum an exhibition of work by ex-DGR artists living in the West, *Ausgebürgert: Junst aus der DDR 1949–1989*. He is now Director General of the Staaliche Kunstsammlungen, Dresden.

Interview with Jonas Storsve, 1991

In 1981 the Danish painter Per Kirkeby wrote of Georg Baselitz: 'That was the end of the 1960s, and who still remembers the artistic Zeitgeist *that made painting almost impossible? In sheer desperation, those of us who could not keep away from the proscribed activity of painting salved our consciences by resorting to all sorts of let-outs: painting only on Sundays, painting only left-handed, turning paintings upside-down.' Did you have the same problem in the 1960s, and if so how did you solve it?*

I just went on painting. But I clearly remember that this anti-painting mood did exist. At the end of the 1960s the art scene underwent its great politicization. Painting was taboo, because it had no 'social relevance' and was therefore a bourgeois thing.

Has being a painter got any simpler since then?

It hasn't got any simpler, because it does the artist no good if society accepts any and every kind of painting, if painting is consumed en *masse*, as uncritically as it has been over the last ten years. You end up feeling as forsaken as ever. It hasn't got any simpler; there's more money around, that's all.

In 1981 you exhibited at the Kunsthalle in Düsseldorf jointly with another great German painter, Georg Baselitz. How did that exhibition come about, and how do you see your own work in the context of this relationship?

I think my painting is more fragile, more endangered and more complicated than that of Baselitz, which always seems to me to be far more confident or self-assured: it is done like a natural piece of work, with no room for doubts. This matter-of-factness and strength in his paintings is something I now value very highly. At one time I didn't like him much, and he didn't like me. We were in two different 'camps'; he was with Werner and I was on the other side, and things got quite hostile. Perhaps the exhibition was seen as an experiment, a way of bringing the two of us, or the two camps, closer together. It didn't achieve much. Done now, it might be more interesting – but I don't really believe that; what would be the point of bringing together Seurat and Manet, or Titian and Velázquez?

Whose idea was it?

Jürgen Harten, Rudi Fuchs, Konrad Fischer, Michael Werner and many others wanted it. It was a piece of showmanship. We were both sort of famous by that time, and it was as if we had to be put in the ring together. But there was no contest. We stood side by side and did nothing to each other. Even though the exhibition didn't make much public sense, and the forced comparison (which is better?) may not have achieved much, it did make me look at the pictures, his and mine, rather more closely than I would have done otherwise.

Were you influenced by Duchamp, when you painted the pictures Woman Walking Downstairs *(1965) and* Ema *(1966), and when you made the* Four Panes of Glass *(1967)?*

I knew Duchamp's work, and there certainly was an influence. It may

partly have been an unconscious antagonism – because his painting
Nude Descending a Staircase rather irritated me. I thought very highly
of it, but I could never accept that it had put paid, once and for all, to
a certain kind of painting. So I did the opposite and painted a
'conventional nude'. But, as I said, it was an unconscious process, not a
strategy. The same happened with the *Four Panes of Glass*. I think
something in Duchamp didn't suit me – all that mystery-mongering –
and that's why I painted those simple glass panes and showed the
whole windowpane problem in a completely different light.

*You're now working with glass again. A mirror picture is on the wall
here in the studio, and in your last exhibition in London there were a
number of new mirror works. Does all this still relate to the same set of
issues, or has that altered with the passage of time?*
It's about glass again. This time glass that doesn't show the picture
behind it but repeats – mirrors – what is in front of it. And in the case
of the coloured mirrors, the result was a kind of cross between a

monochrome painting and a mirror, a 'Neither/Nor' – which is what I like about it.

Do you get a similar feeling from your early representational pictures?

Yes, maybe I do. Those have the same blurred look, whereby something has to be shown and simultaneously not shown, in order perhaps to say something else again, a third thing.

In 1979 you painted a cycle of works after Titian's Annunciation *(in the Scuola Grande di San Rocco). Why did you choose that picture in particular?*

Simply because I liked it so much. I saw it in Venice and thought: I'd like to have that for myself. To start with, I only meant to make a copy, so that I could have a beautiful painting at home and with it a piece of that period, all that potential beauty and sublimity. I don't really know what the period was like: maybe it was ghastly. But the theme is very beautiful. This woman to whom something is being announced: a beautiful truth, and no doubt well painted. But then my copy went wrong, and the pictures that finally emerged went to show that it just can't be done any more, not even by way of a copy. All I could do was break the whole thing down and show that it's no longer possible.

You had a long period of painting mainly abstracts, and then in 1988 you painted the cycle 18 October 1977. *In your last exhibition in London there was one additional representational painting, the portrait of your daughter* [Betty], *which was painted during the same phase. And in 1987 you went back to painting landscapes. Have you an idea for a new representational cycle?*

No, more's the pity. I'd very much like to paint figurative pictures, but I don't know how.

But you do still paint landscapes?

Not any more. I don't like any of my photographs. I'm still taking them, though not so many of them. Perhaps it's because I can imagine how it would all turn out, and I don't like it.

Might that be a similar situation to what happened in 1976, when you painted only Grey Pictures?

Yes, now might be the end. (Laughs.)

In the cycle 18 October 1977, *you took not only your theme but also your format from history painting (the biggest picture is more than 2 metres by 3). The* Dead Man *seems even to bear a resemblance to a celebrated nineteenth-century history painting, the* Dead Toreador *by Manet.*

I don't think so. Most history paintings were much larger. I'm not really very interested in history painting, and I don't know much about it. The starting points for my October paintings were photographs.

Photography has always played an important part within your work, partly as a motif, but also as an autonomous medium – as in your earlier photographic multiples, or more recently in the 1990 self-portraits. What is the importance of photography within your work? Does it have equality of status with painting?

There is never any such thing as equality of status. But I've never thought about what significance photography has for me. Painting is the form of the picture, you might say. The picture is the depiction, and painting is the technique for shattering it. Now there's painting on one side and photography – that is, the picture as such – on the other. Photography has almost no reality; it is almost a hundred per cent picture. And painting always has reality: you can touch the paint; it has presence; but it always yields a picture – no matter whether good or bad. That's all theory. It's no good. I once took some small photographs and then smeared them with paint. That partly resolved the problem, and it's really good – better than anything I could ever say on the subject.

Photography plays a very big part in present-day art. One almost gets the feeling that photography has taken over the role previously performed by painting. Does photography suit our age better than painting?

There's almost nothing left to say about photography, because it's so obvious that photography has taken away one important part of painting: the function of portraying, depicting. This has made a great difference to painting. But the invention of photography wasn't the only reason for the change. Music is passing through comparable difficulties, undergoing comparably vast changes, and those can't be

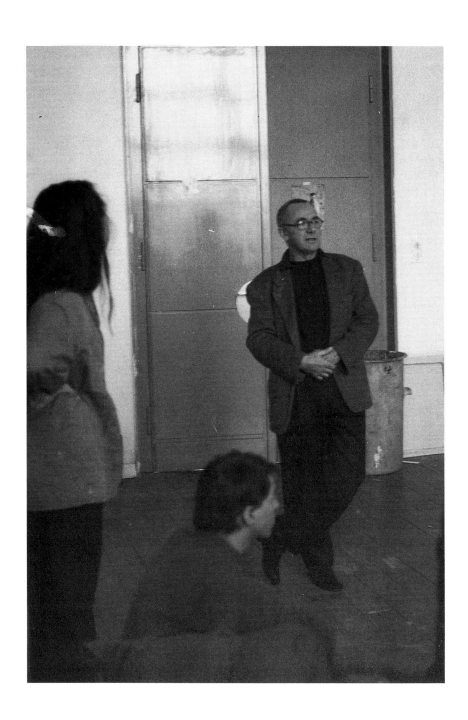

228 Kunstakademie, Düsseldorf, 1992

traced back to any one technological innovation. There are other causes. But this is a complicated subject, best left to the specialists.

Is there a way forward for painting?

Yes. We're carrying on, and true painting has yet to come – maybe in the next millennium. (Laughs.)

You also teach. Is it really possible nowadays to teach a thing like painting?

Virtually impossible. Nevertheless there are reasons, and I don't mean reasons of artistic technique, that justify a course of study at an academy; because the conventional structures – a class, a studio, students, teachers, administration and all that goes along with it – constitute a social order in which it is possible to change both content and working practices. The academy today basically operates in the right way, even though the teachers haven't much to say and the students are pretty idle by past standards. The work being done is of a completely different kind – I hope!

Many critics speak of a constant process of stylistic change within your work, and you seem to have no single identifying characteristic. Is this a conscious tactic on your part, a way of evading all efforts to fit you into a category; or is it an unconscious need to have more than one way of expressing yourself?

More of an unconscious need: one that corresponds to my personal structure, and one that makes it unendurable for me to have to do the same thing all the time. I'm too restless for that; too uncertain, too. And in this day and age I can never imagine myself taking up an obstinate, immovable stance. On the other hand, I do perceive an unchangeable basic attitude, a constant concern that runs through all my works like a style. That's why it's quite easy to identify my pictures, however different they are externally; they're often easier to recognize and identify as 'Richters' than pictures by any other painter. And that's why it's really wrong to talk about frequent changes of style in my work. You wear different suits on different occasions; that has nothing to do with style.

How did you come to do the Abstract Pictures? I mean the pictures painted without photographic originals.

It's hard to put that in a nutshell. It's a long evolution – from
childhood onwards. (Laughs.) Perhaps because non-representational
painting is so simple to do: it's just getting colours down on paper.
Totally free, or so it seems. It's still fun today. When I was eighteen,
I handed in my first portfolio as an applicant for admission to the
Dresden Academy – it was all wild daubs, and of course they didn't
take me. Much later, I took it more seriously. And I've been doing the
Abstract Pictures, properly so called, only since 1976, when I quite
deliberately accepted the random, wilful element and painted those
fairly colourful, heterogeneous pictures. Perhaps I was harking back
to my youthful beginnings. At all events, this kind of painting still
fascinates me today; it feels like a force of Nature.

Are these paintings still random and wilful?

Not directly, any more. I'm more concerned now to have them evolve
of their own accord. I don't work at random but in a more planned
way, in the sense that I let a thing happen by chance, then correct it,
and so on. The actual work consists in taking what appears, looking
at it and then deciding whether it's acceptable or not. Perhaps this way
of working has something in common with the Readymade: the artist
lets someone else – it doesn't matter who – do the work of making the
objects, and the real work lies in observing the thing and deciding
whether it's any good. I think the same thing is typical of our present-
day art. It doesn't matter how the things are actually produced:
painted, built, installed or however.

*You said earlier that you took an interest in abstraction during your
time in Dresden.*

It was a forbidden tendency at that time, and I had no idea what it was
really like. What I was doing was pretty childish.

*When you crossed over to Düsseldorf in 1961, the West German art
scene was dominated by Art Informel and Zero.*

Yes, but at the same time there was Nouveau Réalisme, and then came
Fluxus and Pop – and all that mattered much more to us.

*What was your reaction? Did you feel at home in any of these
movements?*

For a short time I did feel that I was a Pop Artist, but the main thing

is that Pop and Fluxus had a decisive influence on me – like Tachism previously. Nouveau Réalisme was never that important to me, and Zero not at all.

Your work is now shown in many different contexts. This year, you're represented in the Pop Art *show in London, as well as in* Metropolis *in Berlin.*

I've always really liked that – being shown in a variety of exhibitions and settings.

You don't mind critics and art historians interpreting your work in different ways?

No, I don't know exactly what it is, myself. It's only natural that there should be a number of different interpretations.

Many see your work as conceptual painting.

I don't really know what that means. It's obvious that you occasionally reflect and think about what you're doing and what you might do. In that sense, all painting is conceptual, except the painting of idiots. But I am primarily a painter, and so I'm neither a Conceptual Artist nor an intellectual.

How do you yourself see your work? Is it divided into separate groups, or do you see it as different aspects of the same thing?

I think it comes down to different aspects of the same thing – and if you like you can always subdivide and arrange that. You can put it into a lot of pigeonholes: small pictures, big pictures, medium-sized, representational pictures, colourful pictures, black-and-white pictures. But what counts is always just one thing: how I am to cope in this world, with myself and with painting.

Interview with Doris von Drathen, 1992

I am not nearly so talented as you think.

As a painter?

As a talker. I've never studied it; it was never my inclination, never my skill.

Writing, on the other hand?

That happens quite rarely, too. When I'm alone and in the right mood: then it sometimes works. But talking is hard.

We were only going to talk about quite simple things, such as the question whether the analytical, aesthetic debate about your painting might obscure the pictures themselves and their power. They strike me as being painted by someone who believes in pictures.

Belief is something with many sides to it. Believing in pictures like believing in God – or believing in pictures in a practical sense, at a time when painting is rather out of favour – or believing that pictures still make sense. And that I am sure about. We're always creating pictures; take fashion, for example. We put something on because we believe in it, and we thereby offer a picture of ourselves that tells other people who we are and what we're like. The same happens in other ways – we're always creating pictures for other people to understand if they can.

So paintings too –

Here there's a lot more to do than there used to be – because in abstract

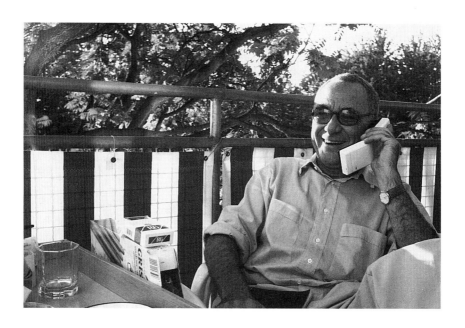

paintings, like these, there's not much to see. Here faith plays a bigger part. And often you turn out to have believed in something that isn't true.

Do you believe in your own paintings?
There are a few that I like, but I wouldn't go so far as to stand up and say I believe in them.

But surely you ought to – otherwise why go to all that trouble?
Of course, I have to believe that I can produce something useful. And the pleasure of making counts for a lot in painting – as when someone's making music. There's no room for doubt.

Doubt as to what?
That it might make no sense, or be unnecessary or passé.

Doubt as to the possibility of still making a picture you can believe in?
There are so many believable pictures in the world, and we love them; we travel long distances to see them. We need them. And there are some people who need to make pictures themselves.

How does this idea of need relate to your earlier statement that you were looking for the maximum possible indifference?
That was an attempt at self-protection – saying that I was indifferent, that I didn't care, and so on. I was afraid my pictures might seem too sentimental. But I don't mind admitting now that it was no coincidence that I painted things that mattered to me personally – the tragic types, the murderers and suicides, the failures, and so on.

If we look at the photo paintings, the Atlas *and the Abstract Pictures as a coherent whole, there may be a factor in common – the idea that someone is looking for a way to grasp an appearance.*
That may be so. But what do you mean by appearance – the way reality looks, or what appears in the pictures?

I'm thinking rather of Giacometti's sense of grasping an appearance: the way your pictures duck away from the viewer reminds me of the way he tried to catch a fragment of reality by surprise; or the way Sartre describes that awkward borderline between the registers of 'there is' and 'there exists'.
That's too difficult for me. This cup: it exists, and it appears. The photograph there shows only the appearance of the cup.

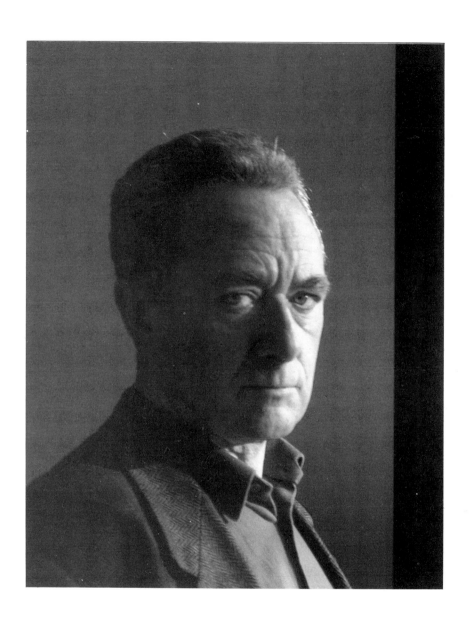

234 Museum Haus Lange, Krefeld, 1989

And the painted picture?
The same.
Is the painted picture closer to the reality or to the appearance?
In one sense it's closer to the appearance, but then it has more reality than a photograph, because a painting is more of an object in itself, because it's visibly hand-painted, because it has been tangibly and materially produced. That gives it a reality of its own, which then as it were substitutes for the reality of the cup.
So can a painted appearance tell us more about reality?
Perhaps it can, because it's more unsettling. It's always more or less different from reality, and that's unsettling. You ask more questions.
You get closer?
Yes, closer to our relationship with reality. The cup on its own is boring.
Exactly. Now let's take the Gulf War.
That's too difficult.
But this is just the set of problems we're talking about. What do you think of the theories of philosophers like Baudrillard or Virilio, who are the virtuoso commentators on the loss of our relation to reality, on the vanishing of reality? What do you think of essays like Baudrillard's, which must have appeared in German by now: 'The Gulf War Never Happened'?
I think absolutely nothing of it. Things haven't really changed that much. People in the past knew about wars by hearsay, too; they were just told in a different way, that's all. It's exactly the same thing as television and newspapers nowadays. But maybe faraway wars of that kind don't always get to us any more, and we'd like to be in a real one of our own. A touch of bloodlust.
I was really thinking that maybe the theories on the aesthetic issue of 'reality loss' fail to take account of our responsibility to picture reality for ourselves. Wouldn't it be far more to the point to ask how, in a media-saturated world, we could manage to keep our consciousness wide enough awake to figure reality out, and react to it?
A small war, right here?
No, be serious. Don't you think there might be such a thing as an obligation to grasp reality, and to act on it?

But the fact that we know of the war by hearsay, or from television, *is* a reality. And then we have other, less passive realities as well, such as the reality I have here and now. And to me the distant, mediated reality is like an example or illustration of my own attitude or inner state. If people out there are slaughtering each other, that's not really so alien to me as all that.

Because what happens here in your studio is a kind of slaughter?
Yes, more or less.

Now I hardly like to ask what significance painting can still have, in relation to that responsibility of grasping reality.
It's hard to say whether – as people do sometimes assume – painting in the past had more effect and more reality, on the grounds that it was better understood, or more popular, or was always on view in the churches to everyone. But painting still has a reality and an effect now. It is shown and bought and discussed, and quite a lot of effort goes into all of this. And so long as the art justifies the effort, by being interesting enough, then in a sense that will do for now.

It might be possible for pictures to launch something like a leap in perception or in consciousness. Someone might suddenly look at things differently, react to them with more doubts, or with more involvement. Indifference might be overturned by pictures.
I believe it might. But I've got nothing to say on that subject.

You have no desires in that direction yourself?
Of course I have – it just doesn't do any good to take on that kind of elevated responsibility. We all know, don't we, what well-intentioned paintings look like.

Kasper König once showed your figurative paintings – the cycle 18 October 1977 – *and abstract paintings in direct succession, in order to show that the theme is the same.*
He was right to do that. Even so, it's difficult, because figurative paintings are always more attractive than abstract ones. As soon as there are persons or objects to be seen, you get more interest.

In 1968, in the period of the Grey Pictures and the Four Panes of Glass, *there is a double panel called* Way Through. *It gave me a sense of a sacrifice, in the joyous, pagan sense of the word: giving something*

*up and getting something in return. Did it feel like leaving something
behind you, shaking something off, slipping away from it, in order to
get to something different?*

Certainly. And for that you always have to give something up, or
destroy it, or scratch it out – as in this little abstract here.

*Let's stay with scraping off for a moment. Is this removal of paint
an aggressive thing?*

Yes, certainly.

It has something to do with injury.

Yes, with injury, and with taking something that has been made and
destroying it, subtracting it, scratching it out. And then the pleasant
feeling that you can get something else in return.

Perhaps that's the basic idea of giving things up.

Getting something better.

*In the very recent pictures the scraping is far more radical; and it
goes deep, right down to the ground of the canvas, which is laid bare.*

Yes.

*Has that got anything to do with pleasure? It may be that only
activity satisfies.*

In a sense, yes, it does, but then you start to see what has come out of
it, and then you aren't satisfied any more. So you start all over again,
and again, until it's right, and then it looks quite simple – successful,
somehow – as if it were perfectly easy to make and easy to repeat. But
unfortunately you have to take the long way round every time. You
have to put in the whole effort to paint a picture, fail, go on painting
and so on.

*What about the light in your pictures? In the early abstracts, or so it
seems, the light is placed centrally, like the Gesù Bambino in the Early
Renaissance; but in the Forest series and the Red series the light is
diffuse, like light underwater. How do you place your light? Intuitively,
as with everything else?*

Certainly. I've never really thought about it. Somehow I tend to start
off with very bright colours, and they get more and more veiled, or
else brought forward again, or added on. But light is the right word,
because these bright areas always have an illusionistic aspect to them.

238　Museum Haus Lange, Krefeld, 1989

You once painted two eagles for Marcel Broodthaers. What sort of contact was that? Did you have anything to do with his ideas?

He was an incredibly likable and fascinating man; we always greeted each other warmly, and from time to time we ate together – but to this day I still don't understand what he was doing. I like it, and I'm always glad to see it.

And the Eagles *for the 'Département des Aigles'?*

He asked whether we could make an exchange of works. So that's how it happened.

But you never had any affinity for his ideas.

I never got involved with them.

The Eagles *do have something noncommittal or encyclopaedic about them, like the 48* Portraits.

They all come from an encyclopaedia. At one time I used to find encyclopaedias somehow comforting.

Comforting in the sense of circumscribed and verifiable?

Yes, neutralized and therefore painless.

And why do you say 'at one time'? Don't you need that kind of comfort any more?

I'm afraid it wears off.

Looking through your Atlas *I always get the feeling that I am just about to understand the system on which you based your selection; but then an image crops up that demolishes all the criteria.*

I don't really understand that. I always thought there was a consistent, dominant way of seeing, a basic intention that's just there, whether I like it or not.

So can you agree with a blanket interpretation of all your work – the sort of interpretation that is attempted in this monograph here – seeing the pictures in terms of walking along an existential knife-edge?

I couldn't put a name to it.

So is such a view entirely beside the point?

No, it's not. But how can I start talking like that?

I can't come along and say here I am walking along a knife-edge, right on the brink, another day and I'll kill myself.

What reason is there for continuing to paint?

Money.

You must surely have enough of that by now. You don't seriously believe that.

No – but what else am I supposed to do, question the point of painting?

That's just it. Why is painting needed? Because it's clear that it is needed.

You can't count on that. It's like a fashion or whatever. People have a kind of blind faith in painting for a while, and then they wake up, as if from a big dream, and realize that they've been buying nothing but nonsense.

But let's get back to this idea of need. Can pictures save us? Does painting make us into better people?

In principle, yes. Yes.

Is painting better placed than other media to satisfy Sedlmayr's yearning to find a way back to the Centre?

That Centre is long since lost, and there's absolutely no point in trying to reinstate it.

But painting is possible, and necessary? In the midst of all the image overload generated by the mass media, perhaps painting is necessary so that we can still have some pictures which – without harking back to the nineteenth century – can create detachment precisely by incorporating the new experience of virtual worlds; pictures to create what Aby Warburg calls 'space for mature thought'; pictures to give the human individual some sense of his or her own autonomy?

I have difficulties of my own with concepts like detachment and autonomy, and I'm reluctant to attach a name to what it is that painting gives us. All I know is that painting is useful and important, like music and art in general – that painting is an indispensable necessity of life.

Notes, 1992

1 June 1992. So-called circumstances cannot be changed by reason and insight; they change themselves in unpredictable ways, more or less spontaneously.

For instance, the realization of climatic damage and the prospect of a climatic catastrophe creates fear, but no effective action towards changing it.

On the contrary, fear is only a sign of our certainty that we can change nothing, and to palliate our fear we go in for displacement activities that make not the slightest possible difference; just like our ancestors, who faced up to Nature, armed with nothing but prayers and sacrificial offerings.

Nature goes on, as naturally merciless as ever. It creates the continual changes that we have always feared. We are helplessly and painfully at its mercy, and can do nothing but palliate and comfort ourselves.

Palliation is always childish: a few green corners in the car parks. Comfort is always a lie: false promises of a beautiful future. That seems to sum us up.

3 June 1992. Consciousness is the capacity to know that we and others are and were and will be. It is therefore the capacity to visualize, and therefore the belief that keeps us alive. Without visualizing the future, and our own goals and tasks, we should vegetate and — since we lack the instinct that the animals have — we should perish. Belief (view, opinion, conviction, hope, plan, etc.) is thus our most important quality and capacity. And in the form of faith it can dominate us with such power and conviction that we transform it into destructive superstition. That is why we must always confront belief with scepticism and analysis.

26 June 1992. It might be for us to look on killing as part of our own nature — of the very Nature that we seek to regard as our antithesis, as the inhuman, 'blind' Nature of natural disasters, carnivorous animals and exploding stars.

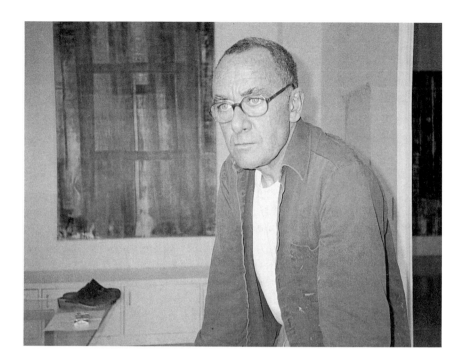

Our behaviour conforms to this Nature in two ways: on the one hand as active killing, both in wars and as civilian murder; on the other in the still more horrifying passive mode of assent (we watch the news while eating dinner; we enjoy seeing murders in films). This is because of the way we take death for granted: just as we know that we are alive, we know that we die; death comes as naturally to us as life. The instinct to stay alive limits our compassion and our willingness to help; we give our help and our pity only under duress, and when it seems to be to our own advantage.

The suppression and repression of these facts gives rise to dangerous delusions, the politics of hypocrisy, false and lying actions.

And yet to accept them would be so unimaginable and so unworkable that we knowingly and impotently prefer to allow for – that is, include in our plans – all future catastrophes.

2 September 1992. It would be easy to say that the growing and baffling complexity of the world causes and accelerates the relapse into barbarism and the destruction of civilization through sheer helplessness and apathy. But all the tradition I can pick up goes to confirm my opinion that things have never been any different, that the world has always been complex and baffling, and that civilization and art have very seldom become a reality. Murder and mayhem are the norm: unmitigated chaos.

5 September 1992. Almost every day we get the fat catalogues of exhibitions and so-called collections; we read of newly built museums, of gigantic cultural foundations of all kinds; and indeed the sums laid out from State, municipal and private funds for art and culture are dizzying. It would be interesting to find out the total sum expended for these purposes over the past ten years. Whatever it might turn out to be, it would strikingly confirm our natural lack of compassion for the poor.

19 September 1992. No religion has ever promised Paradise on Earth; only the Communists have ever been stupid enough to do that. It makes them not only frauds but murderers. Because, by transferring all the blame to others, they make themselves absolutely good, and thus rob themselves of the capacity to attempt anything good whatever.

(And anyone who believes that he can change the whole world is bound to regard any small improvement of the status quo as sabotage.)

Blasé scum.

Our own malevolence (which ranges from lack of compassion to the homicidal impulse) is something we have to accept, as we do our intrinsic fallibility and inadequacy. That is the only way we can ever enable our better sides to develop and to act.

The repression of evil creates hypocrisy, and hypocrisy is not only a 'homage to virtue' but the subtlest way of translating our own evil into reality (thus wiping out a few individuals or hundreds or thousands or millions).

Hypocrisy, being the murder weapon that suits us best, also makes it easier for us to indulge in arrogant condemnations of the killing methods of the past – which actually did incomparably less harm.

22 September 1992. Scraping off. For about a year now, I have been unable to do anything in my painting but scrape off, pile on and then remove again. In this process I don't actually reveal what was beneath. If I wanted to do that, I would have to think what to reveal (figurative pictures or signs or patterns); that is, pictures that might as well be produced direct. It would also be something of a symbolic trick: bringing to light the lost, buried pictures, or something to that effect.

The process of applying, destroying and layering serves only to achieve a more varied technical repertoire in picture-making.

23 September 1992. Because Marxist intellectuals refuse to own up to their own disillusionment, it transforms itself into a craving for revenge. And so they turn their own ideological bankruptcy into the

utter bankruptcy of the whole world – mainly the capitalist world, of course, which they vilify and poison in their hatred and despair. 'Political correctness' is one of their methods, whereby they even accept the destruction of their own values in order to do more effective damage.

25 September 1992. To the depressive, all pictures become vacuous, meaninglessly painted rectangles, no matter what they represent. He sees them with the eyes of a cow – and, worse, they cause him disgust and pain.

The art world seems increasingly to suffer from this disease, and we can expect decades of misery (the price to pay for previous mania).

17 October 1992. Hypocrisy is the display of a respectability that can never be achieved. Worse still, and a public menace, is the edifice of respectability presented by ideologies: they are recognizable as tissues of lies, but indispensable as means to terror. This becomes a double hypocrisy: that of believing what is not true, and that of proclaiming what is not even believed. It also does double damage: it is like criminal assault and self-mutilation in one. This practice must make sense in some way as yet undiscovered.

17 October 1992. All this exaggerated humaneness and helpfulness – this compassion with every murderer in a death cell, every fish that perishes in an oil slick and every dying tree – all this stands in contrast to the unprecedented vastness of the misery currently caused by war, starvation and disease; it stands in contrast to the predictably catastrophic future of an overpopulated earth whose inhabitants are going to slaughter each other and starve to death in unprecedentedly chaotic circumstances – it contrasts with the inevitable emergence of a conscious contempt for humanity and an extreme incapacity for love or mercy. It springs from the fear of all this.

19 October 1992. It might seem that we are less cruel and merciless than we were a hundred years ago, when mutual mayhem was publicly

practised and accepted. And we have indeed become more sentimental: we cry when animals are maltreated, we take pity on refugees, and we do our best to protect embryos, to love Gypsies and make things all right for the disabled; we can no longer stand idly by when someone dies; but we look on as thousands perish, starve and are murdered; we see and hear and read the daily growing figures that represent the misery and death of millions; we store the figures and add them up. Panic. (But most of the time we manage to salve our consciences by planting a tree.)

18 November 1992. We have no possibility of coping with the daily growing numbers of people who are unemployed, homeless, starving, dying of epidemics, persecuted and abused. What we achieve, often with desperate commitment, is no more than a minimal, palliative gesture. We would have to turn the whole world into one vast camp, which would operate not much more humanely than Auschwitz. So we let Nature take its course. We have never yet been able to do anything else.

3 December 1992. For some time now, the Marxists have been gloating again: since the collapse of Socialism, misery has grown. They still believe in a 'system' – which causes the misery, if it is a right-wing system, and which would put everything right, if it were a left-wing system.

8 December 1992. Artist: more of a title than a job description. It's a word that still earns you considerable respect. People associate it with splendour and misery, with the attainment of freedom and with unexampled independence. Artists' lives seem exceptional and exotic: they are ahead of their time; their works are among the loftiest works of the human race; their undaunted courage defies the incomprehension of the philistines and the persecution of the dictatorships. Artists are the truly creative ones, the geniuses; their fame and the fame of their works derives from their God-given talents and from their passionate devotion to their work, which they perform with intuition

248　Studio, Cologne, 1992

and intelligence on behalf of the community. They are always progressively minded and critical of society, always on the side of the oppressed; and, rich or poor, they are always privileged.

Understandably, everyone would rather be an artist than endure the shame of some ordinary occupation. But the artist's image is going to be adjusted, sooner or later, when society realizes how easy it is to be an artist, and to set down (on or off the canvas) something that no one can understand and consequently no one can attack; how easy it is to inflate one's own importance and put on an act that will fool everyone else and even oneself. By then, if not before, the title of artist will induce nausea.

11 December 1992. Seen rationally, what we live through, and therefore call Life, is senseless, useless, vain, unnecessary – an absurdity. Our reason chases after it, constantly supplying us with interpretations and justifications that are of course nothing but flimsy attempts to bend and block the truth.

14 December 1992. Fears of death. Our fear of death comes from the certainty of dying and the uncertainty of the way of dying. In very much the same way, we are frightened by the predictable, catastrophic future of the world; because our minds respond to the present in terms learned from the past, we cannot see the galloping growth of population as anything but a disaster. Nor can we comfort ourselves by reasoning that circumstances themselves affect our judgment, so that we cannot anticipate the salvation that lies in the future, or think the thoughts that future events and needs will suggest.

Where catastrophes have been foreseen in the past, there has mostly been no chance of averting them: the full weight of suffering has had to be borne. ('Things are never as bad as they look' mostly has to be replaced by 'It's always worse than you think.')

Nor is it any real comfort to know that ideas of death, suffering and dying frighten the healthy more than those who actually are suffering or dying – who often accept suffering as an all-absorbing duty, far more so than the professional duties of their healthy lives.

It is also no real comfort to know that the will to live is ineradicable until the organism is destroyed (even though a kind of endogenous opiate makes dying more bearable, and though the organism, or its will to live, generates hope in defiance of reason until the very last moment).

Hope blinds reason. It is produced by a physically and psychically intact organism as a kind of hallucinatory drug, in order to distort the realistic perception that would weaken our will to live. Animals have no consciousness, and therefore they need no hope. But they are essentially no different from us; they are possessed by the same craving for life, which forces them – as it does us – to stay alive until the last breath is drawn. Aliveness, or the craving for life, uses the organism until the latter is destroyed. It is therefore wrong to assume that the will to live is a property of the organism: nor do the genes created by the organism govern its will to live, but the reverse: it is 'Life' that creates the physical organisms for itself and uses them until death, in order to remain active as Life.

A terrifying – because utterly inexplicable – vision. Aliveness, Life, as an invisible, non-material Something; a monstrous Unknowable, by which we are abused. And the catastrophic, blind superabundance of our own reproduction, like the remorseless squandering of organisms to the point of the destruction of whole species, only goes to confirm this.

Life is therefore inexplicable, in the same way as the Big Bang and all those physical and extra-physical processes in the universe; and certainly made of the same stuff. Energy and mass: the most unsatisfactory name for it.

(If, as has sometimes been said, we are only the envelopes, the will-less tools of the genes, this only raises a chain of further questions: whose tools are the genes, and so on, down to the ultimate cause. It seems to me that no one has ever enquired as to the nature of the 'energy' which drives a virus to be alive and to reproduce itself, and which produces the virus for itself as its bearer. I did not use the relatively apt word 'energy' earlier, perhaps because it is so much taken for granted that no one asks what it is.)

30 December 1992. What counts is the world of the mind, and of art, in which we grow up. Over the decades, this remains our home and our world. We know the names of those artists and musicians and poets, philosophers and scientists; we know their work and their lives. To us, they – and not the politicians and rulers – are the history of human-kind; the others are barely names to us, and the associations that they arouse, if any, are horrific ones: for rulers can make their mark only through atrocities.

No greater contrast is conceivable than that between Kafka and Kaiser Wilhelm II.

Interview with Hans-Ulrich Obrist, 1993

You were uncertain about these 1962 Notes.
Yes, it all sounds rather sententious and stilted.

It begins like this: 'The first impulse towards painting ... comes from the need to communicate.'
That's certainly not wrong, but it's a bit of a truism.

In the same text you dissociate yourself firmly from the idea of Art for Art's Sake. Against that you emphasize the idea of content – not imposed content, but also not content infiltrated through the back door, of the kind you hear of nowadays.
That was an idea that was current in the East in the 1950s, a kind of ritual abuse of decadent, bourgeois art. Somehow or other I had managed to internalize the idea that art can't be Art for Art's Sake but has to be about communication; I later said the same thing in a different way.

The repetitions between one text and another bring out certain basic structures in your thinking, such as your aversion to ideologies.
That's probably innate. By the age of sixteen or seventeen I was absolutely clear that there is no God – an alarming discovery to me, after my Christian upbringing. By that time, my fundamental aversion to all beliefs and ideologies was fully developed.

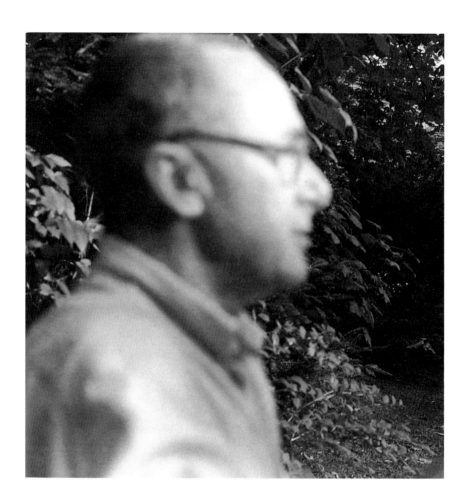

252 Südpark, Cologne, 1991

This runs like a scarlet thread, as it were, through all the texts.
And on the other hand the knowledge that we need belief – which
I sometimes refer to as a mania, an illusion that we need in order
to survive or to do anything, a prime mover. And at the same time
this vulgar materialist view that we do not essentially differ from
the animals, that there is no such thing as freedom or free will –
this doesn't directly come out in the texts, but those convictions
were established very early on.

That sounds fatalistic.
So it may, but the important thing for me is that this kind of fatalism
or negativism and pessimism is a useful strategy in life; there is a
highly positive side to it, because one has fewer illusions.

Hopeless, or inescapable?
Either will do, to make us feel better, to make us create hope.

So hope is another scarlet thread?
Hope is something I always have. And the less we deceive ourselves,
the more pessimistically and fatalistically we see a thing, without
kidding ourselves that we have free will, or that it is possible to move
a pencil from left to right by our own autonomous decision, the more
we shall succeed in not succumbing to false faiths.

The press invitation to the 'Demonstration for Capitalist Realism'
makes it clear that this was a unique event, a Happening.
And not the inauguration of an art movement.

More of a parody of all Isms.
Perhaps.

Why wasn't Polke there?
Purely by chance – maybe we'd temporarily fallen out at that time;
but then, this demonstration was never meant to be all that important.
We just wanted to do a little exhibition.

In the course of your conversations and texts, the word 'Readymade'
turns up again and again; especially from Buchloh, but also in more
recent notes and interviews in which you speak of your abstract paintings
as Readymades – which is taking things as far as Duchamp's statement
that the Readymade concept expands to include the entire Universe.
I do believe in the Readymade in this overriding sense, because if you

confine it to art alone it tends to turn glib and illustrative: the 'Plinth for the World' was one example of that.

Besides the 'Demonstration for Capitalist Realism', were there other, similar projects of the same kind that never came off?
Any amount of them. In Paris, on the roof of the Galeries Lafayette, we wanted to put up a photograph of the Alps, with a cut-out for the skyline, so that Paris could have its own Alps. And there are some lovely views in the Neanderthal area; we wanted to take people out there in buses and announce: 'Here is our art.' Others later did just that.

On the one hand there was this ubiquitous reference to Pop Art: existing and available images were taken out of context, appropriated and recombined. But on the other hand the 'Demonstration' also reveals a connection with Happenings and Actionism.
That's what fascinated me most, at that time. For instance, we were obsessed with the idea of holding an exhibition of Lichtenstein paintings, all of which we would paint ourselves. But that turned out to be too much work.

This scepticism about the ideas of authorship and genius has led to a number of attempts to deconstruct the Modernist claim to originality and authorship, by simply appropriating someone else's work without permission.
A terrible cop-out. Especially when a person builds his whole life on it. To do it once, as a demonstration, that I can understand.

In your response to Pop Art at that time, were you already distancing yourself from it, or were you involved in adopting or appropriating it as a movement?
My distancing was mostly about Good and Bad, and the idea or the programme didn't interest me for long anyway. And nothing has changed, really. I always thought that some were bad and some not very good, and the best were Warhol, Lichtenstein and Oldenburg. And that's the way it still is.

The 'Demonstration for Capitalist Realism' was an exercise in brinkmanship: it came close to a point where art dissolves into its social or political context, so that convergence must either take the form of

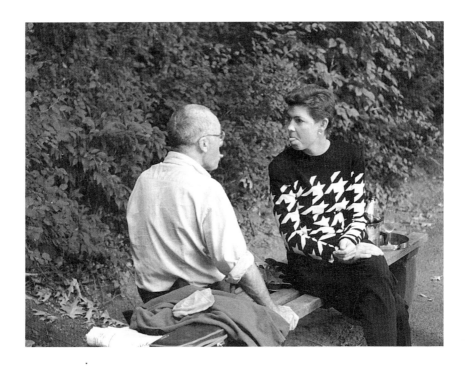

disappearance or of a clash. And as to contextual convergence: the Happening took place in a furniture store, and it left the existing display unchanged. Art converged with a pre-existent context; but it was never about art dissolving into the context of life.

Yes, we were rather playing with fire – to find out just how we could go with the destruction of art. But in principle I never had the remotest desire to allow painting or art to dissolve into anything else. That kind of radicalism made no sense to me at all, though radicalism was generally regarded as the be-all and end-all at that time.

As a criterion of quality?

No, Art was the most important quality. That's why I then made fun of it all in the Polke/Richter text for Hanover, and said that I was conventional and loved Raphael and beautiful paintings.

Were you then conscious of these distinct positions?

Yes, of course I was, and sometimes I had a guilty conscience about not being quite radical enough.

Not even in the 'Demonstration for Capitalist Realism'?

When you're doing a thing like that, you tend to get high on it and just do it. But then when you're making something of your own again, or thinking over how terrifically radical other people are – Pollock's drip paintings, or Carl Andre's metal plates, or Arman with his containers: now that was regarded as radical. And I've never seen myself that way; I've always painted.

In spite of your constant dialogue and exchange of information with Polke and Fischer, the mechanisms of group bonding were never formalized, as they were for instance in 'Art and Language'.

That was quite deliberate. There were rare and exceptional moments when we were doing a thing together and forming a kind of impromptu community; the rest of the time we were competing with each other.

There's this text lifted from a newspaper, on a poster for Galerie Friedrich & Dahlem.

Now that was a Readymade, wasn't it?

Your only textual Readymade known to me, except for the Perry Rhodan composite in the Galerie h catalogue, and your non-statement in the book by Herzogenrath.

To me it was just the same as a found photograph. But I don't think anyone twigged, because it was on the poster and just disappeared. Later I often tried out texts or text montages of the same kind.

How did the Perry Rhodan text collage come about?

We'd read the stuff, and it fitted into the utopian naivety of the 1960s, with all those ideas about other planets. This inartistic, popular quality, it all went together with photographs, magazines, glossies, that was the Pop side of it. All completely unimaginable today.

Another absurdist text is Polke's imaginary Richter/Thwaites interview. The term 'Pop painter' turns up in that: was it meant ironically, or did you all then define yourselves as the German representatives of Pop Art?

It was meant ironically; at that point we were trying to keep our distance from Pop. It was only at the very beginning that we were naive enough to go off with Konrad Fischer and do the rounds of the

galleries, Sonnabend and Iris Clert, and announce: 'We are the German Pop Artists.'

But the use of existing images and texts did come from the influence of Pop, which freed available, popular images from their contexts and saw them in a new way as pictures in new combinations.
Yes, of course, but maybe that can also be seen as the time-honoured practice of taking something over, setting it in a new context, and so forth. Nothing new, really.

In your texts and interviews the word 'Informel' turns up repeatedly. You don't categorically reject it, but you draw a clear line of demarcation between Informel and realism. At the same time, your work is a kind of reaction against the then dominant stylistic and manneristic games of the Informel and Tachist school, which arose from automatism – and the term 'Informel' stands for the exploitation of that potential. What does the word 'Informel' mean to you today?
As I see it, all of them – Tachists, Action Painters, Informel artists and the rest – are only part of an Informel movement that covers a lot of other things as well. I think there's an Informel element in Beuys, as well; but it all began with Duchamp and chance, or with Mondrian, or with the Impressionists. The Informel is the opposite of the constructional quality of classicism – the age of kings, of clearly formed hierarchies.

So in that context you still see yourself as an Informel artist?
Yes, in principle. The age of the Informel has hardly begun yet.

And this landscape here?
This is Informel, in spite of all the structure, which has rather a nostalgic look to it.

Although there's no leading idea, no leitmotiv, there's no uncontrolled use of chance either. In your pictures, chance never takes the decisions; at most, chance asks the questions.
It's the found object, which you then accept, alter or even destroy – but always control. The process of generating the chance event can be as planned and deliberate as you like.

In the same Notes you talk about the photographs everyone takes, and their function as cult objects. The banal source images reveal an

unexpected, lasting, universal pictorial quality. When you said that, were
you exploring the possible legitimization of illegitimate pictures – an
'illegitimate art', as Bourdieu calls it?
The legitimate pictures are the photographs – the devotional pictures
that people hang or set up in their homes. We then sometimes use
them for art, and that may well be illegitimate.

In the same Notes you also say that a photograph can be seen as
a picture, outside the categories of High and Low, ritual photography
and art. This is an important difference between you and Polke, isn't it,
your refusal to go in for darkroom manipulations?
That's more of a technical, formal point; it's not that significant.
I just don't like being in darkrooms. But to go back to legitimization:
perhaps it's also illegitimate to bring the snapshot form too close to the
Readymade. Photographs are only Readymades because they're so easy
to produce, by comparison with painstakingly hand-painted pictures; as
with a Readymade, you only have to select them. The whole distinction
is rather a shaky one, because it may well turn out that there are no
such things as Readymades at all. There are only pictures, which have
value to many people or to very few, which remain interesting for
a very long time or only for a few seconds, and for which very little
or a very great deal is paid.

So the people who take the snaps are artists –
Yes, and when I then paint another picture of Uncle Rudi, the little
officer, I'm actually watering down the true work of art achieved by
those two or three private individuals who put Rudi behind glass and
stood him on the sideboard or hung him on the wall. The only sense
in which I'm not watering it down is that by painting the thing I am
giving it rather more universality.

The displacement makes it exemplary.
Yes, and blurring was the only way of getting this done quickly.
The Photo Realists later painted photographs in a finicky, detailed way.
I haven't the patience for that; and then there are the distracting
perceptual factors that find their way in. One is the outsize format, and
the other is admiration of the labour involved: the fact that it takes a
whole year, the response of marvelling at the way it looks 'just like a

photo'. I wanted to avoid all that by cheapening the production values. You can see that a photograph is meant, but it hasn't been laboriously copied and duplicated. This worked, and the pictures had the basic resemblance to photography without looking like copies of photographs.

You talk elsewhere about photography as drawing – or as the camera obscura, which Vermeer used – in the sense of a preliminary stage in the production of a picture. This reverses the primacy of photography, which is supposed to have given rise to Modernism by breaking down barriers. You simply use the photograph in making the picture, as a matter of course.

In the traditional practice of painting, that's the first step. In the past, painters went out into the open air and sketched. We take snaps. It's also meant to counter the tendency to take photography too seriously, all that 'Second-Hand World' stuff, which is wholly unimportant to me. Many critics thought that my art was a critique of contemporary life: criticizing it for being cut off from direct experience. But that was never what I meant.

The camera crops an image. It doesn't give the one, absolute image. The selected, partial image pushes forward and simultaneously recedes.

It's often been said that my pictures look like details. That may be so, but I can't understand it, probably because I take it too much for granted already. But maybe it was meant to refer to a certain inconclusive, open-ended quality: pictures that are cropped on four sides but can never show anything but sections, details.

And each time just one of many possibilities.

There are exceptions, of course, where it isn't one of many possibilities at all – as in the *Betty* portrait or the *Ema* nude.

And the Burnt-Out House.

Maybe the house too. Those works tend towards the masterpiece, and if they aren't masterpieces it's just because I know that that just won't do; it's only ever like a quotation of a masterpiece, perhaps. But in principle everything is a detail.

In Betty *and* Ema *the masterpiece status just seems to creep in – I was also thinking of* Cathedral Corner.

But it can also happen with a Grey Picture. On a museum wall there's something masterpiece-like about it: the way it's hung.

And the other abstract paintings?

I might include pictures like *Janus* and *Juno*, for instance. But maybe only because they have such beautiful titles. There are some.

'SDI', 'OZU'. The masterpiece is the utter antithesis of the anecdote. And of the detail, and of the sequence. On the one hand you talk about the impossibility of absolute painting: on the other you bring back the concept of the masterpiece.

Perhaps that's what one is always striving for, the masterpiece; it's just that it never is one. The masterpiece seems so far outside time that one can't even strive to attain it.

In the German dictionary of the Brothers Grimm, 'masterpiece' is defined as 'an excellent, artistically perfect picture'. In his book Überwindung der Kunst (Transcending Art), *Alexander Dorner tells of a survey conducted in department stores to find the criteria of choice that defined the most popular pictures. The result is amazing. People buy colour reproductions and posters on the following criteria: (1) pictorial depth – a concept derived from centralized perspective; (2) narrative content.*

There's not much of either quality in Van Gogh's sunflowers. In that case, it's 'The Vincent van Gogh Story' that seems to be most important. And the whole masterpiece debate is relativized by the fact that the pictures we now regard as masterpieces may well have been the perfectly ordinary consumer art of their own day.

The 'Mona Lisa' had its aura, even in Leonardo's lifetime. That kind of premonition of the enduring quality of a work is a well-known phenomenon.

But at that time the word 'master' itself had a different meaning, which had far more to do with craftsmanship.

In London the Betty *portrait suddenly had an enduring, universal, almost absolute quality; and curiously enough the same thing applied to the wider response that it got as a poster on the Underground. The masterpiece always implies this movement; you say it and then you take it back. It is one, and at the same time it isn't.*

It's slightly refracted by the historicist or nostalgic effect.

The discussion of works and artists' positions, which are important to you, comes to a head in the Buchloh interview, with a kind of reconstruction of your view of the history of art. In a much earlier interview you mentioned principally Barnett Newman, as representative of a historical position, and Gilbert & George as contemporaries.

Barnett Newman was always important. He came to me straight after Mondrian and Pollock. Newman was an ideal, because he created these big, clear, sublime fields that I could never have managed. He was my complete opposite.

Did your kinship with Gilbert & George lie in a shared interest and wish for normality at that time, the idea of disappearing into a completely banal life?

I liked them as outsiders, above all. At that time, Minimal, Land and Conceptual Art were dominant. I valued all that, though I had very little to do with it. With Gilbert & George, too, I liked the very nostalgic side. They were the first people who liked my landscapes. I think what impressed me the most was the way they took their own independence as a matter of course.

Not forcing pictures into the dogmatic Modernist straitjacket?

The ideological straitjacket. Perhaps I have a kind of immunity to ideologies and fashions, because movements have always passed me by: the piety of my parents' house, the Nazi period, Socialism, Rock – and all the other fashions that made up the *Zeitgeist* in thought, attitudes, dress, haircuts and all the rest. To me it all seemed intimidating rather than attractive.

It's a surprise that you never mention Magritte.

He's too popular, too pretty for me. Wonderful calendar art, village schoolmaster's art. 'This is not a pipe': to me, that's just not a very important piece of information.

What seems important to me is his recurrent doubt as to the names of things.

Perhaps it got excluded because I could already see that I was in danger of painting something a bit too popular. I notice that at exhibitions: I get a very good reaction. The doormen and cleaning ladies think it's all great, even the abstract paintings. It's actually the ideal state of

affairs, if you do something that everyone likes.

The Modernist rejection of any 'Art for All' sprang from a feeling of resentment, because painting had lost all its representational functions to photography. The ease with which you use photography puts the boot on the other foot – though without reviving the old unity between observer and object, or reverting to direct experience of the object. The construction of the picture now appears in a shattered mirror.

The image of the artist as a misunderstood figure is abhorrent to me. I much prefer the high times, as in the Renaissance or in Egypt, where art was part of the social order and was needed in the present. The suffering, unappreciated Van Gogh is not my ideal.

And his pictures?

I like Courbet's better.

How important was Beuys to you?

Mainly as a phenomenon and as a person. When I first saw the work,

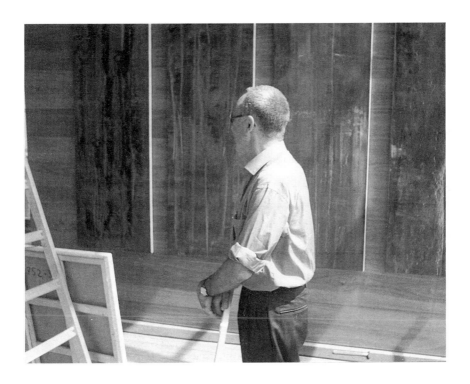

I wasn't all that interested; it was too eccentric for me. I'm increasingly in favour of the official, the classic, the universal.

Along with Manet and Ingres, Beuys is the only other artist who hangs in your studio.

Because he still fascinates me as a person more than anyone else; that special aura of his is something I've never come across either before or since. The rest are all far more ordinary. Lichtenstein and Warhol I can take in at a glance; they never had the dangerous quality that Beuys had.

In connection with the abstract paintings of the 1980s, you bring the idea of chance into play once again. Cage made chance operations out of methods based on uncertainty. But I never see chance in your work in terms of his interpretation of chance operations; you have less of the serial juggling with known elements, governed by the throw of a dice, that was usual in Conceptual Art.

Except for the Colour Charts. Those were serial; I mixed the given colours and then placed them according to chance. I found it interesting to tie chance to a wholly rigid order.

That means giving it a form.

An architect once asked me what was so good about the Colour Charts; what was supposed to be the art in them. I tried to explain to him that it had cost me a great deal of work to develop the right proportions and give it the right look.

To give it a form, in other words.

Yes, because there would have been other possible ways of realizing the idea. I could paint these biscuits here in different colours and throw them across the room, and then I would have 1024 colours in a chance form. Or in the Grey pictures: if I had painted those because I couldn't think of anything else and because it was all meaningless anyway, then I might just as well have tipped out the paint on the street, or done nothing at all.

The later abstract paintings also evoke the idea of the picture as a 'model'. Is that meant in a Mondrian-like sense?

This was something that came up in an interview with Buchloh: the idea that Mondrian's paintings might be understood as social models of

a non-hierarchical, egalitarian world. Perhaps that was what prompted me to see my own abstract paintings as models, not of an egalitarian world but of a varied and constantly changing one. But fortunately Mondrian's paintings are not read as models of society. Their most important quality is a very different one. It would be terrible if the *Broadway Boogie-Woogie* painting were a model of society; there would be the Yellows, the Reds and the Blues, all moving ahead in straight lines.

Roland Barthes says 'To be modern is to know what is no longer possible.'
What is no longer possible is everything that has already been said, and all the attendant stupidities of substance and form, pseudo-intelligent messages and dishonest intentions. If you try to avoid all that, it's hard at first, but eventually it works.

This avoidance is something you once described as 'escape'; and in your earlier pictures this referred mainly to the choice of motifs.
Like Beuys's hare. He was always on the run too. How shall I put it, escaping from falsehood is always a good starting-point.

It seems to me that this idea of escape is always cropping up in the present-day world. It's an escape that faces the facts: neither a nostalgic escape into the past nor a utopian escape into the future.
I hope so. Although it does create more uncertainty; because the utopian or nostalgic escapees are always the ones who have the advantage of knowing where they're going.

Uncertainty as the diametrical opposite of the controlled working plan?
Basically, yes; though the whole thing may seem fairly professional, it isn't, because it is not planned and controlled: it just happens.

Whistler's 'Art happens.'
Or Buren's 'It paints.'

In your Atlas *there are sketches and designs for rooms that reveal an effort to find a place to fit the pictures, to create a kind of place-specific quality.*
That sort of thing only works in sketches, because the execution would be unendurable, overblown and bombastic. But it was good to design

sanctuaries of that kind, for pictures with an incredible total effect.

Utopian spaces?

And megalomaniac ones.

The Two Sculptures for a Room *by Palermo, now in the Lenbach-haus in Munich, create a state of permanence without reference to the actual location.*

It's a very modest thing.

What works of yours exist in public space? The Underground station in Duisburg, the Hypo-Bank in Düsseldorf?

And *Victoria*, two large-format works in an insurance company. The two yellow *Strokes* are in a school. That's all, almost. And at BMW, rather badly hung, there are three large canvases, red, yellow, blue, each one three metres high by six metres wide – as an enlargement.

Commissioned works –

Yes, sometimes I've enjoyed doing commissioned work, in order to discover something that I wouldn't have found of my own accord. And so, when Siemens commissioned my first townscape, that led to all the townscapes that followed. It's also very nice when pictures have a known place to go to.

You've always made it a point of principle not to control where your pictures go, not to decide where and how they are hung. No reliance on your own hall of fame or private museum. You've just let the pictures go.

Let them go unconditionally. They need no precautions. If they're any good, they'll always find the right place; if they're not, they'll end up in the basement, and quite right too.

Haacke, for instance, tries to get this total control. He has been trying to strengthen the artist's position.

Just imagine Giacometti making stipulations of that kind! I'm glad he didn't, so that his sculptures can be shown differently each time, now in Denmark, now in Stuttgart. Every time they look different, and yet they always stay the same. There are some frightful instances of artists who have created these imperishable monuments for themselves. A certain Herr Tiefenbach, for instance, on Capri. Embarrassing.

There are some positive examples: the Segantini Museum, the Rothko Chapel, the Earth Room.

And Walter De Maria's *Lightning Field*. And all those beautiful churches, of course – there it has worked wonderfully well.

The pictures have lasted through time, thanks to their symbiotic relationship with the space.

We're a long way away from that at the moment. Kounellis, in that curious conversation he had with Beuys, Kiefer and Cucchi, talked about building a cathedral.* Simulated presence. It's sometimes done for reasons of art politics, when galleries and curators want to force something through and set up artificial monuments of that kind, full of pseudo-masterpieces.

The 'New Museology' of the 1980s arose from the Beaubourg Effect, which also had its political side. Individual works from a wide-ranging collection serve to illustrate the chronological charts; the display is designed for the masses, and only stops short of the final logical step, which would be to replace the originals with copies –

Pity.

In view of this combination of haste and cultural illiteracy, it seems to me more important than ever that there are some places where one can go and pay a visit to works – the way I visit your Baader-Meinhof work in Frankfurt from time to time.

Not that that's an ideal museum, exactly. But I know what you mean.

*When I saw your room in Kassel**, I wondered at first whether the wood was chosen by you, whether it was taking up something that is implicit in the pavilion architecture. The wood might be part of a prefabricated kit, and it ironically forces the whole thing almost down to the level of a neat domestic interior. At the same time, it strongly emphasizes the break with the 'White Cube' formula.*

It was Paul Robbrecht who suggested the wood panelling. The obligatory white walls date back only sixty or eighty years.

The only other place where I've seen that kind of floor-to-ceiling hanging in relation to your work is in your own studio.

* Joseph Beuys, Jannis Kounellis, Anselm Kiefer, Enzo Cucchi, *Ein Gespräch: Una Discussione*, ed. Jacqueline Burckhardt (Zürich: Parkett-Verlag, 1986).
** A room of paintings, *documenta 9*, Kassel, 1992.

It only works in small spaces, on the private side. Whenever I've tried it on a temporary partition in a big exhibition, it's never worked.

What surprised me in Kassel was the flower piece. Was that painted after your visit to Japan?

Yes, perhaps that trip did have some influence: it affected those vertical scraped stripe paintings, too.

The flower piece has remained unique in your work. But at the time it put me in mind of a cycle. It could be a starting point.

I have tried painting photographs of flowers since then, but there's nothing suitable. And when I tried to paint the flowers themselves, that didn't work either. Unfortunately. I should have remembered that it hardly ever works for me to take a photograph in order to use it for a painting. You take a photograph for its own sake, and then later, if you're lucky, you discover it as the source of a picture. It seems to be more a matter of chance, taking a shot with the specific quality that's worth painting. The same happened with the *Cathedral* picture. I took the photograph in 1984. I was not in the best of moods at that time. And when I painted it, three years later, I went on to photograph some other 'cathedral corners' of the same kind – but I didn't get one usable shot. The state of mind counts for a lot –

– a state that is specific to a time –

– and makes you receptive to something. If I went to that cathedral now, I wouldn't know what to photograph. There's no reason why, and I can't force it. I even went all the way to Greenland, because C. D. Friedrich painted that beautiful picture of *The Wreck of the 'Hope'*. I took hundreds of photographs up there and barely one picture came out of it. It just didn't work.

So the 'quest for the motif' has very seldom led you to a picture?

The quest for the motif is strictly for the professionals. On the other hand, when I sit down somewhere out there, more or less aimlessly and not looking for the motif, then all of a sudden the thing I've not been looking for may open up. That's good.

The flower pieces in particular raise the issue of the experiential reality of Nature, which is no longer a direct experience of Nature.

Because the flowers are cut and stuck into a vase –

– or because it happens via the photograph.

I think that's less important, because directly painted flowers would be no less artificial. Everything is artificial. The bunch of flowers, the photograph – it's all artificial. There's nothing new about that.

Or, to turn it round again: the Demiurge and Nietzsche's eternal recurrence of Nature. The painter goes into Nature and sees it as a picture created by him.

A nice idea, and one that's absolutely right, not only for painters but for everyone. We make our own Nature, because we always see it in the way that suits us culturally. When we look on mountains as beautiful, although they're nothing but stupid and obstructive rock piles; or see that silly weed out there as a beautiful shrub, gently waving in the breeze: these are just our own projections, which go far beyond any practical, utilitarian values.

When did you first use mirrors?

In 1981, I think, for the Kunsthalle in Düsseldorf. Before that I designed a mirror room for Kasper König's 'Westkunst' show, but it was never built. All that exists is the design, four mirrors for one room.

The Steel Balls *were also declared to be mirrors.*

It's strange about those *Steel Balls*, because I once said that a ball was the most ridiculous sculpture that I could imagine.

If one makes it oneself.

Perhaps even as an object, because a sphere has this idiotic perfection. I don't know why I now like it.

At the time when you made Four Panes of Glass *in 1967, glass was being used a lot, both in art and in architecture.*

In art too?

Glass was used in Minimal and Conceptual Art; Morris had mirror cubes, in which the exhibition space and the viewer became part of the work; and of course Dan Graham, in his 'Corporate Arcadia' text, shows the strong presence of glass in the architecture of that period. In mid 1960s buildings you watch the people on the lower floors working – it's transparent architecture.

That was a social preoccupation on Graham's part. What attracted me about my mirrors was the idea of having nothing manipulated in them.

A piece of bought mirror. Just hung there, without any addition, to operate immediately and directly. Even at the risk of being boring. Mere demonstration. The mirrors, and even more the *Panes of Glass*, were also certainly directed against Duchamp, against his *Large Glass.*

Duchamp comes back all the time, like a boomerang. You take up a position opposed to the complexity of the Large Glass, *and straightaway in comes the Readymade idea as well.*

Maybe. But what interested me was going against all that pseudo-complexity. The mystery-mongering, with dust and little lines and all sorts of other stuff on top. I don't like manufactured mystery.

In the Four Panes of Glass, *the artistic act was reduced to the most minimal level.*

Once again I had to take the trouble of finding the right proportion, getting the right framework. This is not a Readymade, any more than Duchamp's *Large Glass* is.

Because so much work went into it.

That's right. At one point I nearly bought a Readymade. It was a motor-driven clown doll, about 1.5 metres tall, which stood up and then collapsed into itself. It cost over 600 marks at that time, and I couldn't afford it. Sometimes I regret not having bought that clown.

You would have exhibited it just like that, as an uncorrected Readymade?

Just like that. There are just a few rare cases when one regrets not having done a thing, and that's one of them. Otherwise I would have forgotten it long ago.

In your studio there's a little mirror, hung in such a way that one is always seeing bits of recently finished paintings reflected in it.

In this case it's a good thing that it isn't head-high, but a little higher, so that you see the mirror and not the usual mirror image, which is yourself.

Over the last two years you've made the grey and coloured Mirrors, which you showed in the 'Mirrors' exhibition at Anthony d'Offay.

Those are panes of glass with a layer of paint on the back. This means that they are somewhere in-between, neither a real mirror nor a monochrome painting. That's what I like about them.

I see the mirror as a metaphor for your work as a whole. The word 'reflect' has two planes of meaning, which bring the viewer into the picture, and thus the viewer is in two states at once. A reflective trick.
The pleasant thing is that it makes the pictorial space even more variable and more subject to chance than it is in photography.

Even more open?
Yes, this is the only picture that always looks different. And perhaps there's an allusion somewhere to the fact that every picture is a mirror.

Making fun of the Modernistic attribute of flatness.
Or rather of the view that every picture has space and significance and is an appearance and an illusion, however radical it may be, right down to the Modernist goal of the flat surface, as in the Grey Pictures: these surfaces, too, have once more become illusionistic.

The steel ball, by reflecting the pictorial space, is simultaneously both the receiver and the transmitter of appearance. Once the attribute of the Emperor's worldly power, it seems to have rolled out of the picture. Partly as a rejection of naive forms of New Age holism. Lately, you've often added paint to paintings or scraped it off.
Just like playing boules. Shoot, create new situations.

Chronology

1932 Born in Dresden and raised in Reichenau and Waltersdorf, Saxony (East Germany).

1948–51 Studies stage and billboard painting in Zittau.

1952 Accepted at the Kunstakademie in Dresden. Studies 'free' painting and, later, mural painting in a realistic style.

1957 For his diploma, paints mural (now covered over) in the stairway of the Dresden Hygienemuseum. Teaching certificate allows Richter the use of a studio at the Kunstakademie for three years. Marries Marienne (Ema) Eufinger.

1959 Visits 'documenta 2' in Kassel and is impressed by abstract painting, in particular works by Jackson Pollock and Lucio Fontana. This 'discovery' of abstract painting strengthens his resolve to move to the West.

1961 Moves to Düsseldorf and studies with Karl Otto Götz at the Kunstakademie where he meets Konrad Lueg (later the art dealer Konrad Fisher), Sigmar Polke and Blinky Palermo (who was then a student of Joseph Beuys).

1962 Begins to make paintings using images from found photographs. First becomes aware of Beuys at Düsseldorf Kunstakademie, and sees an exhibition of Beuys's work near Kleve. Paints *Table*, from a newspaper photograph, and gives it the number '1' in a catalogue system Richter still uses today. First sees Pop Art works in reproduction. Travels to Paris with Konrad Lueg to show their work to Ileana Sonnabend; they present themselves, without success, as the new 'German Pop Artists'. Moves to his own studio in Düsseldorf, where he will work for the next 20 years.

1963 Exhibition 'Gerhard Richter/Konrad Lueg. Leben Mit Pop: Eine Demonstration für den Kapitalistischen Realismus', at Möbelhaus

Berges, Düsseldorf. In Krefeld sees an exhibition of work by Marcel Duchamp.

1964–65 First individual exhibitions at Galerie Heiner Friedrich, Munich; Galerie Alfred Schmela, Düsseldorf; Galerie René Block, Berlin. Paints *Cow*, Pyramids, Sphinxes and Curtains.

1966 Daughter Betty is born. Exhibits with Polke at Galerie h, Hanover. Begins to paint Colour Charts.

1967 Guest Professor at the Hochschule für Bildende Künste, Hamburg. Receives 'Junger Western' prize from the town of Recklinghausen. Makes *Four Panes of Glass*.

1968–69 Paints Cityscapes, Grey Pictures, Forests, Landscapes and Seascapes.

1970 Travels to New York with Palermo. Paints more Grey Pictures, Clouds.

1971 Begins teaching at the Kunstakademie, Düsseldorf. Paints Park Pictures, portraits of Brigid Polk and *48 Portraits* which is exhibited at Galerie Rudolf Zwirner, Cologne; Kunstmuseum, Lucerne; Galerie Nächst St Stephan, Vienna; Sürmondt Museum, Aachen.

1972 Individual exhibition at the German Pavillion, 36th Biennale, Venice. Participates in 'documenta 5', Kassel. Exhibits *Atlas*, an on-going collection of photographs, collages and drawings, at Kabinett für Aktuelle Kunst, Bremerhaven, and Museum voor Hedendaages Kunst, Utrecht.

1973 Paints pictures after Titian, large Colour Charts.

1974 *Atlas* exhibited at Galerie Heiner Friederich, Munich. Paints more large Colour Charts and Grey Pictures.

1975 Paints Tourist Pictures, Seascapes and portraits of Gilbert & George.

1976 *Atlas* exhibited at Museum Haus Lange, Krefeld. Paints Grey Pictures. Begins painting Abstract Pictures.

1977 Participates in 'documenta 6', Kassel.

1978 Guest Professor at the University of Halifax (Canada).

1979 Exhibits Abstract Pictures at Whitechapel Art Gallery, London.

1981 Receives Arnold Bode Prize, Kassel. For the 'Westkunst' exhibition, at Rheinhallen, Cologne, Richter designs an unrealized room of four mirrors. Later exhibits first mirrors at the Kunsthalle Düsseldorf.

1982 Marries Isa Genzken, Paints Candles.

1983 Moves to Cologne.

1985 Receives Oscar Kokoschka Prize, Vienna. Participates in the exhibition 'German Art in the Twentieth Century: Painting and Sculpture 1905–1985', Royal Academy of Art, London; Staatsgalerie, Stuttgart. Paints Candles with Skulls, Landscapes.

1987 Participates in 'documenta 8', Kassel. The artist's notes are first published in the exhibition catalogue *Richter. Werken op Papier 1983–1986*, Museum Overholland, Amsterdam.

1988 Guest Professor at the Städelschule, Frankfurt. Receives the 'Kaiserring' of the City of Goslar. Paintings retrospective exhibited at the Art Gallery of Ontario, Toronto; the Museum of Contempory Art, Chicago; Hirshhorn Museum and Sculpture Garden, Washington, D.C.; Museum of Modern Art, San Francisco. 'The London Paintings' exhibition at the Anthony d'Offay Gallery, London. Paints the cycle *18. Oktober 1977*.

1989–91 *18. Oktober 1977* cycle is exhibited at Museum Haus Esters, Krefeld; Portikus, Frankfurt am Main; Institute of Contemporary Arts, London; Saint Louis Art Museum; Grey Art Gallery, New York; The Montreal Museum of Fine Arts; The Lannan Foundation, Los Angeles; Institute of Contemporary Arts, Boston. Paints *Betty*, portrait of his daughter.

1991 Retrospective exhibition at The Tate Gallery, London. 'Mirrors' exhibition at the Anthony d'Offay Gallery, London.

1992 Creates a room of paintings for 'documenta 9', Kassel.

1993–94 Major retrospective exhibition at Kunst- und Ausstellungshalle der Bundesrepublik Deutschland, Bonn; Musée d'Art Moderne de la Ville de Paris; Moderna Museet, Stockholm; Museo Nacional Centro de Arte Reina Sofía, Madrid. *Gerhard Richter Texte*, writings and interviews 1962–1993, is published in German by Insel Verlag, Frankfurt am Main.

1995 *Atlas* exhibited at the Dia Center for the Arts, New York. Receives the Wolf Prize, Jerusalem. Exhibition at the Israel Museum, Jerusalem. French translation of the writings and interviews, *Gerhard Richter Textes*, is published by les presses du réel, Dijon. *The Daily Practice of Painting*, English translation of writings and interviews, is published by the Anthony d'Offay Gallery in association with Thames & Hudson and The MIT Press. 'Painting in the Nineties' exhibition at the Anthony d'Offay Gallery, London. Marries Sabine Moritz. Son Moritz is born.

Selected Bibliography

*All the writings and interviews by Gerhard Richter printed here have been newly translated from the German edition.

1963

*Gerhard Richter, programme and report for the exhibition 'Leben Mit Pop – eine Demonstration für den Kapitalistischen Realismus', Möbelhaus Berges, Düsseldorf.

1964

Manfred de la Motte, in *Gerhard Richter* [catalogue], Galerie Block, Berlin.

1965

J. Anthony Thwaites, 'Last Summer on the Rhine and Ruhr', *Studio International*, no. 169, January, pp. 16–21.

1966

*Dieter Hülsmanns and Friedhelm Reske, 'Das perfekte Bild' [interview], *Rheinische Post*, Düsseldorf, 3 May.
*Gerhard Richter and Sigmar Polke, in *Polke/Richter* [catalogue], Galerie h, Hanover.
Willi Grohmann, in: Grohmann, *Kunst unserer Zeit*, DuMont Verlag, Cologne.

1968

Heinz Ohff, in Ohff, *Pop und die Folgen*, Düsseldorf; reprinted in *Gerhard Richter* [catalogue], 36th Biennale, Venice.

1969

Jean-Christophe Ammann, 'Zu Gerhard Richter', in *Düsseldorfer Szene* [catalogue], Kunstmuseum Lucerne.
Klaus Honnef, 'Schwierigkeiten beim Beschreiben der Realität: Richters Malerei zwischen Kunst und Gegenwart', in *Gerhard Richter* [catalogue], Gegenverkehr e.V., Aachen.

1970

Rolf Gunter Dienst, *Deutsche Kunst: Eine neue Generation*, M. DuMont Schauberg, Cologne.
Rolf Gunther Dienst, 'Interview mit Gerhard Richter', *Noch Kunst*, Gütersloh; reprinted in *Gerhard Richter* [catalogue], 36th Biennale, Venice, 1972.
Dieter Honisch, 'Die Graphik Gerhard Richters', in *Gerhard Richter: Graphik u. Studien 1965–1970* [catalogue], Museum Folkwang, Essen.

1971

Klaus Honnef, 'Gerhard Richter', in *20 Deutsche* [catalogue], Galerie Onnasch, Berlin.
Dietrich Helms, 'Über Gerhard Richter', in *Gerhard Richter: Arbeiten 1962 bis 1971* [catalogue], Kunstverein für die Rheinlande und Westfalen, Düsseldorf.
René Block, *Grafik des Kapitalistischen Realismus: K. P. Brehmen, Hödicke, Lueg, Polke, Richter, Vostell*, Edition Block, Berlin.

1972

Jürgen Hohmeyer, 'Richter: Wenn's Knallt', *Der Spiegel*, no. 34, pp. 90–1.
Gerhard Richter, *Atlas van der foto's en schetsen*, Museum voor Hedendaagse Kunst, Utrecht.
*Rolf Schön, 'Unser Mann in Venedig' [interview], *Deutsche Zeitung*, 14 April, p. 13.
Gerhard Richter, 36th Biennale, Venice.

Essays by Dieter Honisch, Karl-Heinz
Hering; interviews by Rolf Schön and
Rolf Gunter Dienst.
*Peter Sager, 'Gespräch mit Gerhard
Richter', *Das Kunstwerk*, vol. 25, July,
pp. 16–17.
Heiner Stackelhaus, 'Doubts on the Face
of Reality: the Paintings of Gerhard
Richter , *Studio International*, no.184,
September, pp.76–80.

1973
*Wulf Herzogenrath, *Selbstdarstellung:
Künstler über sich*, Droste Verlag,
Düsseldorf (includes two letters from the
artist, pp.18–19).
Klaus Honnef, 'Problem Realismus: Die
Medien des Gerhard Richter',
Kunstforum, vol.4/5, pp. 68–91.
Jean-Christophe Ammann, 'Zu Gerhard
Richter' in *Gerhard Richter* [catalogue],
Städtische Galerie im Lenbachhaus,
Munich.

1974
Johannes Cladders, in *Gerhard Richter:
Graue Bilder* [catalogue], Städtisches
Museum, Mönchengladbach.
Gerhard Richter, '1024 Farben in 4
Permutationen', in *Andre, Broodthaers,
Buren, Burgin, Gilbert & George, Richter*
[catalogue], Palais des Beaux-Arts,
Brussels.

1975
Heinz Holtmann, 'Gerhard Richter', in
Graue Bilder [catalogue], Kunstverein
Braunschweig.
Manfred Schneckenburger, 'Gerhard
Richter oder ein Weg weiterzumalen',
and Marlies Grüterich, 'Gerhard
Richters Phänomenologie der Illusion –
eine gemalte Ästhetik gegen die reine
Malerei', in *Gerhard Richter: Bilder aus
den Jahren 1962–1974* [catalogue],

Kunsthalle Bremen.
Rolf Wedewer, 'Zum Landschaftstypus
Gerhard Richters', *Pantheon*, vol. 33,
no. 1, January–March.
*Gerhard Richter, 'About eight years
ago', in *Fundamenteele Schilderkunst/
Fundamental Painting* [catalogue],
Stedelijk Museum, Amsterdam.

1976
René Block (ed.), *K. P. Brehmer,
K. H. Hödicke, Sigmar Polke, Gerhard
Richter, Wolf Vostell: Werkverzeichnisse
der Druckgrafik: Band II: September 1971
bis Mai 1976*, Edition Block, Berlin.
Klaus Honnef, *Gerhard Richter*,
Monographien zur Rheinisch-
Westfälischen Kunst der Gegenwart,
vol. 50, Recklinghausen.
Gerhard Storck, 'Beschäftigung mit
Gerhard Richters Sammelwerk "Atlas
der Fotos, Collagen und Skizzen"', in
*Gerhard Richter: Atlas der Fotos,
Collagen und Skizzen* [catalogue],
Museum Haus Lange, Krefeld.
*Gerhard Richter, [statement] in *Räume:
Carl Andre, Marcel Broodthaers, Daniel
Buren, Hans Hollein, Bruce Nauman,
Gerhard Richter, Ulrich Rückreim*
[catalogue], Städtisches Museum,
Mönchengladbach.
Benjamin H. D. Buchloh, 'Ready-Made,
photographie et peinture dans la
peinture de Gerhard Richter', in
Gerhard Richter [catalogue], Centre
National d'Art et de Culture Georges
Pompidou/Musée National d'Art
Moderne, Paris.
*Europe in the Seventies: Aspects of Recent
Art* [catalogue], Art Institute of Chicago.
Essays by Jean-Christophe Ammann,
David Brown, R. H. Fuchs, Benjamin
H D. Buchloh.

*Amine Haase, 'Malerei als Schein' [interview], *Rheinische Post*, Düsseldorf, 16 September; reprinted in Haase, *Gespräche mit Künstlern*, Wienand, Cologne, 1981.

1978
Gerhard Richter: 48 Portraits [catalogue], Midland Group, Nottingham.
R. H. Fuchs, 'Artificial Miracles', in *Gerhard Richter – Abstract Paintings* [catalogue], Stedelijk van Abbemuseum, Eindhoven.
Gerhard Richter, *128 Details from a Picture (Halifax 1978)*, Press of the Nova Scotia College of Art and Design, Halifax, Canada.

1979
Gerhard Richter – Abstract Paintings [catalogue], Whitechapel Art Gallery, London. Essays by R. H. Fuchs, Benjamin H. D. Buchloh.

1980
Zdenek Felix, 'Zwei gelbe Striche', in *Gerhard Richter – Zwei gelbe Striche* [catalogue], Museum Folkwang, Essen.

1981
Gerhard Richter, *Eis (1973/1981)* [artist's book], Galleria Pieroni, Rome.
Jürgen Harten, 'Zum Vergleich', in *Georg Baselitz – Gerhard Richter* [catalogue], Städtische Kunsthalle, Düsseldorf.
Bruno Corà, 'Osservazioni dei percorsi interni, mutevoli e alti della pittura: la via Richter', in *Gerhard Richter* [catalogue], Padiglione d'Arte Contemporanea di Milano, Milan.

1982
Heribert Heere, 'Gerhard Richter – Die abstrakten Bilder: Zur Frage des Inhalts', in *Gerhard Richter, Abstrakte Bilder 1976 bis 1981* [catalogue], Kunsthalle Bielefeld.
Wolfgang Max Faust, 'Gerhard Richter', in Faust, *Hunger nach Bildern*, DuMont Verlag, Cologne, pp. 42–48.
*Gerhard Richter, 'Wenn wir einen Vorgang beschreiben ... ', in *documenta 7* [catalogue], vol.1, Kassel.
Jean-Christophe Ammann, *Werke aus der Sammlung Crex* [catalogue], Kunsthalle Basel.

1983
Bernard Blistène, 'Gerhard Richter: Réflexion sur l'échec de la peinture', *art press*, no. 67, February, pp. 23–6.
R. H. Fuchs, in *Isa Genzken. Gerhard Richter* [catalogue], Galleria Pieroni, Rome.

1984
Bernard Blistène, 'Gerhard Richter ou l'exercice du soupçon', in *Gerhard Richter* [catalogue], Musée d'Art et d'Industrie, Saint-Etienne.
*Bruno Corà, [interview] in *Terrae Motus* [catalogue], Fondazione Amelio Istituto per l'Arte Contemporanea, Naples.
*Wolfgang Pehnt and Werner Kruger, [interview] in *Künstler im Gespräch*, Cologne.
Dierk Stemmler, 'Universale Malerei des Unerklärlichen wegen: Gerhard Richter', in *Sammlung deutscher Kunst seit 1945* [catalogue], vol. II, Städtisches Kunstmuseum, Bonn.
Dietmar Elger, 'Autonome Wirklichkeiten', in *Aquarelle* [catalogue], Kunstverein Kassel.

1985
Ulrich Loock, 'Aquarelle von Gerhard Richter', in *Gerhard Richter: Aquarelle* [catalogue], Staatsgalerie, Stuttgart.

Benjamin H. D. Buchloh, 'Richter's
Facture: Between the Synecdoche and
the Spectacle', in *Gerhard Richter*
[catalogue], Marian Goodman Gallery/
Sperone Westwater Gallery, New York.
Coosje van Bruggen, 'Gerhard Richter:
Painting as a Moral Act', *artforum*,
vol. 23, no. 9, May, pp.82–91.
Ulrich Loock and Denys Zacharopoulos,
Gerhard Richter, Verlag Silke Schreiber,
Munich.
Ulrich Loock, 'Das Ereignis des Bildes',
in *Rheingold* [catalogue], Palazzo della
Società Promotrice delle Belle Arti,
Turin.
Dieter Honisch, 'Gerhard Richter', in
*1945-1985: Kunst in der Bundesrepublik
Deutschland* [catalogue], Nationalgalerie,
Berlin.

1986
Jürgen Harten, 'Der romantische Wille
zur Abstraktion', in *Gerhard Richter:
Bilder 1962-1985*, DuMont Verlag,
Cologne.
Walter Grasskamp, 'Gerhard Richter:
Verkündigung nach Tizian', in
Grasskamp, *Der vergessliche Engel,
Künstlerporträts für Fortegeschrittene*,
Verlag Schreiber, Munich.
R. H. Fuchs, in *Gerhard Richter:
Paintings 1964-1974* [catalogue], Barbara
Gladstone Gallery/Rudolf Zwirner
Gallery, New York.
Klaus Honnef, 'Gerhard Richter', in
*Positionen: Malerei aus der
Bundesrepublik Deutschland* [catalogue],
Sprengel Museum, Hanover.

1987
*Gerhard Richter, [notes] in *Gerhard
Richter: Werken op Papier 1983-1986*
[catalogue], Museum Overholland,
Amsterdam.

Anne Rorimer, 'Gerhard Richter: The
Illusion and Reality of Painting', and
Denys Zacharopoulos, 'Abstract
Paintings', in *Gerhard Richter –
Paintings* [catalogue], Marian Goodman
Gallery/Sperone Westwater Gallery,
New York.
Paul Groot, 'Die Selbstporträts von
I.G.G.R.', in *Isa Genzken e Gerhard
Richter* [catalogue], Galleria Mario
Pieroni, Rome.

1988
Jill Lloyd, 'Gerhard Richter: The
London Paintings', in *Gerhard Richter:
The London Paintings* [catalogue],
Anthony d'Offay Gallery, London.
Denys Zacharopoulos, 'L'Atelier de
Richter, la peinture', in *Gerhard Richter*
[catalogue], Galerie Liliane & Michel
Durand-Dessert, Paris.
*Roald Nasgaard (ed.), *Gerhard Richter
Paintings* [catalogue], Art Gallery of
Ontario, Toronto; Museum of
Contemporary Art, Chicago.

1989
Gerhard Richter: 18.Oktober 1977, Verlag
der Buchhandlung Walther König,
Cologne. Essays by Benjamin H. D.
Buchloh, Stefan Germer, Gerhard
Storck.
*Jan Thorn Prikker, 'Ruminations on
the October 18, 1977 Cycle' [interview],
Parkett, no. 19, March, pp. 143–53.
Gerhard Richter, *18.Oktober 1977* [press
release], Museum für Moderne Kunst/
Portikus, Frankfurt am Main.
Gerhard Richter: 1988/89, Museum
Boymans van Beuningen, Rotterdam.
Essays by Benjamin H. D. Buchloh,
Karel Schampers, Anna Tilroe.
Armin Zweite, 'Gerhard Richters Atlas

des Fotos, Collagen und Skizzen', in *Atlas* [catalogue], Fred Jahn (ed.), Städtische Galerie im Lenbachhaus, Munich.

1990

*Sabine Schütz [interview], *Journal of Contemporary Art*, vol. 3, no. 2, Winter, pp. 34–46.

Richard Cork, 'Through a Glass Darkly: Reflections on Gerhard Richter', in *Gerhard Richter Mirrors* [catalogue], Anthony d'Offay Gallery, London.

1991

Hubertus Butin, *Zu Richters Oktober-Bildern*, Verlag der Buchhandlung Walther König, Cologne (Schriften zur Sammlung des Museums für Moderne Kunst, Frankfurt am Main).

Katharina Hegewisch, in *Sol Le Witt/ Gerhard Richter* [catalogue], Hypo-Bank, Düsseldorf.

*Jonas Storsve, 'Gerhard Richter – La Peinture à venir' [interview], *art press*, no. 161, September, pp. 12–20.

Gerhard Richter, [notes] in *Gerhard Richter* [catalogue], The Tate Gallery, London. Essays by Neal Ascherson, Stefan Germer, Sean Rainbird.

Hans Strelow, 'Leben mit Pop . . . ', in *Die Kunst der Ausstellung*, Bernd Klüser and Katharina Hegewisch (eds.), Frankfurt am Main.

1992

*Doris von Drathen, 'Gerhard Richter: Les Pouvoirs de L'Abstraction' [interview], in *Les Cahiers du Musée National d'Art Moderne*, Paris.

Gertrud Koch, 'The Richter-Scale of Blur', *October*, no.62.

Michael Edward Shapiro, 'Gerhard Richter: Paintings, Prints and Photographs in the Collection of the Saint Louis Art Museum', in *The Saint Louis Art Museum*, summer bulletin.

Benjamin H. D. Buchloh, 'Gerhard Richter und die Allegorie des Abstrakten Kabinetts', in Buchloh, *Texte zu Kunst*, Cologne.

Hans-Ulrich Obrist (ed.), *Gerhard Richter – Sils*, Oktagon Verlag, Munich/ Stuttgart. Essay by Peter André Bloch.

Richard Cork [interview], *Apollo*, no.1, pp. 48–9.

1993

'Gerhard Richter', *Parkett*, no.35. Essays by Jean-Pierre Criqui, Peter Gidal, Dave Hickey, Gertrud Koch, Birgit Pelzer.

Gerhard Richter [catalogue], Kunst- und Ausstellungshalle der Bundesrepublik Deutschland, Bonn; Edition Cantz, Stuttgart. Vol.1: exhibition catalogue. Vol.II: essays by Benjamin H. D. Buchloh, Peter Gidal, Birgit Pelzer. Vol.III: catalogue raisonné.

María de Corral López-Doriga (ed.), *Gerhard Richter* [catalogue], Museo Nacional Centro de Arte Reina Sofía, Madrid. Essays by Corral, Benjamin H. D. Buchloh, José Lebrero Stals.

Gerhard Richter, *Texte: Schriften und Interviews*, Hans-Ulrich Obrist (ed.), Insel Verlag, Frankfurt am Main.

1995

Gerhard Richter, *Textes* [writings and interviews], les presses du reél, Paris/Dijon.

Peter Gidal, 'The Polemics of Paint', in *Gerhard Richter: Painting in the Nineties* [catalogue], Anthony d'Offay Gallery, London.

Index